Life in

VICTORIAN

PRESTON

Life in

VICTORIAN

PRESTON

DAVID JOHN HINDLE M.A.

AMBERLEY

First published 2014

Amberley Publishing
The Hill, Stroud
Gloucestershire, GL5 4EP

www.amberley-books.com

British Library Cataloguing in Publication Data.
A catalogue record for this book is available from the British Library.

ISBN 978 1 4456 1916 3 (print)

ISBN 978 1 4456 1921 7 (ebook)

Typeset in 11pt on 15pt Sabon.
Typesetting and Origination by Amberley Publishing.
Printed in the UK.

Contents

Dedication

This book is written as a tribute to my late wife, Dorothy Hindle (1943–2013), who gained a reputation for her nursing excellence as a ward sister on Brown Ward, the male surgical ward, at the old Preston Royal Infirmary from 1964 to 1987. Dorothy was born in Preston on 30 April 1943, and attended the former Preston Park Grammar School for girls. After leaving school, she commenced work at the former Whittingham Hospital; I was working there at the time and a romance blossomed into marriage in September 1970. Dorothy transferred to the Preston Royal Infirmary as a student nurse and was appointed the youngest ward sister at the age of twenty-one.

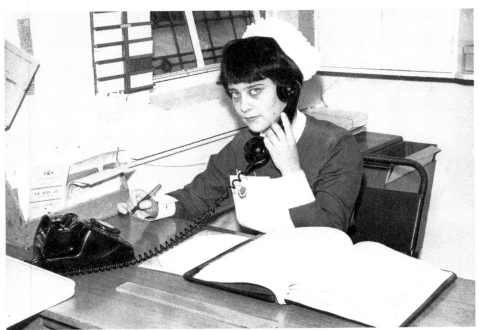

Sister Dorothy Hindle on duty in her office on Brown Ward, Preston Royal Infirmary.

Many of her former colleagues have told me that she was extremely competent as well as kind and well respected by nursing colleagues, doctors and consultants alike. At the same time she carried out her duties with the utmost professionalism, being fully aware of everything that was going on, ready to advise and pass on her skills and knowledge. This reputation was summed up by an elderly patient on the ward many years ago, who pointed Dorothy out to a fellow patient and observed, 'See 'ur there? Sh'is best o' t' lot.'

Yes, I know that I was lucky to get such 'a good 'un'. I was happily married for forty-three years, enjoying the things I like doing most with a very tolerant mentor and best friend who was always very wise in her judgements and yet possessed an incredible sense of humour. Dorothy died on 1 June 2013. During her last week spent as a patient at the Royal Preston Hospital she had been her usual positive, cheerful, courageous and upbeat self. I am told that she was an inspiration to both staff and fellow patients. Fortunately, I am left with a wonderful daughter, Caroline, and two adorable grandchildren. I realise how much my family have contributed to my overall happiness. As a Prestonian born and bred, I have many happy memories of Preston, including attending the Christmas Day events on Brown Ward, hanging around the nurses' home waiting for Dorothy and attending many parties with nurses and medics.

As a further tribute to Sister Dorothy Hindle, there now follows a short history of the provision of health care in Preston and a portfolio of historic photographs depicting aspects of the old Preston Royal Infirmary.

During the mid-nineteenth century, Preston was without piped water, drains or sewers. Cholera and typhus were rampant, and infant mortality was very high among working-class families. Moreover, Preston had the highest infant mortality rate in the country during the Victorian era and sedan chairs were used as hearses for little children, with their coffins placed horizontally on the floor and extending through the windows, while their parents sat on each side of the sedan. The provision for health care was first established in 1809 when a meeting was held at the town hall to 'consider the propriety of erecting by subscription a Dispensary for supplying the poor with medicine to their relief in the case of sickness'. A committee of twenty-four people was appointed under the presidency of William Cross of Winckley Square, Preston, and comprised four physicians, aldermen and other prominent citizens of the town to carry the institution into effect. The first temporary Preston Dispensary was contained in a house situated in Everton Gardens, off North Road. Two years later the dispensary relocated to premises between Lune Street and Fox Street – hence today we have Surgeons' Court, a narrow passage linking the two streets.

A new house of recovery was built on Ribbleton Moor (now Moor Park), opening its doors during 1832. Fortuitously, the timing was right to catch a smallpox epidemic, when 3,000 patients were treated but 170 died. This was the beginning of Preston Royal Infirmary. Brown Ward, where Sister Hindle worked for many years, was named after Sir Charles Brown (1836–1925), a Preston doctor, who on qualifying in London, returned to Preston to be house surgeon at

the dispensary on Fishergate. Dr Charles Brown was later appointed as a member of staff at the Preston Royal Infirmary. He was a great benefactor, who donated in excess of £40,000 to the hospital. The grand old man of medicine remained at the hospital until 1922.

In 1869, the house of recovery was no longer deemed fit for purpose to serve a population that had risen from 15,000 in 1809 to 85,000 by 1870. Henceforth, with the implementation of a trust deed, the house of recovery was to be used solely as an infirmary for the borough of Preston and the surrounding area. Substantial upgrades to the building and equipment were made, with an increase from twenty-four to thirty beds, made possible by a generous bequest of £20,500 by Mr John Bairstow. Queen Victoria became patron of the new infirmary, which was named The Preston and County of Lancaster Royal Infirmary. In 1871 the old dispensary near Lune Street was closed and combined with the new infirmary, and a new lodge, grounds and entrance drive were completed. Diseases continued to be a prominent cause of death. During 1874, sixty-two smallpox cases and 125 cases of measles were admitted, many of which proved fatal.

Queen Victoria commenced her long reign of sixty-four years in 1837. Following her death on 22 January 1901, King Edward VII signified his approval to a change of name to the Preston and County of Lancaster Queen Victoria Royal Infirmary. By the late twentieth century the old Preston Royal Infirmary was outmoded, and a decision was made to build a brand-new hospital at Fulwood. Consequently, the transfer to the Royal Preston Hospital had been completed by 1986.

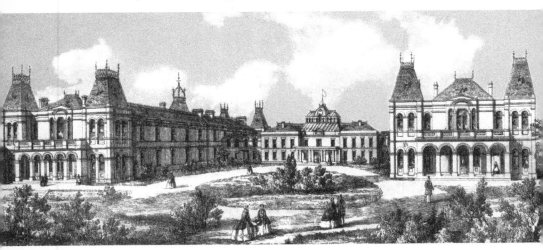

The newly built Preston Royal Infirmary. (Courtesy of Preston Royal Infirmary League of Nurses)

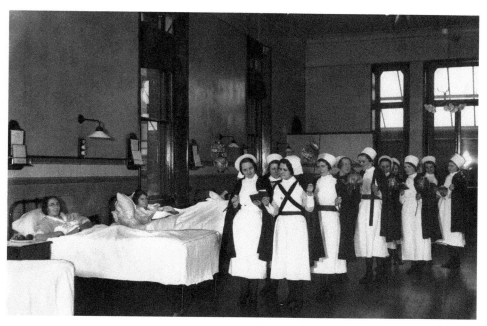

Alice Ward, patients being greeted by early morning Christmas carols in the 1930s. (Courtesy of Preston Royal Infirmary League of Nurses)

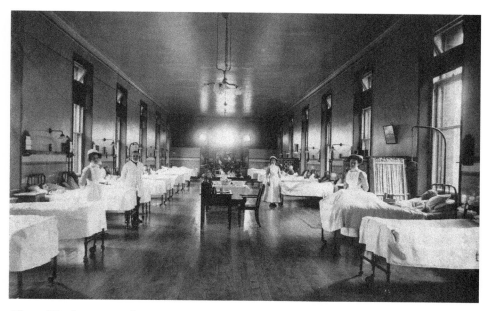

Albert Ward, waiting for Matron's daily round, *c.* 1911. (Courtesy of Preston Royal Infirmary League of Nurses)

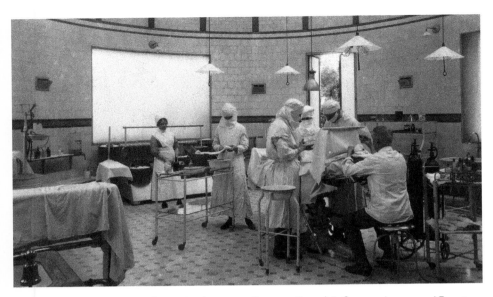

Performing operations in the main theatre at Preston Royal Infirmary in 1935. (Courtesy of Preston Royal Infirmary League of Nurses)

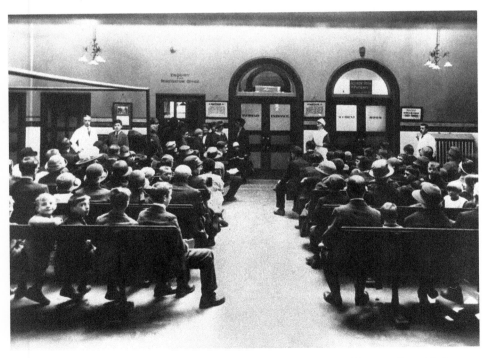

Waiting in casualty, Preston Royal Infirmary, *c.* 1920. (Courtesy of Preston Royal Infirmary League of Nurses)

Introduction

This book draws upon certain key elements of Preston's social and economic history, with a particular emphasis on Preston's entertainment industry and how the Victorians used the railways and other forms of transport for work and leisure. Notable entertainers and touring companies continued to have great reliance on the railways during the Victorian era and the first half of the twentieth century while visiting the variety theatres and other seats of entertainment throughout the country.

The focus will be very much on the Preston model as a baseline for describing the first music halls, pleasure gardens, travelling fairs and circuses and the emergence of the first proletarian cinemas. As I recall, there were some curious flea pits dotted about the town serving local communities, and many older Prestonians hold nostalgic memories of their unique characteristics. The names of these essentially proletarian venues just roll off the tongue: 'Fleckie Bennetts', The Cosy, Carleton, The Empress, Guild Cinema, Rialto, New Victoria, Palladium, Picturedrome, Ritz, The Star, Savoy, Plaza, Queens Cinema and the Empire Cinema on Church Street. I devote an entire chapter to the Empire Theatre, a former music hall. All of the foregoing stimulated further research into the history of Preston's long-lost popular entertainment industry and associated venues, including the Preston Pleasure Gardens.

One of Preston's earliest cinemas, the 'Victory', later known as the 'Rialto', was situated immediately adjacent to the Preston–Longridge branch line and conveniently, for my future wife Dorothy and I, close to the Preston Royal Infirmary. Fortunately one community cinema survives at Longridge, near Preston. An anachronism from another era, yes, Longridge Palace Cinema is undoubtedly unique, for I know of no other community cinema quite like it anywhere in northern England. Furthermore, the Palace personifies the history of music hall and cinema as a microcosm of its development from when it was first established in 1912. That the Palace survives at all is due to the commitment and enterprise of the Williamson family and their team. However, there are no grounds for complacency, so use it or one day we might lose it!

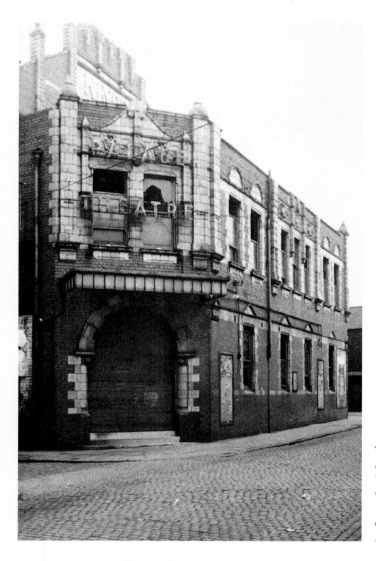

The entrance to the derelict King's Palace Variety Theatre in Crooked Lane in 1960. (Courtesy of Preston Digital Archive)

My parents took me along to the music hall and pantomime performances at Preston's two live theatres, which were the Royal Hippodrome and King's Palace theatres. Pantomime developed in the Victorian Theatre Royal and Gaiety Theatre of Preston into a bulging Christmas cracker of family entertainment. Shouts of children chanting 'It's behind you' and 'Oh yes it is' filled many of the nation's theatres and delighted several generations of children, mine included. Little had changed by the Edwardian period, for the annual pantomime remained a holiday music hall in disguise, a spectacle for parents as much as their children. Preston has produced two of the greatest and most loved pantomime dames, namely John Inman and Roy Barraclough.

The town's so-called good old days of variety theatres and other forms of entertainment peaked in the Victorian and Edwardian eras, at the time of the national music hall boom, which lasted until the outbreak of the First World War. Were they really the good old days in Preston, though? The answer, as we shall see, is a resounding 'no'!

The Victorian historian Hewitson supports the view that Preston had an exceptional level of industrial unrest:

> Numerous conflicts, some very serious, and all of them tending to weaken the bonds of mutual goodwill between the employers and the employed have taken place in the cotton trade of Preston. At one time Preston was deemed the chief battlefield of Lancashire, so far as cotton trade difficulties of any moment were concerned.[1]

In Chapter 3 Charles Dickens paints a clear picture of the social and economic scene in Preston, and describes his journey from London Euston station to Preston. It is believed that the scenes he witnessed inspired his novel *Hard Times*, published during the same year. The description of the fictitious Coketown is widely believed to be based on Preston, and doubtless this absorbing chapter will be of interest to scholars and historians alike. The town's role in history can still be seen in the buildings that have survived, and we take a contrasting and detailed look at the town in chapters 1 and 4.

I aim to take a retrospective look at the railways and how they developed to make an impact on social history with trips to the music hall. The railways, of course, contributed to the creation of a new industrialised working-class environment and rapid population growth in the nation's town and cities. Indeed, Preston broadly assumed its present appearance towards the end of the Victorian era. We focus on those iconic giants of the iron road during the glorious age of steam.

The Liverpool–Manchester Railway officially opened in 1830 and was the first commercial passenger railway to operate in north-west England. Thereafter railway mania was to impact on Preston and indeed the rest of the world. However, at first, progress on the railways was somewhat slow, and in many instances a music hall joke. The carriage of passengers seems to have been of secondary importance, with bizarre happenings and instances of first-class bovines and first-class passengers sharing the same compartment. If the following letter was an example of first-class travel, then what was travel like in third-class carriages during the late 1840/50s?

> On Wednesday last I took it in my head to visit Longridge. I scrambled into a carriage, first-class of course, when to my surprise I found a quadruped in the shape of a fine calf, stretched within the compartment. Our journey, however, was not deficient in interest, for what with the wheezing puffs of the old asthmatic engine, the bleatings of the cow, and the imprecation of an old gentleman, whose juxtaposing with the calf appeared a grievous source of annoyance to him, we had music enough to spare. Would it be to too much to

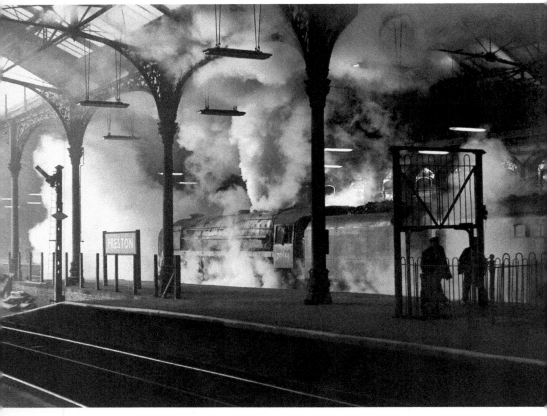

Above: The glories of the steam age are beautifully captured here by Peter Fitton – Britannia Pacific No. 70046 *ANZAC* departing Preston station with a Barrow to Euston train on 5 January 1967.

suggest that a separate box of some kind should be provided for the swine, which are conveyed on this railway? The precedent is a dangerous one, and may grow into a great abuse.

As late as 1868, passengers were still travelling in open third-class carriages, and consequently, being exposed to the elements, took their umbrellas with them. A contemporary leaflet, 'Rules for Railway Travelling', provided general advice to the first Victorian travellers: 'If a 2nd class carriage, as sometimes happens, has no door passengers should take care not to put out their legs. Beware of yielding to a sudden impulse to spring from the carriage to recover your hat, which has blown off, or a parcel that has been dropped.'

Signs of improvement during the same year meant that third-class passengers could now dispense with putting their umbrellas up in wet weather and could rest assured in the knowledge that a braking system had been installed:

A few months ago those who were under the unfortunate necessity of going in a 3rd class carriage to that place [Longridge] in wet weather had to keep their umbrellas up as inside the train as out. This state of things has now been remedied. The present company have provided for ordinary traffic a very commodious train of three carriages coupled with a patent brake, which for the heavy incline will be of great service.

The Victorians, including the squire of Grimsargh with Brockholes, William Cross, used the local branch line in the 1860s to reach the manorial seat at Red Scar, situated 3 miles to the north-east of Preston. The Cross family are an intrinsic part of Preston's history and were great benefactors for Preston during the cotton famine. Katherine Matilda Cross (second generation of the family) collected several hundred pounds, and with the money bought blankets and other creature comforts to distribute among the poor starving people. Her father-in-law, William Cross, became a distinguished lawyer and created Winckley Square. The adjacent Cross Street was named after him. Today, we are reminded of William Cross's legacy and vision of a green oasis in the centre of the city. Winckley Square has long been enjoyed by generations of Prestonians and there are exciting plans for its future. We put the focus on the Cross family in chapters 15 and 16. This heart-warming chapter is a fitting climax to the work, and comes with the kind permission of Anthony Assheton Cross, a direct descendant of the Cross family.

The growth in the number of excursion trains after 1860 was driven by people having more free time and the increased range of available leisure activities. Victorian pleasure gardens were in vogue in several north-west towns, and the first one in Preston was the Preston Borough Gardens, situated in Ribbleton Lane. In 1859 it hosted a 'Great Highland gathering and competition of Scottish Games and Music, as patronised annually by Her Majesty the Queen, taking place on July 11th 1859. Arrangements are being made for excursion trains.' The Borough Gardens were a forerunner to the Preston Pleasure Gardens Co. Ltd, which opened on a 43-acre site in 1877 and are fully described on page 134.

Childhood memories of Preston's parks include the natural amphitheatre of Avenham Park, where I took part in the Preston Guilds of 1952 and 1992, and our local park at Ribbleton, with its very cool open-air swimming baths. My dad once told me that there used to be a motorcycle speedway at Farringdon Park, and before that a zoo set within large Victorian pleasure gardens. As a child I recall catching a maroon and cream corporation bus destined for Farringdon Park and being taken to 'The Dingle', walking over a footbridge spanning a wooded gorge linking two Ribbleton housing estates. Today 'The Dingle' and Brockhole's Wood survive as a legacy of a once thriving Victorian pleasure park and gardens.

Personal memories of Preston Dock include watching the shipping movements at the curiously named 'Bull Nose', where the river meets the dock entrance. As the tide surged up the river, a fleet of five old dredgers, appropriately named *Robert*

Above: The Ribble channel had to be dredged at high tide by a fleet of steam dredgers that were mostly named after the Ribble and its tributaries. Sand hoppers beached at Lytham *c.* 1938, left to right: *Calder, Ribble, Savick, Robert Weir* and *Astland.* (Photo courtesy of Frank Dean (Peter Fitton))

Weir, Ribble, Astland, Calder and *Savick,* sailed west into a glorious sunset on a winter's afternoon, and a flotilla of interesting vessels began to move up and down the channel linking the docks to the estuary. I remember standing near a huge ramp at the north-west corner of the main dock with my father, and watching innumerable articulated vehicles disappearing into the gaping hole of the old *Empire Cedric* – a converted landing craft. Both Father and the ship are now gone, but not forgotten.

Away from the hospital, my father took me along to Preston North End in the late 1950s. There I enjoyed the privilege of watching the late, great Sir Tom Finney playing outside right on the turf at Deepdale, and all I can say is: sheer magic! I queued up for his autograph at Lowthorpe Road, along with lots of other kids, and he graciously obliged and took the time and trouble to have a friendly chat. He was, as most people seem to acknowledge, the greatest of footballers, yet was a down-to-earth and very humble gentleman, and undoubtedly Preston's most famous son, the likes of which we will never see again.

Finally, I have spent many hours investigating primary source material and what follows is the fruit of my research. The illustrations are sure to evoke many memories, and will hopefully serve as a permanent pictorial record of Preston's Victorian and Edwardian heritage.

Setting the Scene for Dickens: 'Preston, Cotton Factory Town'

By the time of the mid-Victorian era, Preston's textile workers' prosperity was adversely affected by periodic strikes and depressions affecting the industry. Victorian Preston was, for many townsfolk, a depressing place to be throughout long periods of the Industrial Revolution: a time when there was much squalor and poverty, housing was primitive and disease was rampant. Through the necessity of work and the effects of poverty, the indigenous workforce in the mills of Preston would have had little time for cultural activity during the first half of the nineteenth century.

The following account of Preston town centre in 1861 provides a fascinating insight into Victorian Preston. The writer takes us on a walk round the town centre, broadly covering Fishergate, Winckley Square, the Old Shambles and Friargate, while focussing on buildings and the topography of the town centre. This chapter features not only the topography of the town but also the deplorable conditions in Preston during the Industrial Revolution, at the beginning of the infamous cotton famine in 1861. Little wonder that infectious diseases were endemic and infant mortality was very high among working-class families. These were factors that probably led to Charles Dickens making several visits to Preston, as we shall see in the following chapters.

The article entitled 'The Conditions of our Towns: Preston, Cotton Factory Town', and the follow-up 'The Black Parts of Preston', are an altogether significant source of primary material sourced from a contemporary journal (The Builder).

Preston, Cotton Factory Town, 7 December 1861

The cotton manufacturing districts represent their exigencies in architecture in a remarkable manner. The factories might be oblong packing cases of brick and mortar, pierced with rows of oblong window openings; and shooting up from this tasteless block is a tall chimney-shaft. Grouped with these, like young factories not yet arrived at maturity, are rows and rows of habitations for the workers, – also oblong, also pierced with oblong windows, only on a smaller scale, and with the chimney-shaft not developed beyond the size of ordinary cottage chimneys.

Nothing plainer could be conceived. The granaries in which Joseph stored the Egyptian corn could not have been built with greater frugality; but, as the manufacturing of cotton into fabric is not with us an ancient occupation, these are all comparatively modern; and the veritable town, as it was of old, lies among them like a tangled skein of thread. Preston is one of the towns to which Henry II granted a charter to the effect that the burgesses should appoint a guild merchant, who, with the burgesses, should enjoy 'all liberties and free customs'; that is, that they might pass through the royal dominions with their merchandise, buying and selling, free from all kinds of toll; and that in their own town they might exact, receive, and enjoy, as the case might be, the following penalties and privileges, – 'all manner of security of peace, soc and sac, toll, in-fang-thief, outfang-thief, hang-wite, homesokyn, gryth-bryce, flight-wite, ford-wite, fore-stall, child-wyte, wapentake, lastage, stallage, shoowynde, hundred and aver-penny'.

And interspersed with the modern commerce and traffic, there is yet much that is associated with these royal, pictorial, heraldic and traditional times. Nevertheless, the great enlargement of the town and increase of the population are due to the modern business of cotton-spinning and weaving. It is these that have enriched the owners of land and capital alike. Directly a factory has been planted down, the land has been turned up for brick earth, a kiln started, bricks manufactured, and rows of poor houses built, – profits being obtained both from the manufacture of the bricks, and in the shape of rent subsequently. The wants of the operatives are few in their homes; and it is only common humanity on the part of the wealthy factory and landowners that these should be provided for. The workers cannot be expected to be refined or even decent, if the home in which they are reared be destitute of decencies ; nor can their children be expected to play anywhere but in the streets if there be no yards to the houses, no public playgrounds, nor public parks. We will see for ourselves, presently, how these responsibilities are recognized.

We are in the main thoroughfare of the commercial part of the ancient borough of Preston, Fishergate. This is an irregular street about two miles long, which was one of the old roads, in the old town, to the market-place. The low, thatch-crowned houses with which it was once lined as it neared the market-place have disappeared, except in one solitary instance; and have been replaced from time to time by the shops, hotels, banks, and offices, needful to modern commerce. The Victoria Hotel is the first object noticeable in Fishergate; and then a large tenantless house next door to it, with centre and wings, looking as a haunted house might be expected to look of a November morning. On the other side of the road is a row of staid houses, with gardens fenced with iron railings in front of them that are one yard wide. These few feet of spongy soil thus pertinaceously tilled in front of town houses admit of rain soaking into the foundations: they can scarcely be considered to be ornamental, except perhaps for a week or two, when newly done up in the spring; and for the rest of the year are dismal and damp engendering. If these spaces were paved much damp would be done away with, and floral effects might be obtained in boxes on the window-sills. Then there is a

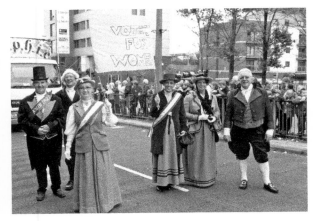

Preston Guild 2012. For centuries, 'Preston Guild' has been associated with civic, commercial and cultural events in the town. Members of Preston Historical Society celebrate the occasion by participating in the community procession appropriately in character, depicting Joseph Livesey, Joseph 'Daddy' Dunn, Richard Arkwright and ladies from the suffragette movement. (Courtesy of Linda Barton)

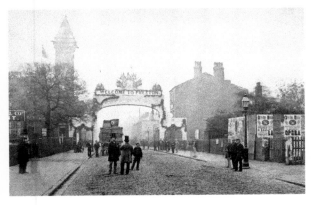

Commemorative arch celebrating Preston Guild in Fishergate in 1862. Note the top-hatted gentlemen and the Theatre Royal poster near to the entrance to the North Union railway station. (Courtesy of Preston Digital Archive)

vacant space on both sides of the road, with a few forlorn trees and a bridge over a grass-grown single iron tramway. This unbuilt piece of ground is occupied, as so many others now are, by a travelling photographic portrait-room – a smart caravan containing two if not more chambers. It is from this point of view that the peculiarities of the cotton district, as shown in the aspect of the town, are first discernible. Fishergate runs along a ridge; and, whenever there is a gap in the houses, a view of the factories in the surrounding hollows is obtained; and this is the first glimpse on the road from the station. The factories are piled up storey above storey and group against group, the tall chimney-shafts keeping guard over all; and the squat houses of the operatives are spun out in rows around. A little way further on, at the corner of Charnley-street, there is a new Baptist chapel, which, with its tower of bold Venetian type, would be an ornament to any perspective. The style is Romanesque, with Moorish details.

A great wheel window in the north end, surrounded by circles, with a miniature repetition of the same on either side of it, is remarkable for much effect with very little light – much stonework and little glass – but which arrangement is admissible on account of the site being a corner one: plenty of light can be obtained at the side. The

clock too, with its illuminated faces on the sides of the tower, is a real boon. The iron balustrade and stone parapets in front are carefully considered in relation to the style of the rest of the building. The front is set back from the line of houses – a disposition which not only shows the building to advantage, but improves the aspect of the street. This specimen of the highest class of architectural art is the more conspicuous by its neighbourhood of plain houses, and a contrast to the hideous box of a theatre on the opposite side of the road. A sewer pipe stuck on end, with a long stick standing upon it, indicates that something is going on in the rear St Wilfred Street – a row of neat-fronted houses; and turning down to see what it may be, we find 17 privies, 17 offal ash-pits, and 17 slop-drains, built up against the 17 neat-fronted houses in question. These harbours for filth have soiled and choked the ground till they could be borne no longer; and drain-pipes are being laid down. The men putting down the pipes, in the cuttings made for their reception, declared that this was the dirtiest place they had ever been in. Below the pebble pavement, which looked so smooth and regular, and extended from one end to the other, in the rear of this row of neatly-fronted houses, the soil for several feet was a mass of foetid corruption – too thick to bale out, yet with not enough consistency to shovel up – vile and filthy. This state of things is at the core of all similar cesspool arrangements: the surrounding soil absorbs the moisture from privies and ashpits, and thence it percolates through houses, and streets, and alleys, till it finds a low level to form a pool; and, from this highly-charged soil, emanations arise that are conducive to the breeding of fever. In this particular instance there is a 'public bakehouse' close by, to make matters worse.

Returning to Fishergate, we note the iron vase on the iron pedestal in front of the Theatre Royal, that is complimentarily called a drinking-fountain; and the doctor's red lamps that light up the miniature portico, and a desire to see more of art in Preston induce us to make, in the evening, an examination of it within. To save recurrence, we may state here that the ceiling is divided into eight compartments, radiating from a sun-burner in the centre, with a figure disporting in each compartment. The boxes over the proscenium are hung with bed-curtains, and look quite as much like berths on board ship; and the decorations generally are in what might be called the paperhanging style. The form of the theatre is good; and, with artistic decorations, might be made attractive and effective. The scene-painting deserves a word, the landscapes being good enough to atone for the miserable interiors, where the paperhanger had evidently all his own way again. The audience, composed of factory operatives, occupied the pit and gallery, and brought their babies with them. The performance comprised the 'Colleen Bawn' and the 'Artful Dodger', with a comic song between the acts; and when we add that Grisi was prospectively expected, it will be seen that there was but little to find fault with.

The pavements in Fishergate are especially commendable: where the pavement widens at Mount-street it is 18 feet broad. The curbs at the crossings are rounded and gradually sloped, without the ordinary sudden stop; and the crossings are made of large blocks, with a groove in the centre. At Chapel-street we strike off to view the huge one-span plain lofty brick room, which is used as St Wilfred's Roman Catholic Chapel. Internally a theatrical effect

is produced by the altar recess being kept dark, except where, by means of an invisible skylight, a stream of bright light falls upon the altar picture of the Crucifixion, with an awe-striking effect. The whole of the interior, the walls, the flat-coffered ceiling, the fronts of the galleries are covered with a Grunerish stencilled decoration, interspersed with medallions, a surface, in a large galleried room, satisfactorily. We get back again into Fishergate, near to the cheerless looking dispensary. After this Lune-street crosses at right angles, and owns a newly-enlarged grand Wesleyan Chapel, and the Corn Exchange, and Cloth Hall. This latter, however, is not a building that strangers need seek to see. It was built in 1832, and is as ugly as even the level of public taste at that time can account for; having pig shambles at one end, and fishmongers and shrimp dealers at the other. The approaches, in a neighbourhood of bonded warehouses and of a large timber-yard, are scandalously in want of scavenage, and all the doorposts are made use of as urinals. There is the triple accommodation of a public room for concerts in the same building, which holds about six hundred persons: it is a long, low room, divided into three compartments, with pink and green flat paper panels, and, owing to the floor being level, but an indifferent view of the performers at the upper end of the room is obtained from the entrance; the whole establishment being but a sorry affair for a town like Preston.

Fishergate still stretches out bravely before us, with bonnet-shops, booksellers, and bootmakers, side by side with the palatial Preston Banking Company's premises – a costly, lofty, highly decorated, three-storeyed, Italian building – dwarfing its unpretending neighbours the chandler's, chemist's, hairdresser's, tailor's, and butcher's shops.

Then the Preston Pilot office, in Clarke's stationer's shop; another stationer's at the side of it; and the Lancaster Banking Company's offices, more modest and staid than those of the Preston Banking Company, yet equally tall and effective. On the other side more chemists, hairdressers, upholsterers, drapers, and glovers' shops; and here Butler's shop, full of Roman Catholic accessories, sculptured and pictorial crucifixes – ivory, ebony, brown wood, and bronze crucifixes of all imaginable sizes – by the side of the Kendal Bank. By the side of the Lancaster Bank is a very narrow street of very low houses, occupied by surveyors, land agents, valuers, a beadle, a sheriff's officer, a beer-shop, and a tailor; down which flakes of soot are flying and settling on the cracked, bad pavement, in which channels are made in communication with external wooden spouting to the houses. Beyond this, among the smart shops in Fishergate, stands a thatched house, with bulged plaster walls – the last vestige of old Preston in this bustling stream of modern traffic. Past the Shelley's Arms there is a very neat butcher's shop, formed of three round arches with iron grilles and plate glass sliding windows. Within, the table top is covered with marble. If the walls were lined with white tiles, instead of coloured a dirty sallow brown, this would be a model of a butcher's shop, and prove that shop-fronts for this business can be made architecturally tasteful and suitable. More shops – feather-shops, baby linen warehouses, watchmakers; more

courts – dismal, dirty Platt's Court; light and well-paved Woodcock's Court, scented with an aromatic maltous odour.

The offices of the Preston Herald Company (limited); the offices of the *Preston Chronicle* opposite; Thorp, Bayless, & Thorp's great drapery establishment, with a row of ventilating funnels behind the iron balustrade over the shop-front; a narrow alley with 'James Leigh, brewer,' at one corner of it, and a small butcher's shop at the other, and a full ash-pit seen in the midst thereof from the main road. Then Cannon street, branching off, with Hogg's fruit and game shop at the corner, where pheasants and hares hang in festoons; partridges, pine apples, grouse, and grapes are grouped very artistically; then mat and matting shops, china shops, and the *Preston Guardian* office, at the corner of new Cock's yard – which yard leads to the new Cock Inn, and is used as one wide urinal, the miserable pebble pavement being full of hollows of slops.

At last the Townhall narrows the road, just where Cheapside leaves Fishergate at a right angle, and the market-place opens out in view. The Townhall is neither modern nor ancient; but is a dingy worn-out mansion. The entrance immediately

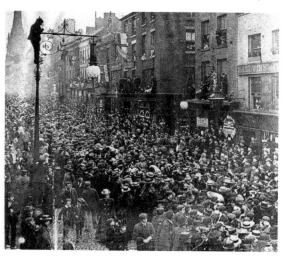

Fishergate, with period shops bedecked with numerous onlookers from every available vantage point. It depicts troops en route to Preston railway station and the Boer War during 1901. (Courtesy of Preston Digital Archive)

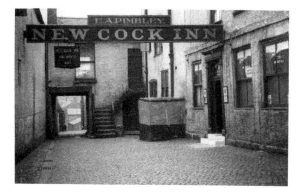

The New Cock Inn, situated in New Cock Yard, was off Fishergate. (Courtesy of Preston Digital Archive)

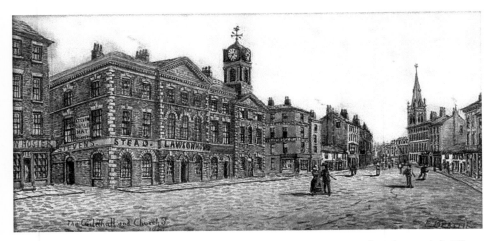

Above: The Old Town Hall (1782–1862) was known as the Moot Hall and preceded Gilbert Scott's Town Hall, which opened in 1867. (Edwin Beattie, courtesy of Preston Digital Archive)

faces an alley 3 or 4 feet wide, by the side of the 'Legs of Man' inn, down which is a dirty perspective. Brewster and Burrowe's double shop is a noticeable feature from this point: it is a draper's shop below; and above, the first floor has been taken out and another shop front, displaying cabinetmaker's goods, placed in its stead. We are familiar with show-rooms over shops; but this is shop above shop. The rear of the Townhall is open to the market-place, and is ragged, tasteless, smoky, and dirty. Shop shutters are leaning against the ruined walls, as are temporary wooden urinals; and placards and posters are stuck upon every available space.

The market-place is a handsome roomy parallelogram, surrounded on two sides by good shops, inns, and hotel; by the Town Hall on the third; and by a row of shops on the fourth side, which is broken up by alleys leading to the shambles in the rear of them. Hay seeds, hay, and straw, are scattered over the pebble pavements; and on the off market-days the great open space is occupied by a few odd vegetable stalls on trestles, with movable wooden canopies. As we look on, a rag fair is held – one man selling remnants of highly-coloured, painted and glazed calico, odd bits of cloth, fragments of white linen; another man selling every possible description of cheap haberdashery, reels of cotton, combs, pins, needles, &c.; and both spread their wares upon the ground. It is impossible to be unimpressed with the capabilities of the site. If the Townhall were rebuilt; the row of shops with the butchers' shambles in their rear, with all the narrow courts intersecting this block of building, removed, and a meat market built instead; the block of houses on the north side of the market-place removed, and a general market built on its site; Preston would be able to boast of one of the finest market-places in the kingdom. We were glad to hear that the market committee were in consultation with Mr G. G. Scott upon this subject. But the drainage and paving should not be overlooked in favour of more showy accommodation. The gutters in the market-place run with slops thrown out of the houses in the courts around;

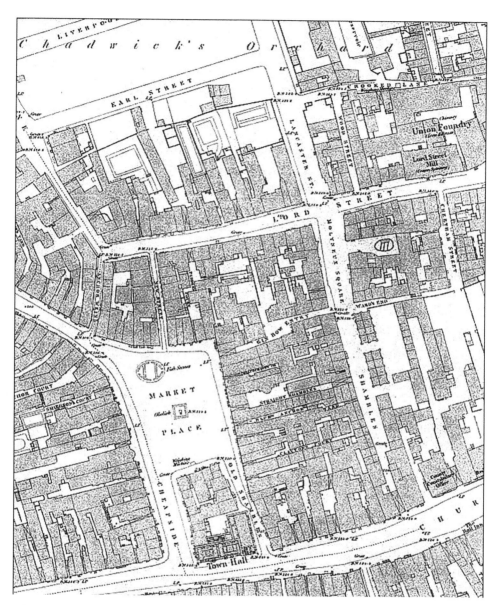

Above: A Victorian plan of the market square area and street topography of Preston. (Courtesy of Preston Digital Archive)

channels across the pavement in Clayton-court – channels from urinals in a passage to the Blue Anchor – channels in passage to Strait Shambles, – all furnish tributaries to the stream down the market kennel. Wilcockson's-court does the same: Ginbow entry, leading to the Wheat-sheaf and White Hart, brings down

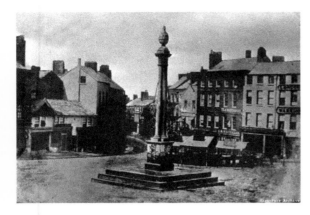

Preston marketplace was dominated by the obelisk. (Courtesy of Preston Digital Archive)

A rare photograph of the New Shambles. The site is now occupied by Miller Arcade and Jacson Street. (Courtesy of Preston Digital Archive)

This atmospheric photograph taken in 1950 portrays rows of cellared weavers' cottages in Mount Pleasant at its junction with Ladywell Street (off Marsh Lane), Preston. (Courtesy of Preston Digital Archive)

the swimmings from exposed urinals and stable muck; and washings from the shambles are flowing down all the livelong day. Strait shambles, one of the passage ways in the block of shambles, may be taken as a type of the rest, – lines of close butchers' shops, running at right angles from the market, with a dark living-room in the rear of each, and a smaller and darker sleeping-room above. The washings from the blocks are finding channels down to the lowest level; losing on the way great part of their bulk, which is absorbed into the soil. And so we pick our way round to the principal facade of the shambles in Lancaster-row. This is recessed back: the upper part projects over the lower, and is supported on rude, monolithic, tapering pillars, out of the perpendicular. The brickwork above is dirty white where it is not dirty black: the windows are very small, and filled with small panes; and the whole place has an uncouth and unclean appearance.

The post-office is near the shambles, and contrasts very favourably with them, being in a block of newly-erected lofty houses exactly opposite: it is roomy and convenient. Attached to the Stanley Arms, in the same block, is a notice-board, inscribed, 'Police regulations. Make no wet.' And yet at the end of the hotel there is an unprotected urinal; and, unprovided for by drainage, the urine flows across the pavement in a broad stream.

A long, old-fashioned, winding thoroughfare, called Friargate, straggles away down hill from the market-place. This is a long tortuous street, of second and third rate shops, to supply the wants of the dwellers in the innumerable courts and alleys with which it is intersected. In the main street scavenage does not appear to be thought of; and in the alleys and courts the laws of boards of health are set at defiance. The rear premises of both sides of Friargate, which is about a mile long, and, starting from the market-place, is in the centre of the town, are horrible masses of corruption and forcing pits for fever. In Fishwick's-yard there are three vile privies and a crammed offal-pit close to the wretched houses, which, with their broken paved and damp floors are scarcely fit for human habitation: and the overflowings from slops of another row of houses run down the yard. Four more dreadful pits at the end near a back lane are piled full, and leak across the alley into Friargate. These are the characteristics of all the courts and passages in the neighbourhood: some of them, such as Hardman's-yard, at the corner of the newly-painted Waterloo Inn, are whitened and made showy to look clean about the entrances; but step past the whitewash near the street, and you will find, as in this case, a monster midden pit, with privies at each end, open to the front of a whole row of houses whose inhabitants they serve. The clothes of the poor people are actually hanging to dry over this disgusting pit; and the pebble pavement around is befouled by the children in the yard, for whom no provision whatever has been made. Peelings, slops, tea-leaves, are strewn about the yard. This pit, of awful dimensions, receives the whole of the refuse from the various families in the row; which lies there rotting for weeks and months, and is then disturbed and carried through into the main street. We noted at the lowest point next Friargate a shutter up to indicate a death. In Milling's-yard [Melling's-yard], a little farther off, matters were a little better, as there were gratings at intervals through which liquid refuse

passed away; but at each of these there were collections of solid filth around, which could not get through, and yet were not swept away. The semi-circular apse end of St George's Church, full of richly-painted glass, is within a dozen feet of the poor homes in this yard: clothes-lines are tied to the church-yard railings, and a quantity of clothes hangs fluttering, like banners, over the graves. The church-yard is, properly, closed. The church is but a travesty of Norman work, – the tower-porch, something between a porch and a tower, being in marvellously bad taste. There are plenty more yards on both sides of the road, – Tayler's-yard, Brown's-yard, Cradwell's-yard [Gradwell's-yard], with 'lodgings for travellers': and all the kennels are running with slops and mud. A space bounded by Chapel-yard is so cribbed and confined, that the rear premises of respectable shops and privies and ash-pits jostle each other in the smallest space that could by any stretch of imagination be called a yard; and over these the inhabitants have to hang their linen to dry. A passage before coming to Union-street has a marine store and rag and bone shop at one end and a candlemaker's at the other; and in Union-street flows a kennel full of moist filth, slops, and tea-leaves, which has a slow current into Friargate.

In the rear of Snow-hill there is another similar neighbourhood: oyster-shells are strewn about, and the ground is the common privy for children. Pawnbrokers and marine-store dealers flourish around.

High-street is a row of poor houses, about one-eighth of a mile long, with small back yards; and at the back of these a huge sewer positively discharges itself on to the surface, and forms a wide bog, the whole length of the row of houses. The solid filth from this overflows the outlets, and stops up the privies of the High-street residents; and to see an old woman raking in the filth to find the sewer was a pitiable spectacle. A man, standing by, remarked that it had been nearly as bad as that for nine years, to his knowledge – 'never anything but a bog, even in summer,' – but that, since Peader & Lever had begun to boil tripe at the top of the street, and throw their boiling greasy water on to the sewage, it was daily getting worse. It must be observed that this is not a made ditch. The Board of Health – or, more correctly speaking, of Illness – has brought a sewer up to the high end of the street, and then discharged its contents, to make its own way. As the ground falls the sewage has made a course for itself; and the overflowings from aged pigsties, middens, and pits, belonging to the houses in High-street, have run into it in tributary streams! The back windows of the houses overlook a large plot of ground in a transitory condition, known by tradition only as the Orchard, which is partly built upon and partly used as a play-ground by the 'roughs'. A spacious Methodist free church and free schools are planted in the midst; while, in another part of it, a permanent wooden circus has been set up, which looks like a vast conical tumulus, or an aboriginal's hut. The rest of the Orchard is a surface of thick, black, hard mud, on which men are playing at 'putting the stone' and 'pitch and toss', and on which a tribe of pigs are disporting pork fashion. Great holes are worn in this muddy play-ground, and pools of offensive colour and odour finish the landscape.

The Builder, Volume XIX, No. 983, pp. 833–835

2

Charles Dickens and Preston

Charles Dickens, one of England's greatest novelists, travelled by train from London Euston to Preston during February 1854, and stayed at the 'Old Bull', formerly the Bull and Royal Hotel, Church Street. Dickens paints a clear picture of the social and economic scene in Preston and describes his journey from London Euston station to Preston. During the severe winter of that year, up to 20,000 people were out of work.

To gain a perspective, we begin with a concise account of social and economic considerations relating to the background of the town during the nineteenth century, with an emphasis on the period when Charles Dickens visited Preston. By the middle of the nineteenth century, factory work was the basis of Preston's prosperity, with around 25,000 people employed by sixty-four textile firms during 1850. Advances in technology transformed textile production from a domestic industry to a factory process and 'Preston held a leading position in spinning as well as weaving'. During the first half of the nineteenth century the textile industry helped create a new, urban, industrialised working class, and a six-fold increase took place in the population of Preston.

Preston Population, 1801–1911

1801	11,887	1861	82,085	1901	112,989
1831	33,112	1871	85,427	1911	117,088
1841	50,131	1881	91,500		
1851	69,542	1891	107,573		

Anderson's analysis of the Preston census for 1851 provides further evidence of the dominance of the textile industry. He shows that, among adults over twenty years old, 32 per cent of men and 28 per cent of women were engaged in cotton manufacture, along with a high percentage of children. Among women, it was the younger wives and those with few or no children who were in employment. In Lancashire during 1851, 'cotton accounted for nearly 40 per cent of girls aged between fifteen and nineteen and about 25 per cent of boys of that age'.

Factory operatives worked up to fourteen hours a day in the early Victorian period. Legislation in 1847 and 1850 saw a reduction to a ten-and-a-half-hour day and the implementation of half-day working on Saturday. According to Anderson, weekly wages in the cotton industry were high relative to wages in other occupations: young men and women under eighteen years could earn between 5s and 13s per week. Adult women earned 9s to 16s per week and, depending on their work description, men earned between 10s and over 20s per week. Further analysis of the Preston census for 1851 shows that, while wages may have been relatively high, there was not much money to spare: 'over 60 per cent of the families of the wives who worked in factories would have been in difficulties had they not done so'. Thus the commercialisation of leisure depended upon the amount and proportion of working-class incomes that could be spared for entertainment. This included young cotton operatives, as there was no legal control over pubs and music halls to govern their admittance until the introduction of the Licensing Act 1872.

Anderson states that 'between the depressions and strikes in Preston, the intervening years were mainly periods of high wages and high employment'. The link between wage levels and the development of the pub industry is referred to by the Reverend John Clay, the chaplain of Preston Prison, in 1852 when he attributed drunkenness to improved employment and increased wages.

Men who left the cotton industry and went into labouring and trading occupations earned far less than they had in cotton. 'Many men who migrated into Preston were unable to obtain well-paid employment in the factories ... One important result of this was that many families lived in primary poverty.' Also, the population of Preston more than doubled between 1831 and 1851 and with this rapid growth had come the predictable sanitary and housing problems.

By 1851, when the population had reached 69,542, the total number of houses was 11,543 and each house had an average of six occupants. Morgan (1990) states, 'Two bedrooms were the norm and inside conditions were very cramped, frequently damp with poor hygiene standards, lighting and sanitation.' In Preston, extensive improvements and slum-clearance programmes were introduced with the Bye Laws of 1876 and the Preston Improvement Act 1880. Morgan confirms that 'Preston's housing was revolutionised with this legislation with most new housing good enough to survive until the present day'.[2]

We have seen that, during the first half of the nineteenth century, Preston's population increased from 11,887 in 1801 to 69,542 in 1851. A steadily rising population increased to 91,500 by 1881 and 112,989 by 1901. This expansion was directly related to the growth of the textile industry. The cotton industry was, however, beset with problems of industrial and economic strife, exemplified by the cotton strike of 1836 and the Chartist riots of August 1842, when the military shot dead four cotton operatives in Lune Street. The strike and lockout of 1854 lasted for thirty-nine weeks, and after the longest cotton mill strike there was the great cotton famine of 1861. Dickens addressed the cotton workers of the town and gave readings from *A Christmas Carol* and *The*

Pickwick Papers at the Theatre Royal and Corn Exchange. Moreover, with seats ranging from 1s to 4s, the town was hardly living up to 'great expectations'. Coinciding with the American Civil War, the Lancashire 'cotton famine' (1861–64) brought mass unemployment and poverty to Preston. Preston and other north-western cotton towns were experiencing a cotton famine due to a shortage of raw material from America. This notwithstanding, there is debate among historians over the extent to which the depression was caused by the North's blockade of shipping from Southern states or whether the war masked an impending cyclical trade depression.

During the great lockout of 1853–54, Charles Dickens visited Preston and gained some inspiration for his depiction of Coketown in *Hard Times*. The 1853 strike and lockout lasted for nearly a year as the cotton workers tried to make up wage cuts in the 1840s. The following extract from *Hard Times* loosely describes the town and refers to the social conditions, the New Church (the present minster), religious persuasions and the temperance influence at the height of the Industrial Revolution. Interestingly, Dickens makes a veiled reference to the chaplain of the house of correction (the Reverend John Clay) and the ruination of an inmate at Preston Prison in his writings describing Coketown:

Coketown was a town of red brick, or of brick that would have been red if the smoke and ashes had allowed it; but as matters stood it was a town of unnatural red and black like the painted face of a savage. It was a town of machinery and tall chimneys, out of which interminable serpents of smoke trailed them for ever and ever, and never got uncoiled. It had a black canal in it, and a river that ran purple with ill-smelling dye, and vast piles of buildings full of windows where there was a rattling and a trembling all day long, and where the piston of the steam-engine worked monotonously up and down like the head of an elephant in a state of melancholy madness. It contained several large streets all very like one another, and many small streets still more like one another, inhabited by people equally like one another, who all went in and out at the same hours, with the same sound upon the same pavements, to do the same work, and to whom every day was the same as yesterday and tomorrow, and every year the counterpart of the last and the next ... The jail might have been the infirmary, the infirmary might have been the jail, the town hall might have been either or both ... You saw nothing in Coketown but what was severely workful ... If the members of a religious persuasion built a chapel there – as the members of eighteen religious persuasions had done – they made it a pious warehouse of red brick, with sometimes a bell in a birdcage on the top of it. The solitary exception was the New Church, a stuccoed edifice with a square steeple over the door, terminating in four short pinnacles like florid wooden legs. Then came the Teetotal Society, who complained that these same people would get drunk, and showed in tabular statements that they did get drunk, and proved that no inducement, human or Divine, (except a medal), would induce them to forego their custom of getting

drunk ... Then came the experienced chaplain of the jail, with more tabular statements, outdoing all the previous tabular statements and showing that the same people would resort to low haunts, hidden from the public eye, where they heard low singing and saw low dancing, and where A.B. aged 24 next birthday, and committed for eighteen months solitary, had himself said (not that he had ever shown himself particularly worthy of belief) his ruin began as he was perfectly sure and confident that otherwise he would have been a tip-top specimen.

Although the above passage was not intended as a literal account of Preston, there are elements in Dickens' writing signifying that the town inspired him to write about the social and topographical aspects of a town he named Coketown. *Hard Times* is the tenth novel by Dickens and was first published in 1854, coinciding with his visits to Preston.

'Return Ticket London Euston to Preston' with Charles Dickens

The account that follows is written by Charles Dickens and is taken from Dickens's *Miscellaneous Papers*. Dickens captivatingly describes how he travelled to Preston by train from London during February 1854, at the time of the strike and lockout. He describes how he engaged in conversation with a fellow passenger he referred to as Mr Snapper and on arrival in Preston alluded to the proceedings of the meetings including the submissions of delegates and cotton operatives from within the Preston Cockpit. He concluded, 'In any aspect in which it can be viewed, this strike and lockout is a deplorable calamity.' Perhaps not surprisingly, Dickens emerges as a social commentator and reformer, notwithstanding that he did not support the formation of trade unions.

'On Strike' by Charles Dickens, 11 February 1854

Travelling down to Preston a week from this date, I chanced to sit opposite to a very acute, very determined, very emphatic personage, with a stout railway rug so drawn over his chest that he looked as if he were sitting up in bed with his great-coat, hat, and gloves on, severely contemplating your humble servant from behind a large blue and grey checked counterpane. In calling him emphatic, I do not mean that he was warm; he was coldly and bitingly emphatic as a frosty wind is.

'You are going through to Preston, sir?' says he, as soon as we were clear of the Primrose Hill tunnel. The receipt of his question was like the receipt of a jerk of the nose; he was so short and sharp. 'Yes.' 'This Preston strike is a nice piece of business!' said the gentleman. 'A pretty piece of business!' 'It is very much to be deplored,' said I, 'on all accounts.' 'They want to be ground. That's what they want, to bring 'em to their senses,' said the gentleman; whom I had already began to call in my own mind Mr Snapper, and whom I may as well call by that name here as by any other. I deferentially enquired, who wanted to be ground? 'The hands,' said Mr Snapper. 'The hands on strike, and the hands who help 'em.' I remarked that if

that was all they wanted, they must be a very unreasonable people, for surely they had had a little grinding, one way and another, already. Mr Snapper eyed me with sternness, and after opening and shutting his leathern-gloved hands several times outside his counterpane, asked me abruptly, 'Was I a delegate?'

I set Mr Snapper right on that point, and told him I was no delegate. 'I am glad to hear it,' said Mr Snapper. 'But a friend to the Strike, I believe?' 'Not at all,' said I. 'A friend to the Lockout?' pursued Mr Snapper. 'Not in the least,' said I. Mr Snapper's rising opinion of me fell again, and he gave me to understand that a man must either be a friend to the Masters or a friend to the Hands. 'He may be a friend to both,' said I. Mr Snapper didn't see that; there was no medium in the Political Economy of the subject. I retorted on Mr Snapper, that Political Economy was a great and useful science in its own way and its own place; but that I did not transplant my definition of it from the Common Prayer Book, and make it a great king above all gods. Mr Snapper tucked himself up as if to keep me off, folded his arms on the top of his counterpane, leaned back, and looked out of window.

'Pray what would you have, sir,' enquired Mr Snapper, suddenly withdrawing his eyes from the prospect to me, 'in the relations between Capital and Labour but Political Economy.' I always avoid the stereotyped terms in these discussions as much as I can, for I have observed, in my little way, that they often supply the place of sense and moderation. I therefore took my gentleman up with the words employers and employed, in preference to Capital and Labour. 'I believe,' said I, 'that into the relations between employers and employed, as into all the retaliations of this life, there must enter something of feeling and sentiment; something of mutual explanation, forbearance, and consideration; something which is not to be found in Mr McCulloch's dictionary, and is not exactly stateable in figures; otherwise those relations are wrong and rotten at the core and will never bear sound fruit.' Mr Snapper laughed at me. As I thought I had just as good reason to laugh at Mr Snapper, I did so, and we were both contented.

'Ah!' said Sir Snapper, patting his counterpane with a hard touch. 'You know very little of the improvident and unreasoning habits of the common people, I see.' 'Yet I know something of those people, too,' was my reply. 'In fact, Mr—' I had so nearly called him Snapper! 'In fact, sir, I doubt the existence at this present time of many faults that are merely class faults. In the main, I am disposed to think that whatever faults you may find to exist, in your own neighbourhood for instance, among the hands, you will find tolerably equal in amount among the masters also, and even among the classes above the masters. They will be modified by circumstances, and they will be the less excusable among the better-educated, but they will be pretty fairly distributed. I have a strong expectation that we shall live to see the conventional adjectives now apparently inseparable from the phrases working people and lower orders, gradually fall into complete disuse for this reason.'

'Well, but we began with strikes,' Mr Snapper observed impatiently. 'The masters have never had any share in strikes.' 'Yet I have heard of strikes once upon a time in that same county of Lancashire,' said I, 'which were not disagreeable to some masters when they wanted a pretext for raising prices.'

'Do you mean to say those masters had any hand in getting up those strikes?' asked Mr Snapper. 'You will perhaps obtain better information among persons engaged in some Manchester branch trades, who have good memories,' said I.

Mr Snapper had no doubt, after this, that I thought the hands had a right to combine? 'Surely,' said I. 'A perfect right to combine in any lawful manner. The fact of their being able to combine and accustomed to combine may, I can easily conceive, be a protection to them. The blame even of this business is not all on one side. I think the associated Lock-out was a grave error. And when you Preston masters–' 'I am not a Preston master,' interrupted Mr Snapper.

'When the respectable combined body of Preston masters,' said I, 'in the beginning of this unhappy difference, laid down the principle that no man should be employed henceforth who belonged to any combination – such as their own – they attempted to carry with a high hand a partial and unfair impossibility, and were obliged to abandon it. This was an unwise proceeding and the first defeat.'

Mr Snapper had known, all along, that I was no friend to the masters. 'Pardon me,' said I, 'I am unfeignedly a friend to the masters, and have many friends among them.' 'Yet you think these hands in the right?' quoth Mr Snapper. 'By no means,' said I. 'I fear they are at present engaged in an unreasonable struggle, wherein they began ill and cannot end well.' Mr Snapper, evidently regarding me as neither fish, flesh, nor fowl, begged to know after a pause if he might enquire whether I was going to Preston on business? 'Indeed I was going there, in my unbusinesslike manner,' I confessed, 'to look at the strike. 'To look at the strike!' echoed Mr Snapper, fixing his hat on firmly with both hands. 'To look at it ! Might I ask you now, with what object you are going to look at it?' 'Certainly,' said I, 'I read, even in liberal pages, the hardest Political Economy – of an extraordinary description too sometimes, and certainly not to be found in the books – as the only touchstone of this strike. I see, this very day, in a to-

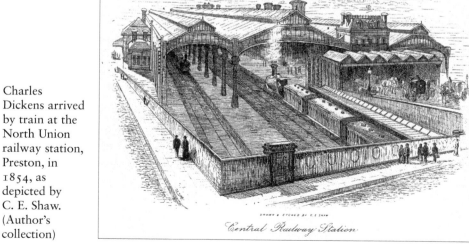

Charles Dickens arrived by train at the North Union railway station, Preston, in 1854, as depicted by C. E. Shaw. (Author's collection)

Central Railway Station

morrow's liberal paper, some astonishing novelties in the politico-economical way, showing how profits and wages have no connexion whatever; coupled with such references to these hands as might be made by a very irascible General to rebels and brigands in arms. Now, if it be the case that some of the highest virtues of the working people still shine through them brighter than ever in their conduct of this mistake of theirs, perhaps the fact may reasonably suggest to me – and to others besides me – that there is some little thing wanting in the relations between them and their employers, which neither political economy nor Drum-head proclamation writing will altogether supply, and which we cannot too soon or too temperately unite in trying to find out.'

Mr Snapper, after again opening and shutting his gloved hands several times, drew the counterpane higher over his chest, and went to bed in disgust. He got up at Rugby, took himself and counterpane into another carriage, and left me to pursue my journey alone. When I got to Preston, it was four o'clock in the afternoon. The day being Saturday and market-day, a foreigner might have expected, from among so many idle and not over-fed people as the town contained, to find a turbulent, ill-conditioned crowd in the streets. But, except for the cold smokeless factory chimnies, the placards at the street corners, and the groups of working people attentively reading them, nor foreigner nor Englishman could have had the least suspicion that there existed any interruption to the usual labours of the place ... As I had told my friend Snapper, what I wanted to see with my own eyes was how these people acted under a mistaken impression, and what qualities they showed, even at that disadvantage, which ought to be the strength and peace – not the weakness and trouble – of the community ... The balance sheet of the receipts and expenditure for the twenty-third week of the strike was extensively posted. The income for that week was two thousand one hundred and forty pounds odd.

Some of the contributors were poetical. As 'Love to all and peace to the dead, May the poor now in need never want bread – three-and-sixpence', the following poetical remonstrance was appended to the list of contributions from the Gorton district: 'Within these walls the lasses fair refuse to contribute their share, Careless of duty – blind to fame, For shame, ye lasses, oh! for shame! Come pay up, lasses, think what's right, Defend your trade with all your might; For if you don't the world will blame, And cry, ye lasses, oh, for shame. Let's hope in future all will pay, That Preston folks may shortly say- That by your aid they have obtain'd The greatest victory ever gained.'

Some of the subscribers veiled their names under encouraging sentiments, as Not tired yet, All in a mind, Win the day, Fraternity, and the like. Some took jocose appellations, as A stunning friend, Two to one Preston wins, Nibbling Joe, and The Donkey Driver. Some expressed themselves through their trades, as Cobbler Dick, sixpence, The tailor true, sixpence, Shoemaker, a shilling, The chirping blacksmith, sixpence, and A few of Maskery's most feeling coachmakers, three-and-threepence ... The following masked threats were the worst feature in any bill I saw: 'If that fiddler at Uncle Tom's Cabin blowing

room does not pay, Punch will set his legs straight.' 'If that drawer at card side and those two slubbers do not pay, Punch will say something about their bustles.' 'If that winder at last shift does not pay next week, Punch will tell about her actions.'

The Masters' placards were not torn down or disfigured, but were being read quite as attentively as those on the opposite side. That evening, the Delegates from the surrounding districts were coming in, according to custom, with their subscription lists for the week just closed. These delegates meet on Sunday as their only day of leisure; when they have made their reports, they go back to their homes and their Monday's work. On Sunday morning, I repaired to the Delegates' meeting.

These assemblages take place in a cockpit, which, in the better times of our fallen land, belonged to the late Lord Derby for the purposes of the intellectual recreation implied in its name. I was directed to the cockpit up a narrow lane, tolerably crowded by the lower sort of working people. Personally, I was quite unknown in the town, but every one made way for me to pass, with great civility, and perfect good humour. Arrived at the cockpit door, and expressing my desire to see and hear, I was handed through the crowd, down into the pit, and up again, until I found myself seated on the topmost circular bench, within one of the secretary's table, and within three of the chairman. Behind the chairman was a great crown on the top of a pole, made of parti-coloured calico, and strongly suggestive of May-day. There was no other symbol or ornament in the place.

It was hotter than any mill or factory I have ever been in; but there was a stove down in the sanded pit, and delegates were seated close to it, and one particular delegate often warmed his hands at it, as if he were chilly. The air was so intensely close and hot, that at first I had but a confused perception of the delegates down in the pit, and the dense crowd of eagerly listening men and women (but not very many of the latter) filling all the benches and choking such narrow standing-room as there was. When the atmosphere cleared a little on better acquaintance, I found the question under discussion to be, Whether the Manchester Delegates in attendance from the Labour Parliament should be heard.

If the Assembly, in respect of quietness and order, were put in comparison with the House of Commons, the Right Honourable the Speaker himself would decide for Preston. The chairman was a Preston weaver, two or three and fifty years of age, perhaps; a man with a capacious head, rather long dark hair growing at the sides and back, a placid attentive face, keen eyes, a particularly composed manner, a quiet voice, and a persuasive action of his right arm.

Now look'ee heer my friends. See what t'question is. T'question is, sholl these heer men be heerd. Then it cooms to this, what ha' these men got t'tell us? Do they bring mooney? If they bring mooney t'ords t'expences o' this strike, they're welcome. For, Brass, my friends, is what we want, and what we must ha' (hear hear hear!). Do they coom to us wi' any suggestion for the conduct of this strike? If they do, they're welcome. Let 'em give us their advice and we will hearken to't. But, if these men coom heer, to tell us what t' Labour Parliament is, or what Ernest Jones's opinion is, or t' bring in politics and differences amoong us when what we want is 'armony, brotherly

love, and con-cord; then I say t' you, decide for yoursel' carefully, whether these men ote to be heerd in this place. (Hear hear hear! and No no no!)

Chairman sits down, earnestly regarding delegates, and holding both arms of his chair. Looks extremely sensible; his plain coarse working man's shirt collar easily turned down over his loose Belcher neckerchief ... But now, starts up the delegate from Throstletown, in a dreadful state of mind.

Chairman, I hold in my hand a bill; a bill that requires and demands explanation from you, sir; an offensive bill; a bill posted in my town of Throstletown without my knowledge, without the knowledge of my fellow delegates – who are here beside me; a bill purporting to be posted by the authority of the massed committee, sir, and of which my fellow delegates and myself were kept in ignorance. Why are we to be slighted; Why are we to be insulted. Why are we to be meanly stabbed in the dark; Why is this assassin-like course of conduct to be pursued towards us; Why is Throstletown, which has nobly assisted you, the operatives of Preston, in this great struggle, and which has brought its contribution up to the full sevenpence a loom, to be thus degraded, thus aspersed, thus traduced, thus despised, thus outraged in its feelings by un-English and unmanly conduct? Sir, I hand you up that bill, and I require of you, sir, to give me a satisfactory explanation of that bill. And I have that confidence in your known integrity, sir, as to be sure that you will give it, and that you will tell us who is to blame, and that you will make reparation to Throstletown for this scandalous treatment.

Then, in hot blood, up starts Gruffshaw (professional speaker) who is somehow responsible for this bill; My friends, but explanation is required here! My friends, but it is fit and right that you should have the dark ways of the real traducers and apostates, and the real un-English stabbers, laid bare before you. My friends when this dark conspiracy first began – But here the persuasive right hand of the chairman falls gently on Gruffshaw's shoulder. Gruffshaw stops in full boil. My friends, these are hard words of my friend Gruffshaw, and this is not the business – No more it is, and once again, sir, – I, the delegate who said I would look after you, do move that you proceed to business! – Preston has not the strong relish for personal altercation that Westminster hath. Motion seconded and carried, business passed to, Gruffshaw dumb.

Perhaps the world could not afford a more remarkable contrast than between the deliberate collected manner of these men proceeding with their business, and the clash and hurry of the engines among which their lives are passed. Their astonishing fortitude and perseverance; their high sense of honour among themselves; the extent to which they are impressed with the responsibility that is upon them of setting a careful example, and keeping their order out of any harm and loss of reputation; the noble readiness in them to help one another, of which most medical practitioners and working clergymen can give so many affecting examples; could scarcely ever be plainer to an ordinary observer of human nature than in this cockpit. To hold, for a minute, that the great mass of them were not sincerely actuated by the belief that all these qualities were bound up in what they were doing, and that they were doing right, seemed to me little short of an impossibility.

As the different delegates (some in the very dress in which they had left the mill last night) reported the amounts sent from the various places they represented, this strong faith on their parts seemed expressed in every tone and every look that was capable of expressing it. One man was raised to enthusiasm by his pride in bringing so much; another man was ashamed and depressed because he brought so little; this man triumphantly made it known that he could give you, from the store in hand, a hundred pounds in addition next week, if you should want it; and that man pleaded that he hoped his district would do better before long; but I could as soon have doubted the existence of the walls that enclosed us, as the earnestness with which they spoke (many of them referring to the children who were to be born to labour after them) of 'this great, this noble, gallant, godlike struggle'. Some designing and turbulent spirits among them, no doubt there are; but I left the place with a profound conviction that their mistake is generally an honest one, and that it is sustained by the good that is in them and not by the evil.

Neither by night nor by day was there any interruption to the peace of the streets. Nor was this an accidental state of things, for the police records of the town are eloquent to the same effect. I traversed the streets very much, and was, as a stranger, the subject of a little curiosity among the idlers ; but I met with no rudeness or ill-temper. More than once, when I was looking at the printed balance-sheets to which I have referred, and could not quite comprehend the setting forth of the figures, a bystander of the working class interposed with his explanatory forefinger and helped me out. Although the pressure in the cockpit on Sunday was excessive, and the heat of the room obliged me to make my way out as I best could before the close of the proceedings, none of the people whom I put to inconvenience showed the least impatience; all helped me, and all cheerfully acknowledged my word of apology as I passed. It is very probable, notwithstanding, that they may have supposed from my being there at all – I and my companion were the only persons present not of their own order – that I was there to carry what I heard and saw to the opposite side; indeed one speaker seemed to intimate as much.

On the Monday at noon, I returned to this cockpit, to see the people paid. It was then about half filled, principally with girls and women. They were all seated, waiting, with nothing to occupy their attention; and were just in that state when the unexpected appearance of a stranger differently dressed from themselves, and with his own individual peculiarities, might, without offence, have had something droll in it even to more polite assemblies. But I stood there, looking on, as free from remark as if I had come to be paid with the rest. In the place which the secretary had occupied yesterday, stood a dirty little common table, covered with five-penny piles of halfpence. Before the paying began, I wondered who was going to receive these very small sums ; but when it did begin, the mystery was soon cleared up. Each of these piles was the change for sixpence, deducting a penny. All who were paid, in filing round the building to prevent confusion, had to pass this table on the way out; and the greater part of the unmarried girls stopped here, to change, each a sixpence, and subscribe her weekly penny in aid of the people on strike who had families. A very large majority of these girls and women were comfortably dressed in

all respects, clean, wholesome and pleasant-looking. There was a prevalent neatness and cheerfulness, and an almost ludicrous absence of anything like sullen discontent.

Exactly the same appearances were observable on the same day, at a not numerously attended open air meeting in 'Chadwick's Orchard', which blossoms in nothing but red bricks; here, the chairman of yesterday presided in a cart, from which speeches were delivered ... Mr Hollins's Sovereign Mill was open all this time. It is a very beautiful mill, containing a large amount of valuable machinery, to which some recent ingenious improvements have been added. Four hundred people could find employment in it; there were eighty-five at work, of whom five had 'come in' that morning. They looked, among the vast array of motionless power-looms, like a few remaining leaves in a wintry forest. They were protected by the police (very prudently not obtruded on the scenes I have described), and were stared at every day when they came out, by a crowd which had never been large in reference to the numbers on strike, and had diminished to a score or two. One policeman at the door sufficed to keep order then. These eighty-five were people of exceedingly decent appearance, chiefly women, and were evidently not in the least uneasy for themselves. I heard of one girl among them, and only one, who had been hustled and struck in a dark street.

In any aspect in which it can be viewed, this strike and lockout is a deplorable calamity. In its waste of time, in its waste of a great people's energy, in its waste of wages, in its waste of wealth that seeks to be employed, in its encroachment on the means of many thousands who are labouring from day to day, in the gulf of separation it hourly deepens between those whose interests must be understood to be identical or must be destroyed, it is a great national affliction. But, at this pass, anger is of no use, starving out is of no use – for what will that do, five years hence, but overshadow all the mills in England with the growth of a bitter remembrance – political economy is a mere skeleton unless it has a little human covering and filling out, a little human bloom upon it, and a little human warmth in it.

Gentlemen are found, in great manufacturing towns, ready enough to extol imbecile mediation with dangerous madmen abroad; can none of them be brought to think of authorised mediation and explanation at home? I do not suppose that such a knotted difficulty as this, is to be at all untangled by a morning-party in the Adelphi; but I would entreat both sides now so miserably opposed, to consider whether there are no men in England, above suspicion, to whom they might refer the matters in dispute, with a perfect confidence above all things in the desire of those men to act justly, and in their sincere attachment to their countrymen of every rank and to their country. Masters right, or men right; masters wrong, or men wrong ; both right, or both wrong; there is certain ruin to both in the continuance or frequent revival of this breach. And from the ever-widening circle of their decay, what drop in the social ocean shall be free!

How Dickens Might Have Perceived Preston: Images of Old Preston

The site of Miller Arcade, Church Street, in 1850 with the Old Town Hall (left). This would have been the view from 'The Old Bull', where Dickens stayed in 1854. (Edwin Beattie)

Lang's Swan With Two Necks, Strait Shambles. The site was later occupied by the Harris Museum and Art Gallery. (Edwin Beattie)

'Curtain Down on the Black Parts of Preston'

'The Black Parts of Preston' reinforces the conditions and considerable poverty in Preston during the mid-nineteenth century and at the time of the visits by Charles Dickens. Those periods of poverty and depravity were emphatically not the so-called good old days. The second account of Preston town centre in 1861 coincides with the beginning of the cotton famine. There is no doubt that it provides a horrifying snapshot of the 'black parts' of Preston during the Industrial Revolution, portraying dreadful housing for cotton operatives, terrible disease and appalling squalor. The article is sourced from *The Builder*.

William Harding's livery building on Fishergate. The site is now occupied by Pitt Street and the County Hall. (Courtesy of Preston Digital Archive)

Another day we go in quest of the Ribble through Fishergate, in the opposite direction to that of our former route.

After passing the railway station, and noting the general neatness of the entrance for departures to Carlisle and Lancaster, as opposed to the disorder of the entrance for departure to the more Midland towns, we observe that Fishergate becomes suburban, casts off its old-world name at Fishergate-hill, and assumes the names of West-end, Ribble-place, and Broadgate consecutively. There are rows of suburban streets and terraces of a generally clean and healthy character; another sepulchral mansion behind a boundary-wall, bulged out by pressure of earth on the inner side, which a thaw after a frost may cause to fall out upon the pavement; and at the end of a regiment of neat little houses, facing each other and flanking the road, with pebble pavements in front, and close yards in the rear, a new church. This is in the Norman style, and is remarkable for two extremely colossal and massive octagon western towers, and for two large round gate-posts formed of Norman pillars, with caps – a confusion of parts that is certainly not common. There is a noticeable feature in this district, in the large perforated coal-cellar plates in the pavement. These are in design like great traceried wheel-windows, about 1 foot 6 inches in diameter; and studded with iron knots to prevent passengers from slipping on them. These perforated coal-plates, or cellar ventilators, are used in other parts of Preston, and are on the same plan that writers in these columns have recommended for London cellars on the paved footways. The mosaic-like arrangement of white headers to the dull red brickwork enlivens the street fronts here and there; and the different turnings branching off, give distant hazy views of factories bathed in steam, with their chimneys saluting – commerce, perhaps – in volleys of smoke. Yet a few minutes' walk, past Stanley-terrace, very sunny with terrace gardens set out in a hollow before it, and Grafton-street, where new villas are building, across South Meadow-lane, fast developing into a street likewise, and we come upon the muddy wharf-side of the river Ribble. A vessel is moored close by, and men are busily unloading it – of pebbles for paving ... On one side of the river there is a morass; on the other a great flat plain between the wharfs and the town, covered with factories, which extend in both directions, and encompass the old town.

A little variety is produced on the gaunt outlines of some of these buildings by tank towers, and in others by great hook-shaped ventilators rising out of the roofs, which, ugly enough in themselves, are palpable evidences of some attempt to better the condition of the operatives, and, therefore, shall pass scatheless from criticism. Also in sight, close to a walled-in group of tenantless premises, which has a mistiness as of a chancery suit hanging about it, there is a great scavenage heap, standing in a pool of the usual deposits, awaiting shipment; and a little beyond this there is the mouth of a sewer issuing forth hot sewage. An immense number of corks has, perhaps accidentally, got into the sewer, and, bobbing about in the sewage, they float out into the river, and indicate its exact course as it intermixes with the stream. These last mentioned facts are, of course, evidences of the existence of some scavenage and sewerage; but they are also evidences of the imperfect

manner in which both are carried out. This, then, is the 'pathway by the river,' the walk to which the lads and lasses of Preston may betake themselves of a summer's evening for air and exercise, unless, indeed, they have a preference for the rough games in the muddy Orchard, or are careless enough to be able to enjoy a walk in the cemetery. The place opposite the sewer out-let, called the Marshes, is the only recreation ground. When will Preston think it good to make a people's park?

From this we wend our way to get a nearer view of the houses of the factory-workers. To do this we cross the plain and pass rows of houses building, with old brick-bats taken out of rubbish heaps, on the old unhealthy plan of digging a pit in the earth for the kitchens; others, in Spring row, already built with pigsties, pits, and water buts on higher ground behind them, so that all overflowing and percolations must filter through the houses the floors of which are below the level of the soil in the rear, common privies in front of the houses, muddy coal-ash roads, and clothes hanging out to dry. Will this generation never learn the absurdity of placing floors below the level of the surrounding soil and then of placing water-butts, privies, and pigsties close to them with no drainage? How long will doctors come and go and cure fever, rheumatism, and other ills, and the causes of them not be removed? Some flaming placards pasted under a railway-arch give the state of the local habits and feelings in an indirect manner: 'Beware! beware! Have you the bowel complaint? Remember that it may assume the form of incipient cholera if improperly or ignorantly treated. Do you want curing, speedily, safely, and pleasantly, without any disgusting medicine which are enough to make an horse sick, then go to Bell & Co., 95, Friargate, at once,' and so on. A little farther on others are being pasted up as we walk: they concern the ward elections. 'Voters, go in for Ware.' 'Ware, and no interference with the poor man's pig.' Beware, Ware! We say, if he intend to let the pigs alone.

By the side of the Aqueduct Inn is another of those unaccountable pieces of mismanagement we have noticed before: the end of a sewer discharges the whole of what drainage there is upon the face of the land. In this case the sewage is steaming with the waste steam from the cotton-mills of Messrs. J. Swinson and W. Tayler. A vacant piece of ground is here bounded on three sides by the rear out-buildings of houses, and on the fourth side this sewer forms a stream. The space within is used as a rough playground by children, who have riddled it into innumerable holes, but it is not of them we would say a word: a butcher, close by, makes use of this space in which to bury, a few inches beneath the surface, the blood and guts and offal from his slaughter-house! Another similar space is left further on off the Fylde-road, where a sort of crater in the centre is full of stagnant slime; twenty-three colossal factories can be counted from this point of view, all shooting from their narrow, long-necked chimneys interminable wreaths of the densest smoke that could possibly be manufactured. Leyland-street and Dawson-street, close to Mr Hugh Dawson's factories, are back to back with cruelly small yards, all of which have privies and pits; and there are two holes made in the wall at the end of the row, for the overflowings to be carried to the rest of the sewage streamlets, with which this neighbourhood is defiled. At one end

of this second open space, thus laid out with volcanic scenery and sewage, there is a magnificent Roman Catholic establishment, containing church, schools and domestic buildings: and immediately before the elaborate west end of the church of the aforesaid establishment, there is another crater-full of green faecal matter, which deponent has but little doubt represents the drainage of the schools and domestic buildings of the establishment aforesaid. Who can wonder that sickness lurks in such neighbourhoods? Its general prevalence may have conduced to bring it under something like regulations, as a notice on the church-door declares 'Sick calls must be given to the priest of the district, and left at the presbytery before ten in the morning.' There are other notices affixed to the church – one giving word of an arch confraternity of the Immaculate Heart of Mary for the conversion of sinners; others notifying a confraternity of the Bona Mors for a happy death, an Altar Society, a Purgatory Society, a Girls' Holy Guild, a Men's and Boys' Holy Guild, a Young Women's Holy Guild. When may we hope to hear of the formation of a confraternity to cleanse the houses and plant health at the hearths of the poor residents of this fearful district? The architectural effect of this fine group of buildings is due to Mr J. Hansom. The church, which is dedicated to St Walbourg, has a very large one-spanned nave – as nearly as a man can count by pacing, 70 feet wide – with a handsome timber roof with carved spandrils, and with a large, bold wheel window at the west end. The tower is still unfinished. The east end of the church overlooks a railway cutting and St Walbourg's-street – a row of houses, with pebble pavement and a sloughy kennel in front, and a row of privies and water-butts in the rear, the drainage from which percolates into a ditch by the side of the railway.

The next row of houses is called Mandland Bank: their contracted yards and crowded ashpits overhang the steep bank of a canal. The view from the canal bridge is ghastly. There are a few wretched, decayed trees on the banks, and the overhanging privies and dung middens have discharged their surplus filth over their boundary walls on to these banks below; sewers empty themselves into the canal; and the water has the appearance of a stagnant sheet of fluid with a thick oleaginous brown crust on it. There is a new, showy, lofty red-brick school close by, with stone facings of good Early Decorated Domestic details, that is as startling in its contrast to the unsanitary conditions around, as is the Roman Catholic establishment just passed. All over Preston this contrast is present. New churches and new schools, surrounded by the most unsanitary conditions, denote that cleanliness is farther from godliness in Preston than it is in the adage, Cold Cold Bath-street, overlooking the said new schools, and Bolton-street, are more rows of poor houses. By this time we have approached the factories. In the neighbourhood of the celebrated Horrocks's factory, – what housewife of discernment is there but prides herself upon the selection of Horrocks's longcloth? – in the neighbourhood of this famous firm is Kirkham-street, where families live in horrible cellars, a second family above them on the ground floor, and a third over that, where the roads are made of coal-ash, the yards so confined that the people must hang out their clothes to dry in the street, at the doors, on the stairs,

over the beds, or else over the terrible choked offal-pits that are within a pace of the back doors. Halfway down Back Bolton-street is the rear of St Peter's School, a dirty old brick building, with a small playground for the boys that overlooks, in one corner, a cavernous pit of liquid-filth, with a trap-door in front of it, next Bolton-street, for the use of the poor residents; and within a stone's-throw is St Peter's Church, with a graveyard choking full and closed. Moss-street is occupied on one side by a factory; on the other by a row of back-to-back houses for the operatives. These houses have no yards whatever, so the tenants dry their clothes in the street on lines fastened from the fronts of their houses to the factory-wall. As there are no yards, there are no privies; but for the accommodation of the whole colony of families who live in the cellars and first and second floors, there is a host of privies built at the end of the street across from the factory-wall to the wall of the houses. The occupants of the other end of the street must traverse the whole length of it, not only to use them, but to dispose of all their refuse. Bedford-street, Brook-street, Atherton-street, Victoria-street, and Ashmoor-street, have all the same characteristics – families living over families, and washing with poss-tubs in the upper rooms, &c. In the rear of Moss-rose-street there are back-yards; but they are literally one yard wide, and the ash-pits, with their rotting contents, are within one yard of the backrooms of the dwellings. This is near St Peter's School for girls – a tasteless, neglected brick building, of the same typo as those just mentioned for boys – where the girls' privies are so disgusting that the children are reduced to the necessity of using the paved yard, which is accordingly defiled with pools of urine; further, a channel has been actually made to convey these away past the entrance-door. The state of the windows and of the whole of the establishment, too, would be a disgrace to a community of savages. There is another open space, bounded by Gordon-street, Brook-street, and Victoria-street, which would be of inestimable value if laid out as a play-ground for the children of the crowded district; but half of this is now occupied by a nest of piggeries, and the remainder as a second-hand timber-yard. Factories are thick upon the ground in this neighbourhood. We see Arkwright's great factory here. There are, too, many more rows of houses built on the same type as those described – Hawkins-street, Spring-fold-street, Murray-street, and more – before we find another open space. But we see another, bounded by Hawkins-street and Emanuel-street, which has been made a temporary playground by children. In the centre of it, however, a pig-jobber has been allowed to form a circular tank, or dung-basin, in the soil, by raising a mud bank and clay parapet, in which he preserves the pig-stye manure. We can only conclude that the Board of Health is paralysed.

Cotton-mills and weaving-sheds have taken possession of a vast tract, or moor, originally quite out of the town. Here are Goodyear's, Gardiner's, and Adam Leigh's factories. Many others are newly built, and still more are building; and the rows of factory dwellings keep pace with these erections. The latter are all built after the same model, – no drainage, the smallest possible yard, with a privy and ashpit and water-butt not 3 feet from the backs of the houses, or none at all. Midway on the moor is a deep ravine, over which a road has been thrown, and

millions of cartloads of scavenage and rubbish are gradually filling it up. Upon this artificial foundation rows of factory dwellings are now being built, and some of them are furnished with cellars; or, more correctly speaking, pits, sunk in this foundation of scavonage. New mills are built without roads. The Queen's Mill, newly built (1861) on this moor, has neither roads nor drains; and the rain and waste steam have formed lakes around it of coal-ash mud, which the operatives must ford to enter the mill. An exception to this state of things has been attempted by Mr Tomlinson, a barrister-at-law and land-owner here. He provided his houses with drainage and water-closets; but, unfortunately, the want of playgrounds obliges the children to play where they may, and the closets soon got out of order; and this pioneer movement was abandoned, and the reign of the cesspool system resumed. A second step has been taken in the right direction. There are ragged and industrial schools on Mill-hill, – another of these over crowded streets; but to make them of efficient avail, the unsanitary conditions of the roads and dwellings should be reformed.

Another day we step out along Fishergate to view the cemetery. This is situate at a sufficient distance from the town. Fishergate, after passing the Town-hall, is called Church-street, and contains the fine rebuilt parish church, a handsome edifice with a tower and spire, but surrounded by miserable dwellings and incongruities, a vendor of 'fresh barm,' 'leeches kept by Mrs Barnes,' 'funeral palls kept,' and a botanist's herbarium. And at the end of an adjacent site, called Graystocks-yard and St John's-place, there are a series of ruinous privies, and a pit of huge dimensions, which appears to serve the whole of the church yard district. After passing the Bull Inn and Royal Hotel, and the Red Lion facing it, with the old bank next door, – a quaint building, with brick pilasters, – Church-street resolves itself into a poorer district, in which the three gold balls of the pawnbrokers are pretty frequent signs. As the roads and paths are badly kept and swept, we are surprised to pass the office of the Board of Health here. Presently we come to a new Independent Chapel, in Grimshaw-street. This is a detached building in the Early Decorated style. There are three doorways in the western I, with a large five-light window over them, a tower on one side and, the base of another on the opposite side. The long sides, for the convenience of the galleries, are lighted by double rows of Domestic Decorated windows, which present a striking contrast to the cathedral-like west-end. The details are, however, good. After this we see a brick factory looking building, which turns out to be the Grimshaw school, erected in 1836, enlarged in 1845; but what takes our attention more is the spectacle of a man on a factory roof, at the end of the street, shovelling out soot into the road. If the Board of Health permit of this manner of disposing of the surplus soot from engine chimneys, the streets are never likely to be clean. After this there is Queen-street, with courts out of it; the Druid's Arms; then Brewery-street, Malt-street, Hop-street, Vat-street – all running out of Duke-street East. There is no privacy to these houses, as the doors stand open for ventilation, and the tenants of the uppor floors must cross the lower rooms to reach the staircases to them. Then there is a sprinkling of rag and bone stores, old brass and copper stores, a small shop where 'herb, ginger, bitter, and nettle-beer' are sold;

then more rag-shops, and we are out upon the London-road – wide and airy, and where there is really breathing room. A paper-maker's waggon is grinding along, full of rags, bound for Withneld Fold ; and the Preston barracks – said to be models internally, but externally presenting a serio-comic castellated appearance – are soon in sight. But we turn out of the road before long at New Hall-lane, in which there are more mills, and more unhealthy houses for the operatives. The streets running off at right angles have double names: thus, Frederick-street is called Thomas-street on the opposite side of the way. A new row of houses is building, which are curiously propped up in the rear; and on inspection it appears that they are run up so thin and slight, that until the floors and roofs are on to bind them together, they cannot stand by themselves, but must be supported. Another street, called Green-street East on one side, and Elizabeth-street on the other, has clothes hanging across the road, and a gasometer at the end of it. More mills, and more mud; a row of houses, with a man weaving in a cellar in one of them; a great stagnant swamp, with a brick-yard in it, and a square dung-heap; an isolated row of houses in Skeffington-road, with pools of drainage spread before them; more mills, more mud, more dwellings propped up while building, with five feet of drainage water in the cellars and a foul ditch in the rear; then a length of blighted trees, blighted hedges, and foul ditches, on either side of the coal-ash road; cows grazing in fields where there are stagnant pools and the grass is tinged, with an unearthly green by the soakage of too much town percolations; more ditches, and more stagnant pools in low-lying fields. Then it is that we count funerals in front of us, funerals behind us, funerals keeping pace with us; mourners dressed in black are passing along the black footways; the hedges, ditches, and sheep in the fields, are all black; the smoke blowing from the factories and hovering over the roads, now eddying, now descending in flakes, is also black; and it becomes difficult to shake off the impression that we are being carried to the grave ourselves. A tombstone mason has a yard by the road side, with a dung-heap in the centre and a haystack at the side, against which some slabs are leaning carved with crucifixes, with considerable feeling, which are facing the cocks upon the midden. The gable end of the mason's house is tarred black, and the whole prospect wears a funereal aspect. At last, after passing a vacant plot with a board notifying that it is building land to let, we come to a group of ecclesiastical domestic buildings and the cemetery gates. We take the former to be the superintendent's lodge, but we are mistaken. It is the Hesketh Arms and Cemetery Hotel! For a hotel to be close to the lodge and entrance gates of a spacious cemetery of fifty acres, with three chapels in it, is an innovation for which we were not prepared. On entering the gates another innovation meets the eye. This is a stagnant pool of drainage from the lodge and retiring place for ladies, cut into a meandering shape to resemble a small lake. A notice-board declares that 'Every person who shall play at any game or sport, or let off firearms, shall forfeit a sum not exceeding £5'. The tendency to indulge in such practices in such a place can be accounted for in two ways; first, by the want of proper recreative grounds; and secondly, by the proximity of the Cemetery Hotel. The cemetery buildings are exceedingly good. The Roman Catholic Chapel has a neat little tower, looking, perhaps, a trifle too much like a

miniature village church; and the spire of the Protestant Chapel is almost double the height of the tower; but there is a pretty bell-turret to the Dissenters' Chapel, and rich metal crestings to them all. Many of the tombstones are of an excellent character; and the general effect, aided by the abundance of green trees, is more than usually appropriate and pleasing.

Our task would not be complete without an examination of the reservoirs. The farm-houses on the route show the infectious nature of the bad example set in the town, as they have ditches full of black foecal matter round them; and one of them has the addition of a lake of the same material close to the door: while Ribbleton Moor, likewise on the route, is undrained and swampy. The reservoirs are in good order, except that there is a weed and a fungus-like leaf growing in all the crevices of the stone bottoms – probably on account of their not having been cleaned of late years.

Facing Preston, on our return, the town presents a most curious aspect, – not a house, tower, or spire is visible; but in their places there are countless jots of dense smoke darting up in the sky, rocket fashion, and these diffusing into heavy clouds cast a threatening aspect over the landscape as of a coming storm. We take a different route back to the town; but there are the same pools lying in the farm-yards, the same moisture in the ditches, more dung-moors, more brick-kilns and waste places, and tracts of privy stuff, the same proximity of piggeries and dwellings. And so we get back to Preston through Wignall-street, in which the road is yet unmade, and through which the filth from the houses flows down past the entrance of a beautiful new church (St Luke's), and round a corner site facing the west end of it, where there is a new school, designed by Mr Carter. A house opposite the church and school and the roads around Napier's mills do their best to spoil the effect of both with their disgraceful negligence. We learn that the school is intended by the incumbent of St Luke's, the Rev. Mr Winlaw, for the Sunday education of grown-up people, and is only part of a scheme which includes the erection of another school and of the establishment of suitable playgrounds for the young. The absence of the latter, as noticed in the foregoing remarks, leads to much mischief: it is a great feat with the boys to throw over the church spire, and hence hundreds of quarries are broken; and the factory windows are destroyed by the same agency. We wish the reverend gentleman all success in his great endeavour. With better health and a better education other careers would open for the Preston operatives, who now have but the choice of entering the factory or the army. The enlisting sergeant will tell that there are more recruits to be had in Preston than in any other town in the kingdom ; but they are so weak with their tea and bread diet that it takes two years to feed them up to be soldiers. Under their present conditions, the men of Preston are old at forty; at forty-five they are 'auld and done.'

If our well-meant words have any effect, the rising generation may last a little longer.

The Builder, Volume XIX, No. 984, pp. 853–855

Victorian Railway Mania

The first railways around Preston began to impact on the landscape from around 1840 and acted as a catalyst for population growth, at the same time transforming the social and economic prosperity of the country's towns and villages. This chapter will examine the birth of the railway network in Lancashire, corresponding with the term 'railway mania', which might be perceived as an utter frenzy over rail construction throughout the second half of the nineteenth century. To illustrate the term, in 1820 there were no commercial passenger railways in Britain; by 1912 the landscape had been transformed, with 120 companies operating over 20,000 miles of track. The railways have played an important role in the history of our country, going from a source of employment to the means by which we shifted freight or passengers.

Throughout the second half of the twentieth century, Preston suddenly expanded outwards and its squalid street and alleys seethed with an unprecedented population explosion. The impact of the dawn of the railways was being felt during the mid- to late Victorian period as the sedan chair, stagecoach, canal barge and various types of horse-drawn vehicles were eventually surpassed by the iron horse. The evolving railway network was assisted by the inadequacy of the road system and the high profits made by the canal operators. Lancashire railways have played a significant part in the development of Preston for both business and pleasure.

The opening of Preston station and the arrival of the line from Wigan on 31 October 1838 saw the beginning of considerable railway development in the area. At the same time, Preston's industrial base during the Industrial Revolution was well established. The new railway from Preston to Wigan reduced the time taken from three hours by stagecoach to less than half an hour. The inaugural return trip was duly reported in the *Preston Chronicle*: 'Loud huzzahs greeted our arrival, the bells sent forth their sonorous peals, the Union Jack was unfurled on the Parish church, the standard of St George floated on top of the Mayor's Mansion and a band of music played in the gardens.' The Wigan & Preston Junction Railway became part of the North Union Railway on 1 November 1838. Entering Wigan from the south, it led to Preston having rail connections with the major cities of London, Birmingham, Manchester and Liverpool, though the railways around Preston had yet to evolve during a period of the rapid escalation of the railway network.

The original Preston station was the earliest within the bounds of the present county of Lancashire and soon became a major junction. Originally it comprised only two platforms, which had expanded to six tracks, four platforms and an extended station building by 1847. The Preston historian A. Hewitson, writing in 1883, did not speak too favourably about the original North Union station or of the first steam engines:

At Preston the station was one of the most dismal, dilapidated, disgraceful-looking structures in christendom. It was not only a very ill-looking, but an exceedingly inconvenient and dangerous station. The

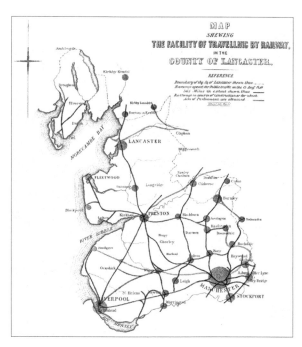

The principal railway lines of Lancashire at the height of Victorian railway mania.

engines were said to be very small and the weak character of the old engines was such that often, when a heavy train was leaving Preston for the north, porters had to push at the side by way of assistance.[3]

Interesting reading, but it was no music hall joke! Furthermore, passengers had to cross the railway lines to reach other platforms. This dangerous procedure was finally ended when a footbridge was erected in 1855.

A writer colourfully described Preston North Union station in 1861:

Neither tradition, politeness, nor truthfulness can call upon us to admire the exit from the railway station from the departure side for London, Birmingham, Liverpool, Manchester, Wigan, and Bolton, by the first and second class booking-office entrance, which is in a coke-shed. It is grimy with coke-dust; all the painted work resembles stucco, as the surface of it is raised with particles of coke dust, which must have settled upon it before it was dry; and the sweepings of platform and offices – dust, scraps of paper, envelopes, and such litter – are lying on the road. For 'the way out' there is a choice of two roads, one for vehicles to the right, in the direction of the goods department – the same road serving for passengers' vehicles and the goods waggons, whereby it gets dreadfully cut up, – and another for pedestrians, up twenty-six wooden steps, which are under cover of the same

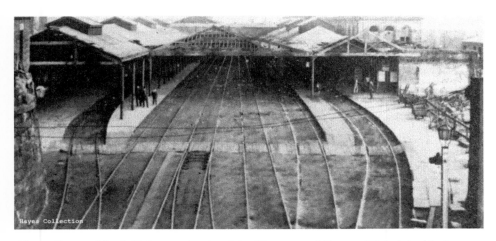

Above: Preston North Union station in 1860. (Courtesy of Preston Digital Archive)

coke-shed. At the top of the steps is a long gallery, with an inclined floor, looking, with its bare walls and flat ceiling, like the entrance to the gallery of a theatre. The plaster, which is grey with coke ash, is not coming off the walls in patches, and not a time-table, nor a placard, relieves its long monotony. There is, however, a railing up the centre, which is apparently provided for a crush, or for division of classes, at excursion times, and which causes uncomfortable conjectures to arise as to the safety of a descent of twenty-six steps in the way of a crowd of the kind. The tubular gallery discharges the passengers into a carriage-road which is used alike for goods and passengers, is wretchedly paved, and never swept. A board declares that no rubbish is to be shot here; clothes are hanging out to dry; and the ruins of the gate-posts of the entrance gateway are lying about – great blocks of stone. On the boundary-wall, so that you may read as you hurry along, are posted placards, inscribed with pithy ejaculations bearing upon the incidents of the ward elections, – 'Jolly doings in St Peter's ward! Beer and bribery for ever!! Remember Miller the just. No coalition between Gudgeon and Whitehead.'

The increased volume of traffic, coupled with the appalling lack of facilities on the original station, led to the construction of a more substantial structure. The new station was completed by the firm of Cooper & Tullis in July 1880.

Further extensions were made in 1903 and 1913, when Preston station reached its zenith with a total of fifteen platforms inclusive of bays. The original Victorian station remains, though the number of platforms has been reduced to six, following electrification of the West Coast Main Line.

Nationally and locally, the golden age of railways actually got under way around 1870 and peaked at the time of the First World War. Hewitson noted in 1883 that 'as to railways, Preston has, for many years, been one of the principal towns in the kingdom. There is no town that possesses a more comprehensive railway service. Prestonians possess facilities which but few provincial people enjoy anywhere.

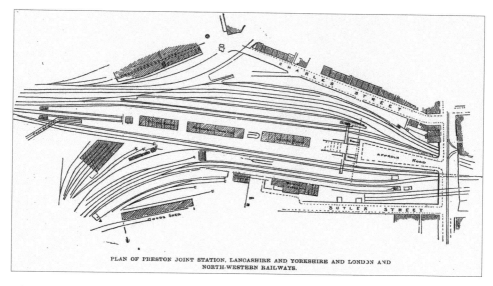

PLAN OF PRESTON JOINT STATION, LANCASHIRE AND YORKSHIRE AND LONDON AND NORTH-WESTERN RAILWAYS.

Above: Plan of Preston railway station in 1895. (Courtesy of Preston Digital Archive)

Right: Aerial image of Preston railway station. (Courtesy of Preston Digital Archive)

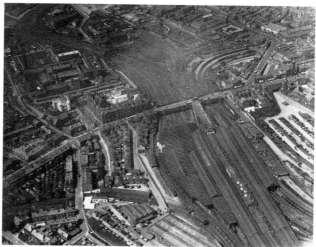

About 450 trains passenger and goods trains arrive at and depart from the principal station every twenty four hours.'[4]

With the expansion of the railway network, better facilities were needed for the servicing and stabling of locomotives and engine sheds were built to serve the railways entering Preston. The North Union's shed was originally situated at Butler Street to the east of the main line. Close by, the East Lancashire Railway and its successor, the Lancashire & Yorkshire Railway (LYR), had their own engine shed with up to five roads capable of stabling around twenty locomotives. This particular engine shed was the forerunner of Lostock Hall shed, opened by the LYR in 1883. The Lancaster & Carlisle Railway Company built a new shed on

the west side of Maudland Junction in 1857. This shed was later being used by the LNWR, LMS and finally British Railways.

Preston's Victorian railway network once had five stations, operated by rival companies. About eight lines radiated from these stations and the original North Union Station, which is today Preston's main-line railway station and remains on the original site. On 4 July 1838, the promoters of the Bolton–Preston railway obtained powers to join the North Union Railway at Euxton, and so enter Preston. The line opened on 22 June 1843, providing a link between Preston and Manchester. Completion was delayed by difficulties experienced in completing a very deep cutting and tunnel to the north of Chorley.

The Preston–Longridge branch line opened on 1 May 1840, linking the town with the village of Longridge, 6½ miles to the north-east. Passenger services operated from 1840 to 1856 from a station a mile to the east of the town at Deepdale Street. This station was detached from the evolving railway network, with passengers being conveyed by carriage between the station and the main Preston station. Following the arrival of the North Union Railway in 1838, the branch was, chronologically, only the second railway to open in the Preston area and, in fact, preceded even the Lancaster & Preston Junction Railway that was to evolve into the main Anglo-Scottish route.

The Lancaster & Preston Junction Railway (LPJR) opened on 25 June 1840. The original terminus at Preston was situated a short distance from the North Union station, on the north side of Fishergate, and was linked by a tunnel. The company painted their carriages in bright yellow and bestowed individual names upon them, as with the stagecoaches of yesteryear and the luxury Pullman carriages of a later era. The Lancaster & Carlisle Railway extended the line over Shap to reach Carlisle in 1846 and

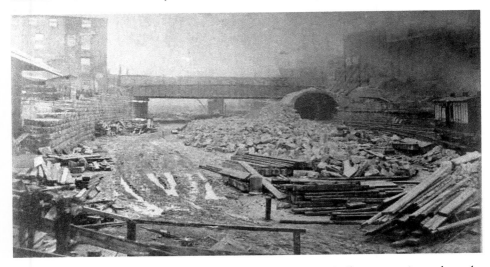

The original terminus of the Lancaster & Preston Junction Railway was situated on the north side of Fishergate, and connected by a tunnel to Preston's North Union station. This historic photograph depicts the tunnel and infrastructure at the time of construction. (Courtesy of Preston Digital Archive)

Glasgow via Beattock Summit in 1848. Thus Preston's main railway station was now to be linked with Scotland as well as London and the Northern cities.

A serious rail accident occurred on 13 July 1896, when the down Scotch Express double headed by engines No. 275 *Vulcan* and No. 2159 *Shark* came off the track on the sharp left-hand curve to the north of Preston railway station. The subsequent enquiry revealed that the train was travelling at 40 miles per hour, in breach of the official speed restriction of 10 miles per hour.

A Journey along the Lancaster to Preston Junction Railway

The following is an evocative account of an early Victorian train ride from Preston to Garstang written by Anthony Hewitson. It makes reference to the Garstang, Pilling & Knott End railway, the so-called 'Pilling Pig', whose passenger service ceased in 1930. This branch line commenced at the former intermediate station of Garstang and Catterall, which was on the main line approximately halfway between Preston and Lancaster.

> Out of the dull Sunday morning town, with only horn thumbed milkmen, and muffled dog-fanciers, and suspicious 'thirsty souls' astir; over a complicated number of railway points, with sharp, saucy, engine-whistles assailing one's ears every other moment; then a quickening, movement by dismal-looking cottages, grim saw-pits, and

Top left: Ex-works Stanier Class 5 No. 45227 works a Blackpool North–Lakeside (Windermere) service over the Brocks water troughs south of Garstang station on the WCML on 1 September 1965. The other three photographs show tranquil railway scenes on the former Garstang–Knott End railway (the 'Pilling Pig'). (Courtesy of Noel Machell)

lofty-sided mills; and then we have a clear-breathing space in the country, with green fields and cattle on each side, and hills filling up bravely and beautifully the eastern horizon; gentlemen's residences breaking in upon the view occasionally; sundry glimpses of a roundabout, obsolete canal; tempting views of hares and rabbits, with a stately-walking pheasant now and then thrown into the bargain; periodical sights of fish-ponds, with broad yellow flowers, and quick-witted little water-hens floating amongst them; a swift penetration into a shadowy wood, whose branches and foliage seem to be opening out with a wild rustle for the flying train; a return of daylight and free breathing space; a whistle; and in a few moments afterwards a stoppage. This is about the sum and substance of a journey by train from Preston to what is called Garstang station – an elevated, exposed place, on the main line, about two miles from the town of Garstang, and recently connected with that said town by a poor little junction, which runs to Pilling, and winds up in a field there. We expected being able to catch a train on this small contribution to railway science for Garstang; but the station-master informed us we could not – said that not a single train ran upon it on a Sunday; so we had to walk. At first we set down this closing up of the little junction to some special spell of piety or Puritanism – to a desire on the part of the directors to get to heaven quicker than all the other railway folk, except those saints who live in Scotland; but we subsequently learned that the directors were not so very punctilious after all – that, in fact, their line was kept quiet on the Sunday, not because it was sinful to run drains on that day, but because if the trains were run they would not pay! We got peacefully and safely to Garstang, on foot, – much better, at least, than some men who have visited the old town.

On 15 July 1840, the Preston & Wyre Railway (PWR) was opened, connecting Preston with Fleetwood. The PWR station at Preston was situated at Maudland, off Leighton Street, to the north-east of the main union station. During February 1844, PWR passenger traffic was transferred to the North Union station and Maudland station was closed to regular passenger traffic, though not to goods and excursion traffic. The company had ambitious plans for the development of Fleetwood as a port and during the same month the railway carried a staggering 20,000 passengers. Before the Lancaster–Carlisle railway was built an Anglo-Scottish route was an option, running via a steamer service from Fleetwood to Ardrossan in south-west Scotland as well Bardsea (near Ulverston) on the Furness peninsula. At the time it was the quickest route to Scotland.

Two branch lines originating from the Preston–Wyre Railway opened during 1846: from Poulton to Blackpool (Talbot Road) and from Kirkham Junction (later Bradkirk) to Lytham. Major new seaside resorts became established at Blackpool and Fleetwood, the latter named after its founder, Peter Hesketh Fleetwood. The significance of all of this was that the railway was to transport millions of tourists through Preston to the popular Lancashire coast resorts during the summer wakes weeks throughout the next two centuries.

The Blackburn–Preston line opened in May 1846, with coaching stock painted in a blue-and-black livery. The opening was accordingly reported upon: 'The pleasure of the

Above: An unidentified LYR locomotive hauls a train along the East Lancashire line over Ivy Bridge at Avenham Park, Preston, around 1900. (Courtesy of Preston Digital Archive)

day was much enhanced that no accident or mishap occurred to cast a gloom over any aspect of the proceedings.' Two months after opening, the line was taken over by the East Lancashire Railway (ELR) and became known as the East Lancashire & Liverpool Railway. Preston's East Lancashire railway station was accessed from the eastern, or Butler Street, entrance and was served by its own platforms adjacent to the main station. The amalgamation of the ELR with the LYR took place on 13 August 1859. The Butler Street station then constituted LYR property and was owned and operated solely by the LYR for trains approaching Preston along a route from the south-east via a station called Preston Junction, later to be known as Todd Lane Junction.

The Liverpool & Preston Railway via Ormskirk was also owned by the East Lancashire Railway and was finally completed in 1849. It was not until 1850, however, that the East Lancashire lines gained a direct independent route into Preston, known as the Preston Extension. This involved the construction of a spectacular fifty-two-arch viaduct and iron bridge spanning the valley and River Ribble between Avenham and Miller Parks. Southport was first reached by rail from Preston in 1855 from a junction at Bursough Bridge, with the Preston–Liverpool line, which linked it with the Manchester–Southport line.

The last major railway construction project in the Preston area was the West Lancashire line from Fishergate Hill to Southport via Hesketh Bank, opening at the beginning of Preston Guild on 15 September 1882. Work commenced on the 15-mile branch from Southport in 1871 and eventually reached Preston (Fishergate Hill) in time for the 1882 Guild celebrations.

It is interesting to note that during 1882 a scheme for running a line from Blackpool via a bridge over the Ribble at the Naze, Freckleton, to the West Lancashire Railway

The exterior of the West Lancashire railway station, Fishergate Hill, Preston. (Courtesy of Linda Barton)

at Hesketh Bank had been proposed, but in 1883 the Bill was withdrawn following opposition from Preston Corporation, who wanted to improve the river for navigation purposes.

The original terminus at Fishergate Hill was closed to passengers after only eighteen years on 16 July 1900. Thereafter a new link facilitated the running of passenger trains into Preston (Butler Street) station. The line had always served thinly populated rural districts, and was an obvious candidate for the infamous Beeching axe. This was wielded, the departure of the last passenger train from Preston taking place at 10.35 p.m. on Sunday 6 September 1964.

The Whittingham Hospital Railway was regarded in some quarters as yet another music hall joke! Indeed, had it been able to grace the music hall stage it would probably have been regarded as a star 'novelty act' for it ranked as one of the most unique and colourful Victorian steam railways in the country. For example, the vagaries of the timetable depended on the driver, who knew his passengers so well that if anyone missed the train he would reverse the engine to the station to pick them up. On the railway there were no intermediate stations, merely a few unscheduled stops. If the old engine ran out of steam, or perhaps between flexible train times, opportunities often arose for train crews to gather field mushrooms or to collect the wild flowers growing profusely in the cutting next to the line.

The railway was constructed between 1887 and 1889 as a mineral line to convey coal and provisions to the new Whittingham Asylum from a connection with the Preston to Longridge branch at Grimsargh. Hospital staff soon followed and private stations were built at either end of the 2-mile-long standard gauge hospital line. The train was dubbed the nurses' special, and ranked as one of the most fascinating and antiquated Victorian steam railways in the country. Passengers were conveyed free of charge. The very last passenger train along the line ran from Grimsargh to Whittingham on 29 June 1957, and shortly after the track was lifted to remain as a scar on the landscape and a legacy to a most interesting Victorian steam railway.

The Allure of the Preston to Southport Branch Line – Photographs by Martin Willacy

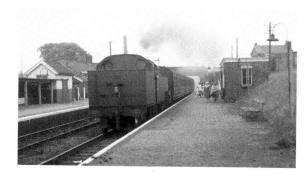

Hesketh Bank station *c.* 1960, with a local stopping train alongside the platform, and two or three passengers.

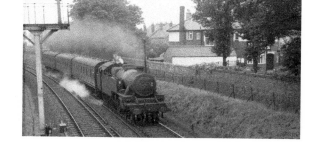

A Fairburn tank approaches Churchtown on the outskirts of Southport in the early 1960s.

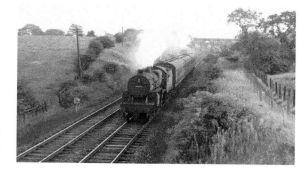

The rural branch line scene is here personified in a cutting close to Penwortham Cop Lane station on the outskirts of Preston.

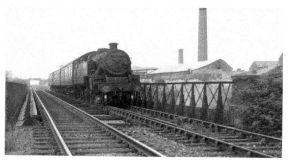

An Up passenger train passes by the old brickworks close to Hesketh Bank station.

Today, Preston is the most important intermediate station on the Anglo-Scottish route which is known as the West Coast Main Line. It remains a significant railway junction, though the busy goods marshalling yards are but a memory, as indeed are the two branch lines to Southport and Longridge. Following substantial investment, there has been a resurgence of passenger traffic both nationally and locally. The Victorians would instantly recognise the railway network around Preston and the glory of its restored station. Significantly, of the railways radiating lines from Preston, only the Longridge and Southport lines have closed completely.

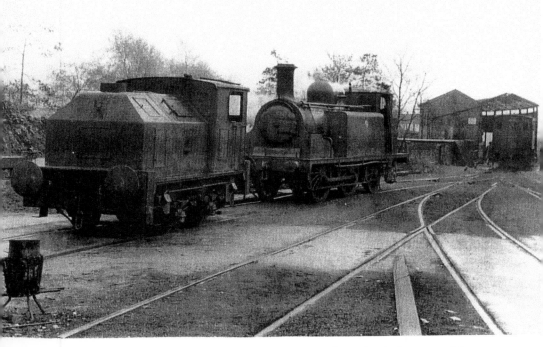

James Fryars joins sister engine *Gradwell* on the shed road at Whittingham on 1 May 1954. (Author's collection)

A Gallery of Steam Around Preston

282 Standard Class No. 76065 (Ex-works, Horwich) at Preston station with a Manchester to Blackpool parcels train on 26 April 1963. (Courtesy of Peter Fitton)

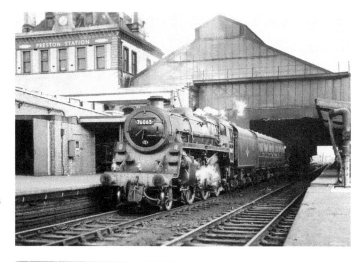

Camden-shedded Princess Royal 46208 *Princess Helena Victoria*, waits in 5B bay at Preston station prior to taking over a Workington–Euston train on 19 August 1962. Three weeks later the locomotive was withdrawn. (Courtesy of Peter Fitton)

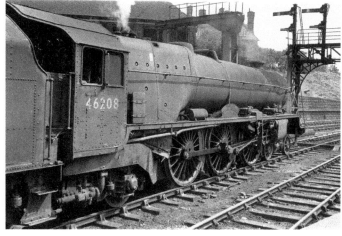

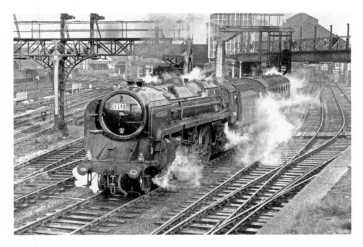

A pristine Clan *MacLeod* No. 72008 departs Preston station on 19 October 1963 with a fourteen-coach Maryport to Coventry football special train. (Courtesy of Peter Fitton)

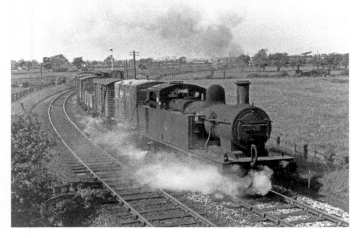

Class 3F Jinty No. 47472, unofficially named *City of Preston*, climbing Farington Bank with a Lostock Hall to Preston freight working in June 1965. (Courtesy of Stan Withers)

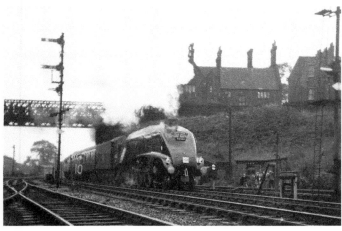

The famous A4 Pacific No. 60022 *Mallard* comes off the East Lancashire line at Preston (Vicar's Bridge) with a special to Blackpool on 30 September 1961. (Courtesy of Martin Willacy)

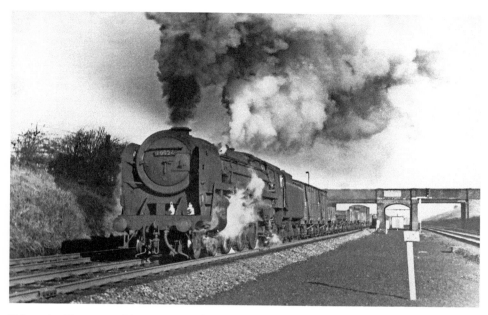

Britannia Class 4-6-2 No. 70024 *Vulcan* heads a southbound fitted freight past the site of the closed Farington Station. (Courtesy of Stan Withers)

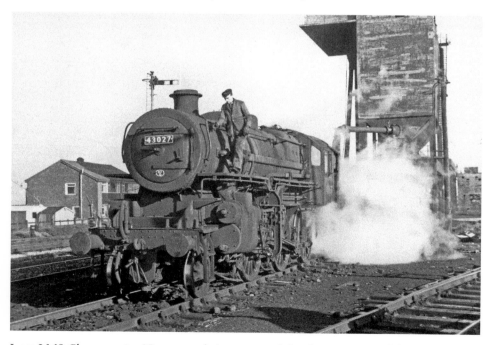

Ivatt LMS Class 4 2-6-0 No. 43027 being prepared for the next tour of duty adjacent to the coaling plant at Lostock Hall Shed. (Courtesy of Stan Withers)

'To Fleckie Bennett's in Old Cragg's Row'

The numerous cinemas scattered throughout Preston, with their neon facades and welcoming managers, represented for thousands an escape from reality and a cheap night out, to be rounded off with a bag of fish and chips and a packet of scraps from the local chippy, an era that has now gone forever and which had its origins in the 1890s. The culture of Preston cinemagoing in all its forms, including the era of the cinema organ, was symbolic of the 1930s. Despite the level of unemployment and poor social conditions, cinemagoing was at its peak when the masses purchased 20 million tickets per week nationally. This was the golden age of Hollywood, when the superstars and cinemas were hugely popular, at the pinnacle of the cinema industry. Long before the popularity of television, cinemagoers could be found most evenings queuing in the streets in all weathers. The birth of cinema came to Preston in the late Victorian era, when the travelling fairs visited the town, and at different periods during the first half of the twentieth century Preston had between eighteen and twenty-two cinemas. The account that follows details their history.

Early Doors

The birth of commercial cinema came when Louis Lumière staged the first-ever film show for a paying audience in Paris in 1895. Moving pictures or cinematograph shows first came to London in 1896. Methods of projection were crude. In those days, *What the Butler Saw* performances could be viewed on the so-called phantascope on Lancashire piers and I well remember curiously observing *What the Butler Saw* on Fleetwood Pier. The cinemas of Preston have their true origins in the last decade of the Victorian era, when the travelling fairgrounds and circuses visiting Preston showed the first films in tents and trailers. Short films later featured in the music hall and the Preston Assembly Rooms within the historic Bull and Royal Hotel, where 'grand daily cinematograph performances and concerts' were given.

Throughout England, a similar pattern emerged with travelling cinematograph operators. At Blackburn, short films were shown at the travelling fairs from the mid-1890s and likewise at Preston. What was probably Preston's first embryonic cinema

performance was reported in the *Preston Herald* on 12 June 1897, featuring a short film with an intriguing title: *The Lady Who Would Take a Bath*. The following description of this dubious event sounds somewhat salacious: 'Here under the very shadow of Preston's stupendous Harris Free Library may be seen a gaily painted temple, bearing on the one side to the effect that along with the ordinary routine of the show a speciality had been added in the form of a "lady who would take a bath", which she proceeds to take in the orthodox fashion in full view of the audience by means of the cinematograph.'[5]

All the fun of a travelling fair held in Preston was described in a contemporary newspaper report in 1898, the fair being held at 'The Orchard' in Preston Town Centre:

> Among the attractions were heavy weight lifters, dwarfs, ghost illusionists, cinematographs, art galleries, boxing booths, and marionettes ... It was highly amusing to watch the keen competition among the showmen, and the manifold methods by which they endeavoured to allure sightseers. There were menageries with daring lion tamers, who loudly boasted of terrible feats and narrow escapes. Coconut shies and other forms of pleasure did a thriving business.

Prior to the First World War the music halls provided the main form of public entertainment, but, paradoxically, moving pictures were to be provided with one of their most secure homes by the music hall. In Preston, images of Queen Victoria's Silver Jubilee procession were presented at the Prince's Theatre (formerly the Gaiety Palace Theatre of Varieties) for one week commencing 19 July 1897. Also on the bill, which boasted the greatest and most expensive company ever seen in Preston, was 'The Great Apollo', who claimed to be the strongest man in the world, and the marvellous 'Steens', a magical act. At first cinema was thought of as a minor item within the musical hall repertory and billed as the Bioscope, but it was not long before this accommodation was seen as competition.

Cine-Variety and Will Onda

The developing cinema industry was to have serious implications for the music hall industry. As in most towns and cities, Preston's cinemas presented variety acts on stage, a form known as cine-variety.

By 1907, the Royal Hippodrome was utilising a Bioscope to blend the silent pictures with music hall acts. The Bioscope was billed in Lloyd's 1911 Hippodrome performance as featuring 'some excellent views of holiday nights and incidents at Blackpool, shown on the Bioscope'. Sophisticated cinematograph equipment was installed at the Royal Hippodrome to show the visit to the town of King George V and Queen Mary in 1913.[6] The music hall accommodated film in its programming but also suffered direct competition from the emerging cinema building, which undoubtedly resulted in a reduction of music hall and theatrical activity.

The Preston-born cinema impresario Will Onda (real name Hugh Rain) played a key role in cinema provision in the town. Hugh Rain was born and brought up in the Starkie Street area of Preston and educated at Eton. His parents intended that he should enter the ministry, but instead he embarked on a show-business career as a circus acrobat.

Will Onda became a renowned local film-maker and established the largest film rental business in the North West in Cinema House, Corporation Street, Preston. He was also a director of Preston North End Football Club and served on the town council from 1920, becoming an alderman in 1935. Will Onda was born at the birth of cinema and pioneered it throughout his life, and perhaps fittingly he died during the heyday of the cinema boom of the 1940s. Onda is credited with bringing one of the first Bioscopes over from France. He also established so-called penny gaffs in shops in the Ashton area, each of which lasted about one minute.

He opened Preston's first cinema on 22 June 1908 in Joseph Livesey's former temperance hall. Preston's dedicated temperance hall was first opened on 5 July 1856, and built on the site of a malt kiln. Hewitson (1882) described the interior as being very plain, with a platform at one end and a gallery at the other and capacity for about 800 people. This trend was in keeping with converting buildings such as theatres, churches and breweries into cinemas. The opening programme at the temperance hall stated, 'Matinee – Saturday at 1.45 p.m. and 3.30 p.m. Children 1*d*, 2*d*, 3p. Twice Nightly at 7 and 9; the family resort; the home of prize-animated pictures, Manager – Will Onda.' What did Will Onda have on offer to the public of Preston in 1908? Everything from *A Trip to Niagra* to *Gamble for a Woman* to *Saved from Cannibals* to name but a few of the curious titles.

The above titles were typical of the entertainment on offer when cinema programmes consisted of a series of cheaply made films in which the stars had little or no acting ability. Nevertheless, heroes and heroines of the silent screen became household names, including Tom Mix, Rudolph Valentino, the Keystone Cops and,

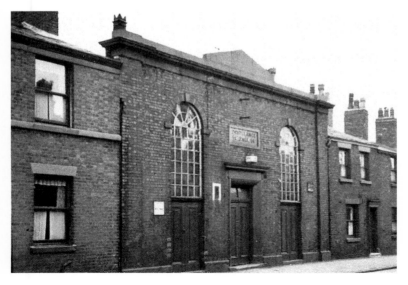

William Onda opened Preston's first cinema in the Temperance Hall in 1908. (Courtesy of Preston Digital Archive)

of course, that famous little man with the bowler hat and cane, jerkily moving along, the famous Charlie Chaplin. Then there were the weekly cliffhanger serials featuring Tarzan in trouble or Pauline strapped to a railway line in front of an oncoming train. Will she, won't she survive – wait and see! Gripping stuff. Silent images of Charlie Chaplin were projected at the Prince's Theatre in 1917 in *Charlie Behind the Screen*, but on a Saturday afternoon Will presented his 'Mammoth Boxing Entertainment'.

It transpired that three of Preston's theatres and music halls, namely the Theatre Royal, Prince's and Empire, eventually transferred their allegiance from safety curtain to the silver screen of cinema, which was by no means unprecedented. Cinema provision was first introduced at the Theatre Royal and the Prince's Theatre by Onda when he started to show the first silent films at these theatres in 1911 and 1913 respectively. He perceived that the future was in films and the Prince's became a full-time cinema around 1915. On 5 September 1913, the Prince's was advertising in the *Lancashire Daily Post* as: 'Will Onda's Pictures and Varieties: Special Notice, full matinee on Thursdays, pictures and turns, popular prices: circle 6*d*, balcony and stalls, 4*d*, pit 2*d*, children half price'.[7] The feature, 'Pictures and

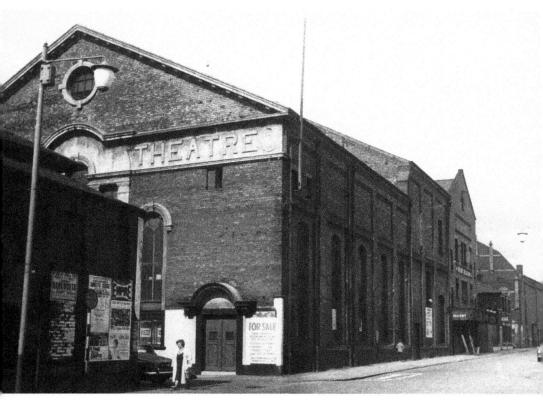

The Prince's Theatre, Tithebarn Street, was formerly known as The Gaiety. Beyond is the Regent Ballroom and King's Palace. The nucleus of Preston's theatre land was opposite the present bus station. (Courtesy of Preston Digital Archive)

Turns,' is a further example of cine-variety presented between films at hundreds of cinemas between 1908 and 1914.

Onda had similar cinema enterprises in Lancaster and Morecambe, managing the Lancaster Hippodrome and Morecambe Alhambra (the latter used for location shots in filming *The Entertainer*, starring Lawrence Olivier). The impresario presented a further threat to the variety theatre when, in accordance with social change and to meet the growing demand for dancing, he had the Regent Ballroom built next to the King's Palace in the 1920s.

Silent Movies and Memories of the Flea Pits

A succession of managers followed Onda's lead and cinemas expanded significantly. The Temperance Cinema was followed by the Alexandra Picture House in Walker Street and the equally primitive Imperial Cinema, Mill Bank, Church Street (almost opposite the prison). This was a former malthouse, opening as a cinema around 1910. *The Dangers of Ignorance* was probably an apt title for the film showing for men only in 1928, for it was billed as being about 'a serious social evil affecting the physical and mental health of the nation'. Fortunately, women were enlightened on separate nights! Another attraction was to be kept up to date with world news. Pathé newsreels were first launched in April 1908. The news lasted about twelve minutes and consisted of short films delivered from different parts of the world. The Imperial Cinema used the music hall terminology of 'twice nightly' for performances at seven and nine, though admission prices were probably more affordable to watch silent movies than music hall at 2*d*, 4*d* and 6*d*.

Will Onda acquired another former brewery for conversion to a cinema and named it the Picturedrome (later Palace Picturedrome). It had curtained boxes, a stage, circle, balcony and a roof resembling a Dutch barn. Local names for cinemas were not uncommon and the Picturedrome was also known as the 'Ranch House' because it specialised in showing westerns.

In the same newspaper advertising a live performance by Marie Lloyd at Preston Hippodrome in 1911, three cinemas were advertising silent films: 'The Pictureland' (Embee Hall), the 'Marathon Electric Theatre' and the 'Imperial Picture Palace', Church Street.

This period in the history of cinema is referred to as the silent era of film. However, to enhance the viewers' experience, silent films were commonly accompanied by live musicians and sometimes sound effects. The early flicks were photographed by hand-operated cameras and hence the characters moved with a definite twitch, shake or tremble, looking almost inebriated, while walking comically at an accelerated speed in constant rain. This latter illusion was caused by coarse-grained film, which projected vertical lines on the screen.

Preston's town-centre Palladium Cinema on Church Street (just a few yards from the established Empire Theatre, which opened in 1911) was built on the site of an old inn called 'The Glass Barrel'. It was the town's first purpose-built cinema, opening

This incongruous building was the former Picturedrome Cinema, Brackenbury Place. I recall going to this cinema only once and that was during Preston Guild 1952. After the cinema performance I went with my parents to watch the torchlit procession. (Author's collection)

The Embee cinema, Avenham Street, had its origins as a rented hall and survives to this day as a restaurant. (Courtesy of Preston Digital Archive)

its doors in 1915 with an incongruously titled film, *The Man Who Stayed at Home*. This was to be a catalyst for the sumptuous picture palaces of the 1940s and its impressive appearance in 1915 is indicative of Preston's prospering cinema industry, which blossomed even more with the advent of the talkies during the 1930s. During the days of the silent movies, most cinemas had a piano or other form of live musical accompaniment. The Palladium Cinema orchestra featured a cello, a couple of violins, trumpet, trombone, drums and maestro MD on the piano. Each Monday morning the silent film would arrive with the musical score. On each stand was a series of numbered lights and appropriate music would be played in accordance with the number being displayed. The Palladium was the first cinema in Preston to be allowed Sunday cinema. Following the heyday of the cinema industry throughout the 1930s to 1950s, the cinema was purchased by Preston Council in 1968 for £45,000 so that it could be demolished to make way for a service road. Today there is no trace of the building.

One of the earliest cinemas, Bennett's Electric Theatre on Cragg's Row, epitomised the community cinema. It was managed by a Mr Ike Bennett and was affectionately known as 'Fleckie Bennett's'. It later became the 'Dominion' and latterly the 'Rex', though disreputably it was locally named the 'Laugh and Scratch', or, even more despairingly, the 'flea pit'. In fact, the locals enraged the management with this song:

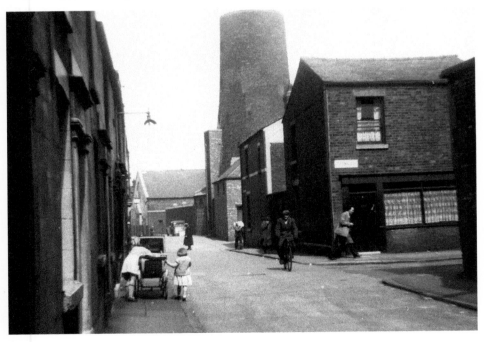

Fleckie Bennett's in Old Cragg's Row. The building in the far distance is Bennett's Electric Theatre, which started off as a chapel and followed the trend to cinema conversion. It was latterly known as the Rex Cinema before closure. Crown Street is turning off to the right and the tower of the old windmill has its origins in the mid-eighteenth century. (Courtesy of Preston Digital Archive)

Oh, ring down the curtain I can't sing tonight,
'cause those little creatures they scratch and they bite,
No more to the pictures will I ever go,
To Fleckie Bennett's in Dirty Cragg's Row

Close by, Fleckie Bennett's arch rival Alfred Wiles opened the 'Cosy Cinema' in a converted chapel in 1921. Most of the early cinemas had their own bouncer, who kept a tight watch on his audience for any malpractice. He would walk around the auditorium with a long stick and give the unruly a prod on the head or simply chuck them out. Albert Wile's second-in-command was a gentleman by the name of Elijah Waddilove, who was the principal 'chucker out and doorman'. Mr Waddilove's speciality act, however, was his own recipe for lemonade, which he sold in jam jars at one halfpenny for a 1 lb jar and one penny for a 2 lb jar. The deal for local children was one penny for an empty jam jar or free admission, and the highlight of the week was a talent show for the locals on a Saturday night. This *ad hoc* music hall presentation featured the textile workers dancing in their clogs, and/or attempting to sing, whistle or dance and the prize, naturally, was a bottle of Elijah's finest home-made lemonade. Clog dancing represents a link with a local tradition in the cotton mills, where a large workforce of women would start beating out a rhythm with their wooden clogs in time to the shuttles buzzing back and forth on the loom. Step-dancing or 'Lancashire Clog' became a favourite with mill workers in Preston and was performed extensively in music hall, representing a strong Northern culture and perhaps even solidarity and local pride during Preston's industrial revolution.

We are reminded of Preston Guild with the advent of silent movies and the pertinently named 'Guild Cinema', Geoffrey Street, which was opened for the 1922 Guild and remained a cinema until 1959. One of Preston's earliest cinemas, the 'Victory', later known as the 'Rialto', was situated on St George's Road adjacent to Longridge branch line. Although it boasted 'the latest ventilating system, clean and free from smoke', the passage of steam trains nevertheless shook the place whenever they passed by, with plenty belching smoke. The year 1921 hailed yet another cinema: this was the Grand in Marsh Lane, which later was renamed the Regal and finally the Lido Cinema. This was a cinema with a difference, where the air was blue with risqué Continental films. Things were getting a little bit hot, and following closure in 1959 the old cinema is today a car maintenance depot.

At the Ritz Cinema I recall the enormously wide auditorium without the usual balcony and the giant screen, over 40 feet wide, on which was projected the very first James Bond film, *Dr No*, which attracted an amazing 25,700 patrons during its two-week run; I was one of them. One had to queue for what seemed like hours along long corridors and into Church Street to see the main feature film, the supporting film, adverts, news and trailers, and in those days it could have all have been in vain if the 'house full' sign was brought out and exhibited in the foyer. However, times change, and with the demise of the town-centre cinema industry, bingo eventually replaced films on the ground floor and the foyer was adapted to club facilities. There was no more 'eyes down and 66, clickety click' after March 1956, and the building was converted to a

skating rink but this 'last stand' failed as well. The main cinema building has since been demolished, though the foyer area has been retained as a nightclub.

The old Queen's Cinema off New Hall Lane was later renamed 'The Continental Cinema' and exploited a similar niche market, with generic listings such as 'Paris Vice Patrols' and 'Dens of Evil' during the swinging (not to mention permissive) sixties. Naturally, it too had double seats for courting couples, where there was many an X-rated performance on the back row. Cinemas such as this without doubt featured in the mating habits of generations of Prestonians, surely an important aspect of our social history. Bridget Bardot's antics in dubiously titled films like *Shocking, Compelling and Raw* and a naturist film called *The Isle of Levant*, complete with nudes of all shapes and sizes depicted in glorious Technicolor, were very much a secondary consideration. We began by holding hands but, hey, who was really bothered about the exotic Isle of Levant with an erotic performance in the back row of the local flea pit in the offing? I speak from personal experience, though not necessarily of 'Twice Nightly' performances!

The out-of-town cinemas had their own singular appeal. The Savoy Cinema on Ashton Street served a popular working-class area of Preston where many would have worked in the mills. At the 'Savoy', pandemonium was frequent during the pregnant pauses between reels or when the projector broke down. The manager, Ernie, sorted out unruly kids with their bags of parched peas or overly amorous members of the audience. Social precedents for the day again demanded double seats for courting couples, and as I recall this cosy arrangement had a major part to play in blossoming romances, though usually interrupted by obsessive usherettes flashing their torches on the back rows.

The traditions upheld at these essentially proletarian venues contrasted with the art deco cinemas built for the talkies, but before that the cinema industry was to ruthlessly impact on Preston's – and indeed the whole country's – music halls and live theatres.

The Arrival of the Talkies

The Preston cinema revolution was revitalised with a second generation of super cinemas at the height of the prospering national cinema industry during the 1930s and 1940s. Britain awakened to the dawn of the talkies in 1927 following the arrival of the first talkie, *The Jazz Singer*, starring Al Jolson and his catchphrase 'you ain't heard nothing yet', which metaphorically summed up the biggest breakthrough for the cinema industry since Lumière. At the dawn of the talkie era in August 1929, the Palladium still boasted cine-variety, advertising 'sound silent attractions and good orchestral music always and on stage the Stan Wootton Trio and Albert Pryor, tenor vocalist'.

The Star Cinema pre-empted the evolution of the talkies in 1929 when it showed a short, experimental talkie supporting film and was named 'Preston's Talkie Theatre – the sound system supreme', featuring an unrivalled orchestra, complete with a live show consisting of a tenor, a comedian and a row of dancers – another classic example of cine-variety at this pioneering cinema where sound was about to revolutionise the cinema industry. Initially there were technical difficulties in

The Continental Cinema, Tunbridge Street, following closure in the early 1960s. (Courtesy of Preston Digital Archive)

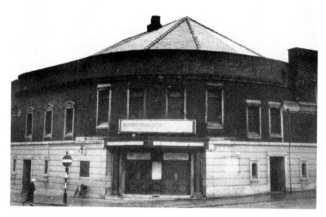

The 'Star Cinema', with capacity for 1,000, opened in 1921 at the corner of Corporation Street and Fylde Road, on a site now occupied by the Mitchell and Kenyon Cinema at the University of Central Lancashire. (Courtesy of Preston Digital Archive)

synchronising images with sound, though there was still enough interest in motion pictures for films to be produced without sound.

Typical of the second generation of cinemas in Preston built for the talkies was the New Victoria, which was opened by Provincial Cinematograph Theatres on 17 September 1928 with a fully equipped stage, dressing rooms and facilities for stage shows. Affectionately known as 'the New Vic' by Prestonians, it epitomised the art deco cinemas of the 1930s, of which there are so few left today. Its features included an impressive central dome in the auditorium, beautiful chandeliers, concealed lighting and seating capacity for over 2,000. Although built for the talkies, the first film at the cinema was silent, with musical accompaniment provided by an orchestra of twenty-two musicians. In the established tradition of cine-variety, it featured Charles Farrel in Harold Hawks's film *Fazil* and live variety acts.

Al Jolson's second talkie, *The Singing Fool*, was ultimately shown for the first time at 'The New Victoria' on 29 June 1929, though this man was no fool and the pioneering film was to gross $5 million – a lot of money in those days. The Preston publicity boasted of 'pictures that can talk like living people'. A matinee

and twice-nightly performances were announced at three, six, and nine o'clock, and the reels were duly loaded. Al Jolson, without undue modesty, called himself 'the greatest entertainer in the world' before singing from his repertoire of 'April Showers', 'Toot, toot, tootsie', 'Rosie' ... in fact, you name it, they were all great songs! The *Lancashire Daily Post* reported, 'The introduction of the talkies by the management of the New Victoria Cinema was a great success with long queues forming at the entrance to the theatre long before the performance was to begin.'

'The New Vic' was well known for its Wurlitzer organ, which emerged from the murky depths below the stage and was sometimes played by the renowned organist Reginald Dixon, later to become the celebrated organist at Blackpool Tower Ballroom of 'I Do Like to Be Beside the Seaside' fame. In April 1954 the cinema changed its name to the Gaumont, and a further change came when the cinema was reconstructed to accommodate the 'Top Rank' ballroom in the stalls. Reconstruction of the stage area meant that theatrical productions were no longer possible and the cinema was renamed the Odeon when it reopened in January 1963. However, the cinema closed completely twenty-nine years later in 1992.

To capitalise on the success of the talkies, the opening film at the Ritz Cinema on Church Street was George Formby's *Keep Fit*. The biggest heroes of the working classes in post-war Britain were Gracie Fields and George Formby, and both were enormously popular in theatre, film, radio and records. They were the embodiment

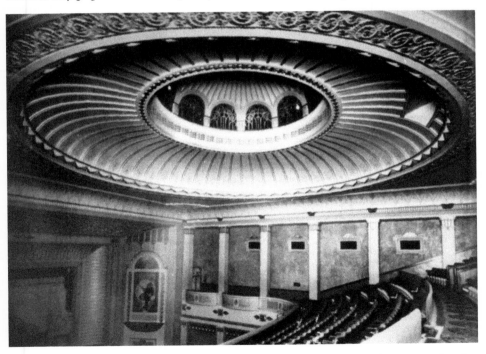

The auditorium of the New Victoria cinema, which opened in September 1938, showing the magnificent central dome. (Author's collection)

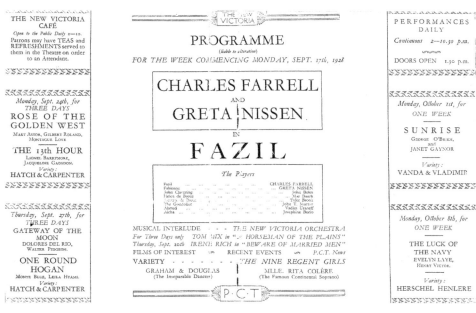

Programme for the opening of the New Victoria in September 1938, featuring a silent movie, *Fazil*. All the forthcoming productions advertised feature variety acts. (Author's collection)

of the native British popular culture during the 1930s. Both these artists continued the tradition of working the halls but they began to capitalise on their enormous popularity by starring in many films. 'Our Gracie' was an established music hall artist by the time of her first film, 1931's *Sally in our Alley*, and gained increased popularity through films between 1936 and 1940. Gracie, playing women of humble origin working at the mill, endeared herself to her audiences.

Iconic stars were now alternating between live performances and the new film media, with the popular theatre audience captured and overtaken by the expansion of the talkies. In 1933, George Formby's first film, *Boots, Boots, Boots*, paved the way for acceptance by a much wider audience beyond the North–South divide. George Formby was one of the highest-paid entertainers of the 1930s. His natural broad Lancashire accent and cheerful disposition symbolised the working classes. People could readily identify with his large number of risqué songs and came to regard him as a gormless yet loveable Lancashire everyman. George made twenty-one films between 1934 and 1946.

Thus a fruitful genre of British films began to appear featuring Lancashire comedians and actors who had made an impact in the music halls of Preston. Several established actors, including Leonard Rossiter, John Baron, Peggy Mount and Janet Munroe, learned their profession on the Preston repertory stage in the 1940s, long before becoming internationally famous.

The Empress, Eldon Street, was opened on 12 October 1929. Fitted with its Western Electric sound system, it was described as the 'atmospheric cinema'. The lovely frescoes

were said to be transformed with beautiful effect by an ingenious system of changing colours. The capacity of the Empress was 900 and the cinema also had a snack bar adjoining the main building. On Coronation Day, the Empress showed a continuous live performance of the Coronation. Like so many other cinemas and theatres, the Empress followed the national trend of closure during the 1960s with a phase as a bingo hall before it finally succumbed to television and changing tastes in youth culture.

Two more suburban community cinemas in the Ribbleton area capitalised on the talkie era during 1932. They were the Carleton Cinema, Blackpool Road, and the Plaza Cinema, New Hall Lane. The Carleton proclaimed itself to be 'the only cinema in Preston built for the talkies'. Inevitably, it too followed the national trend of closure as a cinema in 1961, reopening as a Bingo Hall in 1961.

Meanwhile, the Plaza Cinema started off as a cotton warehouse in the industrial heartland of Preston but was transformed into a super cinema with gilded walls of fibrous plaster and row after row of plush seats to accommodate around 900 cinemagoers at the peak of the industry. As late as 1964 it acquired the super-wide screen, a legacy of the Preston Empire, but following the closure of the Plaza it became known as the Plaza filling station.

Surprisingly, there must have been renewed confidence in the future of the cinema industry when the new ABC replaced the old Theatre Royal (by now a full-time cinema) as late as 1959. However, the building was short-lived and it too finally succumbed to the march of progress in 1984. The new cinema opened in March 1959 and Richard Todd performed the opening ceremony. Every ticket was sold within two hours of advance booking, at then-princely sums ranging from 1s 9d to 3s 6d.

The ABC Cinema, grand though it was, had mounted a brave attempt to resurrect the ailing industry that proved to be ephemeral and, reflecting the national pattern, every single one of Preston's traditional theatres, music halls and cinemas had lost the ultimate survival battle by 1992.

Fortunately, one cinema survives in the Preston area where old traditions die hard; traditions such as the singing of the national anthem, availability of hot drinks in mugs and even double seats for courting couples. The Palace Cinema in Longridge is one of the oldest cinemas in northern England and survives to this day as a unique community cinema. Significantly, the *Kinematograph Yearbook* from 1913–14 lists the Longridge cinema

The completed ABC Cinema opened on 14 March 1959. (Courtesy of Preston Digital Archive)

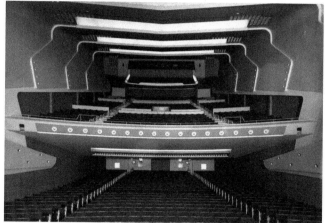

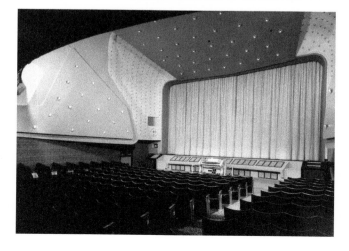

The foyer and auditorium of the contemporary ABC Cinema at the time of the opening in 1959. (Courtesy of Preston Digitial Archive)

as being owned by Will Onda's Prize Pictures! Thus the Palace Cinema yields yet another crucial link with the evolution of Victorian cinema and music hall in and around Preston.

During November 1912, the Palace presented cine-variety with 'cheerful Charlie Lyndon, the brilliant comedian and eccentric dancer and the palace perfection pictures'. A versatile lady called 'Bunny' was a master at tinkling the ivory and played the piano non-stop. At that time there was no electricity installed and the building was operated by a gas engine. Public order was maintained by a burly quarryman who was the chief chucker-outer.

Originally, the building was constructed in the 1860s as a weaving shed. It was successively converted into a music hall, cinema, roller-skating rink and bingo hall before returning to its present use as a cinema and theatre. Purchased by its present owners in 1976, extensive renovations and extensions to the premises were carried out from 1997 to 2000 to upgrade the existing washrooms (including the installation of facilities for disabled patrons), together with the creation of dressing rooms for use during live shows. It is gratifying that this bold venture and unique institution has been so successful and now regularly plays to packed houses and deservedly so.

Conclusion and the Preston Model Contrasted with Other Towns

In Preston, the cinema industry reached its peak in the late 1930 and early 1940s with up to eighteen silver screens, traditionally housed in a plethora of interesting venues and representing two generations of the cinema industry: the silent movies and the talkies. Cinema was also popular on the outskirts of the town and served the local community: Bamber Bridge, Leyland, Longridge and Penwortham each had their own community cinema. In other north-west towns, Blackpool had eighteen, Lancaster seven, Morecambe eight, Chorley five, Lytham St Annes three, Kendal three and Garstang had only one.

The cinema played its part in presenting images of the monarchy to the population at large. At the Coronation of Queen Elizabeth II in June 1953, television cameras were allowed inside Westminster Abbey for the first time. Approximately 20 million people watched the Coronation on television and 1,555,000 watched it at the cinema or in other public places, which were equipped with television screens. In 1953 only the cinema could provide colour, and the film *A Queen Is Crowned* was made by the Rank Organisation with a commentary by Sir Laurence Olivier. It was rated top box-office attraction in 1953 by the British trade paper *Kinematograph Weekly*. The box-office runners up that year were Bob Hope and Bing Crosby in *Road to Bali* (1952), the British war film *The Cruel Sea* (1953) and the British comedy *Genevieve* (1953).

In June 1953, Preston still had sixteen cinemas and two live theatres, presenting an eclectic mix of films featuring legendary Hollywood film stars. For example,

the Empire, Church Street: Special Coronation Attraction and Ivor Novello's *The Dancing Years* starring Dennis Price; Palladium, Church Street: *The Snows of Kilimanjaro* starring Gregory Peck and Ava Gardner; Ritz, Church Street: *Sudden Fear* starring Joan Crawford; Gaumont (formerly New Victoria), Church Street: *The I Don't Care Girl*, starring Mitzi Gaynor; Theatre Royal, Fishergate: *The Bad and the Beautiful*, starring Lana Turner and Kirk Douglas; and the Prince's Theatre (formerly the Gaiety Palace Theatre), Tithebarn Street: *The Blazing Forest* starring John Payne. One out-of-town cinema, the Empress, Eldon Street, featured the complete 'Coronation Television Show', which lasted from 10 a.m. to 5.30 p.m., and in the evening it was *Has Anybody Seen My Girl*, starring Rock Hudson and Charles Coburn.

Meanwhile at Preston's two surviving live theatres it was Reginald Salberg's Preston Repertory Company in *Devonshire Cream* at the Royal Hippodrome, Friargate, and Billy Rhodes and Chika Lane were heading a typical variety bill of fare at the King's Palace, Tithebarn Street.

One by one, the remaining sixteen cinemas that were extant in 1953 closed their doors for the last time. In 1992, the Odeon Cinema, Church Street (formerly the New Victoria and Gaumont), was the last of the traditional old cinemas to close in Preston before the revitalisation and new beginning of the multiplex cinemas.

While drawing comparisons with other Lancashire towns, Preston acts as a template for the expansion of the cinema and music hall industry throughout England. Notwithstanding local characteristics, it can usefully be compared with the East Lancashire towns of Burnley and Blackburn. The first programme of pictures ever screened in Burnley was in 1896 at the Empire Theatre of Varieties.[8] At Burnley, the temperance hall was opened as a cinema in 1906. The first moving pictures in Burnley were shown in 1908 at the Andrews' Picture House.[9] Preston's temperance hall was also converted as Preston's first cinema in 1908. Reflecting the age of sobriety, it too continued to be called the temperance hall and had accommodation for 800 patrons.

The first film to be shown in a Blackburn music hall was at the Lyceum in 1896, being billed as a 'theatregraph' portraying a man getting soaked while watering his garden. Drawing a close parallel with Preston, two Blackburn theatres – the Palace and the Theatre Royal – were showing short films during the interval during the first decade of the twentieth century, and both of these theatres were later to become full-time cinemas prior to closure in the 1960s. Blackburn is significant in the history of cinema in having one of the earliest purpose-built cinemas in the country, opening in 1907. While pounding the beat in the 1960s, I well remember the Alexandra Cinema on Dock Street with the rear elevation of the tiny cinema backing onto the Leeds–Liverpool Canal. Sadly, it has now been demolished.

Blackburn's place in the history of cinema was further demonstrated in the 1990s when Peter Worden made an important discovery in a Blackburn shop on Northgate which was about to be demolished. It was a treasure chest of exceptionally early reels of film of significant social history interest depicting Northern life at the turn of the twentieth century – a holy grail of the history of cinema and now safely

archived at the British Film Institute. The films were shot by the pioneering film-makers Mitchell and Kenyon, who began in 1897 under the trade name of Norden, operating from premises at 40 Northgate, Blackburn. The first film was of Blackburn market around 1897. In 1899 George Green commissioned them to film workers leaving factories, and by 1902 they were filming the traditional egg-rolling event in Avenham Park, Preston. OHMY's circus integrated one of the first cinematograph performances in Preston during February 1901 when it used Gascoigne's Bioscope to project the queen's funeral procession. The sombre occasion did not, however, preclude a full live supporting programme of acrobats, gymnasts and jugglers.

Between 1909 and 1913, no fewer than thirteen picture halls opened in Burnley. Preston and suburbia had between twelve and thirteen cinemas and theatres fulfilling the cinema role during the same period. In both towns, few were purpose-built cinemas.[10] In the First World War, cinemas in Burnley did quite good business and none failed as a result of the war. Many cinemas had their own character and idiosyncrasies. At one Burnley cinema it was half-price to see the film in reverse. Between 1912 and 1927 at the Pavilion Picture Hall the screen was placed in the middle of the hall, and it was tuppence to see the pictures the right way round and a penny to see them wrong way, on the back of the screen.[11]

A second generation of purpose-built cinemas, including the 1929 art deco New Victoria, Preston, were constructed for the talkies. Others were converted from music halls, such as the Preston Empire. At Burnley, the equivalent Empire Music Hall opened as a theatre and music hall in 1894 and had capacity for 2,500. It was rebuilt in 1911, at the time the Preston Empire opened, and like the Preston theatre continued as a theatre until 1930. It became obvious that theatres could not compete against cinemas, whose audiences were growing all the time. The Empire was converted into a cinema and so it remained until closure in 1970, when cinemas were no longer viable propositions.[12] The last show at the Victoria Theatre, Burnley, was an amateur production of *No No Nanette* in 1964.[13] On 10 January 1931, the Palace Hippodrome, Burnley, closed as a theatre. It reopened as a cinema less than a week later, but like the Preston Palace reverted back to live theatre in January 1938. It closed as a theatre in 1956, having sustained bouts of both cinema and theatre, and later turned to bingo. It was demolished in 1973.[14]

In both Preston and Burnley, cinema and music hall theatre eventually succumbed to the innovation of television and changing social trends, exemplified by the popularity of bingo. However, with the country-wide opening of multiplex cinemas the industry is currently enjoying a renaissance; indeed, this is a further example of the change upon change that has been the story of the history of Preston's entertainment industry.

By Sedan Chair to Preston's Victorian Theatre Royal

Preston's first legitimate theatre, the Theatre Royal, on Fishergate, had an illustrious history and opened to coincide with September celebrations for the 1802 Preston Guild. Before the opening of the Town Hall in 1861 and the Public Hall in 1882, it also fulfilled the role of a multi-purpose or civic hall.

A body of shareholders built the theatre and had the right of free admission by transferable silver tickets. The theatre remained in the possession of the shareholders until 1869, when William Parkinson of Scorton, a well-known operatic singer from Garstang, purchased it.

The Theatre Royal was geared to attract the nobility and gentry, with appropriately high admission prices being charged for Preston's wealthiest citizens,

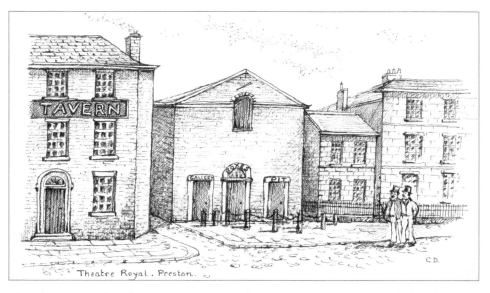

The Theatre Royal, Fishergate (1802–1955), has an illustrious history and played host to several 'scene changes' to its exterior facade, beginning with this structure with separate entrances to the gallery, boxes and pit. (Courtesy of Christine Dodding)

who made their homes in Winckley Square, close to the theatre. Picture the scene on Fishergate during more genteel times at the beginning of the nineteenth century, when the more affluent could afford sedan chairs, first introduced during the Preston Guild of 1662. During the mid-eighteenth century, there was little manufacture and the town comprised an eclectic mix of the aristocracy, professionals, military personnel, burgesses and market traders and long before the cotton magnates of the Industrial Revolution. Hewitson quotes historian Ray when describing the town in 1758: 'Preston is one of the prettiest retirements in England, the resort of beautiful and agreeable ladies and a large number of gentry, which was unexcelled for the politeness of its inhabitants, and vulgarly called Proud Preston on account of its being a place of the best fashion.' The aristocratic upper and middle classes resided in the town's principal streets – Fishergate, Friargate and Church Street. At the beginning of the Industrial Revolution, around 1770, these residences were taken over by small shopkeepers and the attorneys, bankers and gentlemen of the town moved out to Avenham and the fashionable Winckley Square and Fishergate Hill areas, close to the working-class communities. The Preston Guild of 1802 witnessed the rise of free trade and an altogether festival atmosphere which superseded the less formal proceedings of the past when the burgesses had held the monopoly of the town's trade.

In the town centre, the sedan chairs were a convenient means of conveyance. One person was carried in a compartment by two men. The more affluent rode in them to church on Sundays and were carried to the balls and private parties and sedately travelled hither and thither around the town carrying out their business or perhaps visiting Preston's Theatre Royal. In 1785–91, the political differences which divided Preston even extended to the sedan chairs. The coats of the chairmen had collars of the colour of one or other of the two main political parties. Correspondingly, the lady passengers of the town in particular demonstrated their preference for the choice of sedan in accordance with the ribbons they chose to wear. The last passenger ride in a sedan chair was made around 1850, twelve years after the first railway arrived in Preston.

Two men were replaced by horses when sedan chairs were superseded on the streets of Preston by the Hansom cab. It was a certain Joseph Aloysius Hansom who designed the horse-drawn carriage and, perhaps surprisingly, Preston's impressive St Walburge's church, thus establishing his connection with the town. A letter published in the *Preston Guardian* on 24 August 1869 proclaimed the arrival of the first cab, also known as a bath carriage: 'J. Croft respectfully informs the ladies and gentlemen of Preston that he has introduced into the town, one of those fashionable vehicles, a bath carriage, and begs to solicit the patronage of the public. The carriage may be had at a moment's notice by applying at the Legs of Man opposite the Town Hall.' It is likely that Charles Dickens, who gave readings at the Theatre Royal in 1861, welcomed the hansom cab as a means of conveyance.

It now seems almost beyond belief that on the site of the modern HSBC Bank in Preston's Fishergate, great exponents of culture, including such names as Franz Liszt and Niccolò Paganini, had delighted audiences during the first half of the

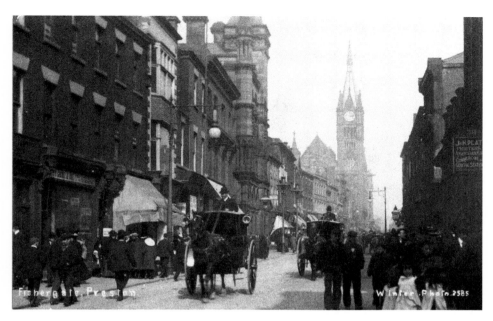

Above: Fishergate, Preston, featuring two Hansom cabs, period shops and Gilbert Scott's magnificent Town Hall around 1900. (Courtesy of Preston Digital Archive)

nineteenth century. 'Signor Paganini is mentioned in Whittle's *History of Preston* as giving a great performance in the Theatre Royal on 27 August 1833; performing before the nobility and gentry and inhabitants of Preston previous to his departure to the Court of St. Petersburg.' Admission prices targeted the aristocracy, ranging from box prices of 7/6d to pit 5/- and gallery 3/-, and drew a large audience according to the *Preston Chronicle*:

> The wonderful violinist gave his promised concert at the theatre on Tuesday evening last, to a crowded and fashionable audience who testified their admiration of his extraordinary musical powers by loud and enthusiastic plaudits at every pause in his performance ... On one or two occasions during the evening, the signor appeared to have succeeded in some new and brilliant extempore passage, and expressed his own satisfaction by smiles approaching to laughter, amidst the simultaneous, deafening, and repeated cheers of the house.

During the reign of William IV, in all probability the maestro would have arrived at the stage door of the theatre by a combination of stagecoach and sedan chair.

The great Hungarian-born composer and performer Franz Liszt travelled extensively in Europe and he also graced the stage of Preston's Theatre Royal on Wednesday 2 December 1840. Implausibly, the concert was given a mediocre review on 5 December 1840: 'Notwithstanding the immense merit of M. Liszt and despite his European reputation he had so readily acquired the Preston Concert was by no

means worthy of the musical reputation of Preston or commensurate with his high deserts.' In all probability the maestro would have arrived by train at Preston railway station, though at the very beginning of the railway era the method of transport might well have been a combination of train and stagecoach followed by a ride in a sedan chair to the theatre. This takes account of the fact that the Preston concert was part of a north-west tour embracing five north-western venues in Halifax, Liverpool, Manchester, Rochdale and, of course, Preston. We note a sprinkling of the fashionable and respectable or perhaps more specifically provincial gentry, many of whom would also have travelled to the theatre by sedan chair.

Pantomime enjoyed wider public appeal and featured at the Theatre Royal during December 1825, with 'the grand eastern dramatic spectacle of *Aladdin or the Wonderful Lamp*'. Joseph Grimaldi is credited with establishing pantomime as a British entertainment at Covent Garden in 1806. Perhaps because of its rich historical past, pantomime is packed with traditions and superstitions handed down from generation to generation and was certainly an influence in the music hall, with integrated song and comedy acts forming the basis of the music hall repertoire.

The Theatre Royal had an important role to play in pantomime as well as circus development, with the theatre integrating comedy and circus entertainment as comic intervals in dramatic performances. During 1829, a performance at the theatre presented a comic-inspired circus interval between two plays, the act featuring two men, Jocko and Jacko, masquerading as monkeys around the gallery and upper boxes before carrying out a daring circus escapade from gallery to stage. This is an example of the kind of act that was later incorporated into music hall programmes and perhaps illustrates how an audience was being drawn towards the culture of music hall, albeit, in this instance, in the established theatre. Such was the popularity of circuses that many nineteenth-century theatres also presented circus acts and you were as likely to see jugglers and aerial acts on a trip to the music hall as at a circus. Trapeze wires were strung from the roof of the Theatre Royal and the famous high-wire artist Blondin performed above the crowds sitting in the stalls.

At the peak of the growth of the pub concert hall in Preston during the 1860s, the response by management at the Theatre Royal was to adapt the programme and bill it in March 1866 as the Theatre Royal Grand Music Hall. A capacity audience enjoyed comic vocalist 'James Taylor, the Court Minstrels, and Dusoni Star Acrobats' and supporting cast.[15] It staged music hall again for three months commencing on 18 March 1867, and was billed as 'a grand amalgamation of star concert hall artists selected with the greatest care from the principal London Music Halls'. There was a further music hall season commencing 5 September 1868. Prices were designed to attract a working-class pit or gallery audience at 3*d* and 6*d* respectively.[16] There is, therefore, evidence that the theatre had begun to feel the effects of the concert rooms and singing saloons in enticing their working-class audiences.

The theatre staged similarly generic music hall performances to the established pub music halls for three consecutive seasons between 1866 and 1868. In this respect, Reid's findings on the legitimate theatre in Birmingham draw a similar parallel. 'The legitimate theatre offering Shakespeare and melodrama as well as

music hall was popular with the working classes and the pit and gallery segregated audiences, although it would be probably be an overconfident assumption to conclude that higher-priced tickets always attracted the upper classes.'[16]

Successive management changes brought several major phases of reconstruction to the building. According to *The Era Almanack*, the management was C. H. Duval in 1875, W. Morgan in 1877, E. Anderson in 1880 and T. Ramsay in 1882. In 1869 the theatre was given a Regency-style facade and altered interior by Preston architect James Hibbert, who is well known for his magnificent Harris Museum and Art Gallery of 1893. *The Era* for 21 July 1878 refers to the Preston theatre as being The Theatre Royal and Opera House, and indeed opera became part of the range of cultural entertainment offered to the public of Preston.

The effect of the railways on popular entertainment meant greater mobility, not only for the public but also for the London-based touring companies and their actor-managers. Productions were now able to penetrate the provinces and visit the Theatre Royal, which had started out with a resident stock company but was, by mid-century, establishing itself as a touring house. Henry Irving toured the provinces as an actor-manager with his company and visited Preston during September 1878, the events being duly reported in the *Preston Guardian*: 'Special representation of Mr Henry Irving to appear in his great representation of Hamlet, imported by the Lyceum Company, side boxes 8/-.' A review extolled the Preston performance in the national trade paper *The Era* on 13 October 1878. 'Henry Irving and the Lyceum Theatre Company presented *Hamlet* on the first night and *The Bells* on the second night. Irving was received in a most enthusiastic manner by crowded houses and fully retained his reputation. Called before the curtain after the last act, he was cheered to the echo.' *The Bells*, featuring Henry Irving, had rescued the ailing but now fully restored Lyceum Theatre in London for future generations. Henry Irving was to become the first theatrical knight and there can be little doubt that the appearance of Sir Henry Irving was a major attraction in Preston.

In 1898, the Theatre Royal underwent another facelift, which included renovations to the three upper tiers, giving a total capacity for 1,700, viz.: stalls, 100; boxes, 300; pit, 600; gallery, 700. The stage measured in depth 40 feet, width 50 feet, height to fly rail 20 feet 6 inches, to grid 42 feet 6 inches, and 27 feet to the proscenium arch. It reopened on 9 November 1898 and continued as a live theatre presenting mainly drama and revue. In November 1928 the theatre was adapted for sound pictures and no entertainers ever graced the stage again – except on the silver screen.

The provision of live entertainment in Preston at the end of the Victorian era was suitably described by Pye in 1945, with particular reference to the Theatre Royal, long before the present legislation governing health and safety regulations: 'The memories of exciting entertainment as for instance the plays and pantomimes at the Theatre Royal, with the uncontrolled crush at the pit and gallery doors, in the days before the queue-system had been invented.'[17] Further evidence of the popularity of the Theatre Royal during its Victorian heyday, but as for the 'good old days of Preston', I rather doubt it!

The 1898 plan of the
Theatre Royal. (Courtesy
of Lancashire Archive)

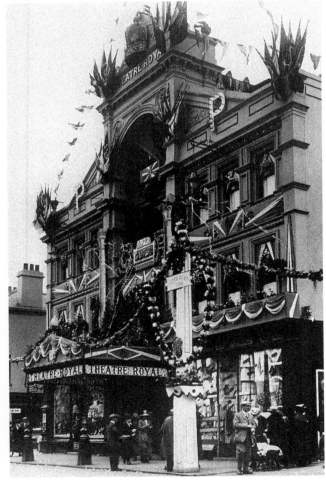

The impressive facade of
the Theatre Royal, suitably
adorned for Preston Guild
1922. (Courtesy of Preston
Digital Archive)

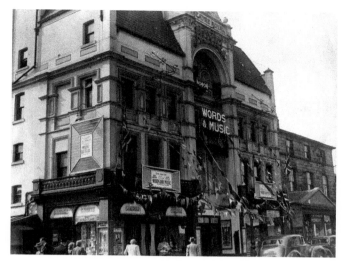

A scene change to the facade of the The Theatre Royal Cinema in 1949, where in 1956 I attended a cinema performance and saw *Reach for the Sky* from that steepest of rakes in 'the gods' with no parachute! (Courtesy of Preston Digital Archive)

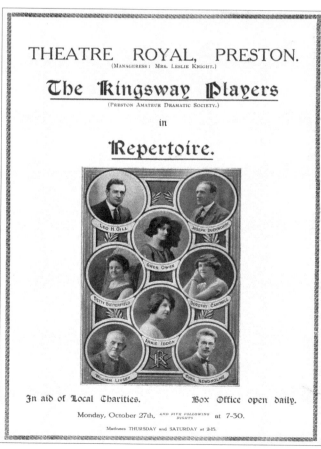

This rare Theatre Royal programme, dated 27 October 1924, features repertoire presented by the Kingsway Players. In 1928 the theatre became a full-time cinema until closure in 1955. (Author's collection)

The Travelling Menageries and Circuses

Throughout the nineteenth century, travelling menageries and circuses journeyed extensively throughout the country, visiting many towns and cities including Preston. Showmen like George Wombwell delighted hundreds of communities everywhere they went with both common and exotic animals. Most people would never have the opportunity to see such animals and the shows were always informative, enjoyable and enlightening. In 1872, Wombwell's travelling menagerie was described as 'having done more to familiarise the minds of the masses of our people with the denizens of the forest than all the books of natural history ever printed during its wandering existence'. George Wombwell's colourful animal show totalled fifteen wagons and was the largest in the country.

Travelling Circuses and Menageries Visiting Preston, 1824–1840

Venue and Date	Entertainment Style	Admission Price	Typical Elements of Performance
Preston Market, March 1824	Atkin's Menagerie and travelling fair	Admittance ladies and gentlemen 1s, servants, children 6d. feeding time half past nine, 2s	Performing male lion and the beautiful Bengal tigress in the same cage.
Chadwick's Orchard, May 1834 (Preston Market)	Circus and travelling fair	Not advertised.	Closing with the *Siege of Janina*, a pantomime.
Grimshaw Street, December 1834	Ryan's Equestrian Temple Travelling Circus	Admission charges front boxes 2/6d, second boxes 1/6d, pit 1/-, gallery 6d.	
Preston Guild 1842	Pablo Fanque's Travelling Circus	Front boxes, 2/-, side boxes 1/-, pit 6d, gallery 3d.	Featuring the fairy ponies, Albert and Nelson and 'first female equestrians in the world'

On 27 March 1824, Atkin's Royal Menagerie came to Preston Market Place. The *Preston Chronicle* reported,

> There were extraordinary scenes of affection for the performing male lion and the beautiful Bengal tigress in the same cage. The noble lioness has again whelped two cubs – the cubs, which are now living in perfect health, are so tame and inoffensive that they may be handled and caressed with the same ease and safety as a lap dog. And as for that truly singular and most wonderful animal, the Aurochos, – words can only convey the two long horns growing from its forehead in a form peculiar to no other animal. See a pair of those extraordinary rare birds, the pelicans of the wilderness – the only two in the United Kingdoms.

To see these extraordinary animals and events, the public were charged the following prices: ladies and gentlemen 1s, servants and children 6d. To witness the feeding time of the animals at 9.30 a.m. the charge was increased to 2s.

The travelling menageries continued to visit Preston throughout the whole of the Victorian era. During December 1889, E. H. Bostock's Grand Star Menagerie visited Leyland, Preston and Chorley. Furthermore, 'Captain T. B. Cordono, the Great American Hunter, will be present'. Admission prices were graded from 1s before 6 p.m. and 6d thereafter with extra charges at feeding time.

One of the factors that made circus so popular was that fairground entertainers travelled to their audiences. The earliest circuses usually comprised an equestrian clown, a tightrope walker, and two or three horses, which hauled the wagons when the circus was on the move. In addition, certain travelling circuses and menageries visiting Preston featured spectacular pageants and pantomime. In May 1834, *The Siege of Janina*, with an animated representation of the Storming of the Citadel by Armed Warriors, was presented at the Pavilion, Chadwick's Orchard. Also featured was the grand spectacle *Mazeppa, or the Wild Horse of Tartary*. During the Preston Guild of August 1842, Pablo Fanque's Circus Royal visited Preston. Mr Pablo Fanque appeared along with 'a superior company of male and female equestrians and rope dancers, trampoline leaps, extraordinary and diminutive fairy ponies'. Pablo Fanque's Circus returned to Preston to play Chadwick's Orchard in February 1868.

Tenuous links between music hall and travelling fairs and circuses were now becoming established. Circus acts often featured in music hall billing and vice versa. In Preston, this concept extended to the pleasure gardens. During the second half of the nineteenth century, the development of the railways enabled circuses to travel extensively with trainloads of equipment. Wooden circus buildings were erected on both sides of Preston railway station, thereby facilitating the movements of animals and sets as well as international performers and their audiences. Newsome's Circus was constructed east of the station in Butler Street in 1872. Advertising propaganda proclaimed, 'A new and elegant building has been erected by the railway station.

The company is a brilliant one and includes several accomplished daughters of Mr Newsome.'[18]

On 3 July 1872, railway passengers, including those from outlying villages, were encouraged to enjoy the thrills of the big top by the *Preston Guardian*: 'Newsome's Grand Circus – adjoining the railway station, Butler Street, Preston, immense success of last night's *Cinderella* – notice to the inhabitants of Longridge, Goosnargh, Fulwood and neighbourhood, a special train will leave Preston tomorrow, Thursday evening at a quarter to eleven, for the accommodation of parties from that locality visiting the circus.'

Newsome remained at this site until October 1880, when the original building was adapted by Henry Hemfrey, a local comedian and impresario. Hemfrey transformed Newsome's wooden circus pavilion for theatrical use and named it 'The Gaiety Temperance Theatre of Varieties'. *The Era* documented the proceedings and style of performance:

> The wooden structure recently vacated by Mr Newsome has been fitted up as a theatre and is at present occupied by a concert hall party under the guidance of Mr Hemfrey. A large audience has assembled. The building has undergone a wonderful metamorphism and for comfort, elegance and convenience could not be improved. The artists at present engaged are: Mr Tom Callaghan, comic and dancer; Mon Descombes – globe performer and juggler; Madam Laura – invisible wire equilibrist; Miss Julia Bullen – serio comic; Sisters Coulson – duettists and dancers, acrobats and contortionists; Jolly Little Lewis and Messrs Clifford and Franks.

Significantly about this time, the same circus artists were appearing at both music hall and pleasure garden.

The original Gaiety Temperance Theatre Music Hall staged both circus and music hall. We have seen that it was a direct descendant of the Newsome's Circus building of 1872, and conveniently built next to Preston railway station.[19] The theatre was subject to period reviews during 1880/81: 'This place of amusement continues to draw lovers of Concert Hall talent and promises to be popular during the winter evenings. Great houses attracted during the holidays. Henry Hemfrey gave a dinner in the theatre on Christmas Day to 100 poor people of the town followed by short entertainment.'[20]

Interestingly, Blackpool's Grand Theatre was built on the site of OHMY's old wooden pavilion circus building at Blackpool in 1884, mirroring what happened in Preston. Poole shows that another Lancashire town regularly had circus alongside music hall: 'Wooden pavilions were commonly used in the period in Bolton by travelling circuses and this highlights the close connection with circus and theatre including the established theatre.'[21]

The *Preston Chronicle* of 4 March 1893 describes the original topography of Butler Street and the location of Newsome's circus before the North Union railway station was developed in 1880. 'Butler Street then had a continuous line of houses on the right as far as the old Lancashire & Yorkshire railway station, on the left of the street the site of the present Railway Hotel was part of a considerable area

of waste ground (now the Fishergate Centre) on which were sometimes pitched Newsome's circus and other peripatetic expediencies for amusement.'

Newsome's Circus presented a show during the Preston Guild of September 1882:

> Long before the performance was advertised to commence the doors of the building were besieged by crowds of people eager to obtain admission. Mr Newsome introduced two trained ponies, Hartley and Thorncroft, and following this was the Lancers quadrilles, performed on horseback by four ladies and four gentlemen in full military costume. Mons Louis, a French artist, engaged especially for the Guild week, showed a marvellous performance on flying rings, and Emmeline Loyal, an artist also newly engaged, won loud applause in an equestrian act, jumping over banners and through balloon in a most accomplished style. Mons. Sessene appeared in a bare backed act of horsemanship, 'The French Jockey', in the course of which he accomplished the feat of leaping from the centre of the arena to a standing position on a horse's back. The programme concluded with two comic mules, 'Punch and Judy', which, by their eccentric behaviour, created roars of laughter.[22]

Newsome's Circus was also a major attraction at the Pleasure Gardens in June 1889, again illustrating the popularity of circus performers throughout the nineteenth century with all social groups.

OHMY's Grand New Circus came to town in March 1884, visiting a new building on the west side of the railway station in Pitt Street that was to be displaced by the building of County Hall by the turn of the century. The spectacular 1884 opening night next to the railway station was duly advertised as 'one of the best companies now in England'. It consisted of no less than twenty-six traditional circus acts including performing horses, ponies, mules, donkeys, goats, dogs, monkeys, pigeons and the smallest pony in the world. Foreign and British artists included Madam Cooke, from Barnum's Circus, Mons. Syllvester, 'the great somersault rider', Miss Louisa, 'the great French rider', and seven clown acts, including 'the people's jester'.

The name OHMY was derived from its proprietor Joseph Smith, who, as a circus bungee jumper, was in the habit of shouting 'ohmye', and this led to the naming of his travelling circus. The 1901 Census shows circus artist Joseph Smith, 46 yrs, residing at 5, Fox Street, Preston, with his wife and four children. Mr Smith's new circus building was reported upon in the March edition of the *Preston Guardian*:

> The beautiful new building, the best ever erected in Preston, has been constructed from designs of Mr OHMY, splendidly decorated, comfortably seated, carpeted and well lit-up with gas. The circus is arranged with the same style as the grand Paris Circus with beautiful boxes, cosy pit, extensive promenade and smoking lounge, and one of the most comfortable galleries in England. Open every evening, Saturday at 2.30 p.m. stalls 3/-, box 2/-, pit 1/-, promenades 6d, gallery 3d. Season ticket one guinea, children under ten and public after 9 o'clock – half price – except gallery.[23]

OHMY's circus also visited the Preston Pleasure Gardens during March 1884.

In November 1889, Quaglieni and Allen's Grand Circus, Corporation Street, had capacity audiences despite relatively high admission prices of 3s, 2s, 1s, 6d and 3d. Over a one-month period it was claimed that the circus attracted 37,000 people, and such was the popularity that in December it was presenting an equestrian version of *Cinderella*.[24] Such was the immense popularity of the circus in 1889 that it probably impacted on the music hall and illustrates the demand for live entertainment. The first Gaiety Theatre in Butler Street and its successor in Tithebarn Street were linked to the circus both in terms of origin and style of performance.

On 30 January 1905, only two weeks after it opened, the Royal Hippodrome Theatre was staging 'Woolford's Stage Circus', which suggests an attempt to draw upon an audience that had been accustomed to circus throughout the previous century. In 1945, Harry Pye documented his recollections of late Victorian circuses that visited Preston:

> The memories of exciting entertainment, as for instance OHMY's big wooden circus building at the Fishergate end of Pitt Street and all for a penny for children on a Saturday afternoon. Then later on, Buffalo Bill's gigantic Wild West show, housed in immense and numerous canvas erections on the Holme (Penwortham). Later again in time, the enterprising Barnum and Bailey combinations on the same site.[25]

Most of the Preston theatres and travelling circuses held a promotional circus procession of acrobats, jugglers and strongmen as well as dogs, monkeys and even elephants. Travelling circuses continued during the twentieth century, with Chipperfield's, Bertram Mills and Billy Smart's and Hoffman's circuses erecting their big tops on Moor Park, but, with the demise of animal acts, the travelling circus, like the music halls and local flea pits, is now largely consigned to history.

The Circus Parade comes to town, featuring Hoffman's Circus, here seen in leaving Preston railway station and forming a processional route along Fishergate. (Courtesy of Pete Vickers)

10

Variety Theatre or Music Hall?

The *Oxford English Dictionary* defines music hall as a 'hall used for musical performances; a hall licensed for singing, dancing and other entertainments exclusive of dramatic performances'. Quite apart from this definition, the term can equally apply to a performance style and the early variety theatres of the late nineteenth century. Variety can be defined as a series of attractions or 'turns' unconnected by any theme. In Great Britain it was originally known as music hall, though the two terms are often used interchangeably.

Russell's definition of music hall covers three key aspects in consideration of the term music hall. He defines the term 'music hall' as being used in at least three separate ways: 'To describe a certain performance style, an entire section of the entertainment industry or an individual building … It was essentially from the singing saloons that music hall emerged … For this reason no accurate count of halls can be made' – a problem which is applicable to Preston. 'Singing saloons and prototype music halls also went under the names concert room, concert hall and by the 1860s the term music hall appears to have won the day.' He considers that the growth of music hall is 'one of the most striking features of nineteenth-century history'.[26]

In the variety theatres the sale and consumption of alcohol was supplied in separate bars away from the auditorium and was ancillary to the entertainment, whereas in the music halls that existed in Preston during the Victorian era the entertainment was ancillary to the drink in an auditorium, hosted by the chairman, who announced the acts in his own inimitable style.

The Birth of Preston's Victorian Music Halls

At the time of the Theatres Act 1843, the market for commercial entertainment was already being exploited by publicans in pubs and beer houses, with a gradual adoption of music hall acts derived from diverse sources. Tavern entertainment in the mid-1830s gradually evolved into the first singing saloons of the 1840/50s and then to the more elaborate and commercialised George Music Hall of 1864. In 1852 there were said to be 'public houses in every part of Preston and its vicinity and nearly in

every nook and corner'.[27] This is not just an indication of the number of places serving alcohol, some of which were embryonic music halls; it also shows that workers had money they were ready to spend in the pubs and on entertainment. The movement against music hall and the associated drinks trade was strengthened because of the local influence of Joseph Livesey, the founder of the Preston Temperance Society. The advocates of temperance led the attack because of the close association between music halls and alcohol consumption, and temperance reformers used moral arguments in support of their campaign against music hall, promoting alternative attractions.

Livesey and six others introduced teetotalism to the movement through their innovation of the total abstinence pledge at Preston's first temperance hall on 1 September 1832. Livesey observed that much of the squalor and distress experienced by the poor stemmed from alcohol abuse and spent the rest of his long life crusading against the evils of drink. Only total abstinence was acceptable and his followers were called upon to sign a pledge promising to abstain from alcoholic beverages. It was one of his followers, Richard Turner, who coined one of the most famous words to be connected with the temperance movement. A reformed drinker and ardent follower, he was one day fervently advocating total abstinence when he is said to have stuttered over the word 'total'. The resulting 't-t-t-total' was picked up by Livesey and very soon came into the language and the word 'teetotal' has appeared in every English dictionary since that time. It follows that the temperance movement was especially active in Preston, campaigning against drunkenness and low moral standards in the town's growing number of public houses and singing saloons throughout much of the Victorian era.

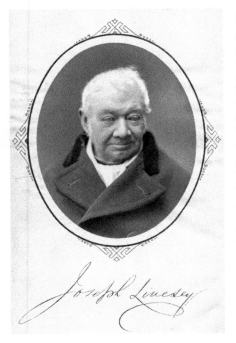

A link between concert halls and public house expansion can be seen in tables 1 and 2, indicating a prospering trade in the post-cotton famine years from 1864. The inclusive seating capacity in seven of Preston's concert halls plus seasonal music hall productions at the Theatre Royal gives an estimated capacity of between 7,000–8,000 seats for music hall during the late 1860s and early 1870s. This served a steadily rising population that had increased by 3.5 per cent to 85,427 by the time of the 1871 Census. According to Bailey, 'after the take-off in the 1850s music hall enjoyed its first great boom in the 1860s and early 1870s'.[28] Thus Preston broadly corresponds with the national expansion of the music hall industry during the same period.

Table 1 – Preston's Public House Concert Halls of the Victorian Era[29]

Albion Hotel, Church Street	1839–1856
Wagon and Horses, Tithebarn Street	*c.* 1859–*c*1868
Crown Music Hall, Church Street	1872–1874
George Hotel, Friargate	1864–1889
Black Swan, Water Street	*c.* 1865–1880s
Guild Inn, Library Street	1866–1870
Sun Inn, Main Sprit Weind	1870–1874
New King's Head, Friargate	1870–1882

Table 2 – Licensed Premises in Victorian Preston[30]

Year	Public Houses	Beer Houses	Total Licensed
1852	169	254	423
1868	226	264	490
1870	226	252	478
1876	221	236	457
1880	204	228	432

Preston's established concert halls were annexed to public houses, where the venerable chairman introduced typical music hall acts, including locally inspired acts such as clog dancers. The establishment of a purpose-built concert room or music hall first originated with the somewhat decadent Albion Singing Saloon, Clarke's Yard, Church Street, which opened in 1839, placing Preston at the forefront of national music hall growth. Prison chaplain the Reverend John Clay provides evidence of three extant early Preston concert halls in his 1842 *Annual Report*: 'One of the concert rooms, capable of holding 650 persons, was opened in the summer of 1839. Two others of smaller dimension were opened in the spring of 1841.' Therefore a pattern of growth and evidence of commercialisation and regularity of the industry begins to emerge.

Comedy, in a variety of styles, was a vital part of Preston's evolutionary music hall repertoire, with serio-comics featuring prominently. Another key figure to emerge in Preston music hall was the singer, whether he was comic, duettist, sentimental ballad or operatic singer. The diversity of performance styles began to appeal to a wider audience. The level of sophistication was sometimes wanting, however, especially when Miss McDonald appeared at the Crown Inn Music Hall, Church Street, in October 1863. The *Chronicle* advertised 'Miss McDonald the Scottish giantess – the largest woman in the three kingdoms who may be seen for a short time at the Crown Inn, Church Street'. This type of performance parallels the travelling fairground booths that visited Preston and Blackpool's golden mile in the 1950s. Whatever its faults, music hall had a strong appeal

to the working classes and was the preferred option to the temperance hall, yet there was clearly a need for social and legal reform, illustrated by the 'Spare Bed' narrative, featuring what is believed to be the first historical account of a male striptease act to be staged in a Victorian Preston music hall during 1850! (See Appendix 2.)

The opening of purpose-built concert halls, as distinct from singing saloons, is consistent with the pace of the industry and national music hall development. The 1860/70s was a time when Preston sustained about eight pubs with music halls attached. The opening of the George Music Hall in November 1864 is one such example. The fact that 'hundreds were refused admission to prevent suffocation' shows how successfully they had timed their strategy.[31]

The George Music Hall is of particular significance in illustrating the development of the Victorian Music Hall in Preston. *The Era* (21 July 1878) provides a snapshot of a typical music hall bill of the period. For your delectation and delight there were Tom and Rose Merry (duettists, vocalists and dancers), Marie Santley (serio comic), Will Atkins (comic), Mr and Mrs Patrick Miles and Young Ireland (known as the solid man) and Tom Walker (described as topical). The 1,000-capacity concert room witnessed regular generic music hall performances for twenty-five years. (See Appendix 1 for details of music halls and performance styles.)

Second-Generation Music Halls

The pub music halls were a precursor to the Preston's Gaiety Palace Theatre of Varieties, opening to coincide with Preston Guild 1882, and with capacity for 2,000 patrons. The Gaiety was the first big Victorian music hall to be unattached to a public house and as such was a great influence on the evolution of local music hall in Preston. In appearance it anticipated the Edwardian variety theatres with its curving balconies, rows of seats, large stage and proscenium arch.

> Hitherto the halls had borne unmistakeable evidence of their origins, but the last vestiges of their old connections were now thrown aside, and they emerged in all the splendour of their new-born glory. The highest efforts of the architect, the designer and the decorator were enlisted in their service, and the gaudy and tawdry music hall of the past gave way to the resplendent 'theatre of varieties' of the present day.
> *Charles Stuart and A. J. Park, The Variety Stage (1895)*

Traditional circus acts continued to be popular in this music hall and, of course, the annual pantomime was equally very popular. On 23 December 1882, the new grand pantomime and extravaganza ballet in five tableaux, *The Willow Plate*, was presented, where one could witness 'the giant hobgoblin, the peasant prince and the magic sword; ladies – grand day performances on Tuesday, December, 26 and New Year's Day. Admission prices: Reserved seats 1/-, sides and promenade 6*d*, Pit 3*d*. Half price to reserved seats at 9 o'clock.'

The evidence suggests that, at the Gaiety Palace Theatre, the tradition of music hall being a working-class male preserve was beginning to change as early as 1882, when a high level of discipline was apparent: 'Police in attendance and strict order enforced.' Female attendance was encouraged with the inducement of 'Thursday nights: ladies free if accompanied by a gentleman but children must be paid for'.[32] The Victorian inference was that an unaccompanied woman in a public place was a prostitute and this included the theatres and music halls. Consequently, respectable women did not normally attend evening performances unless accompanied by a gentleman.

Preston's music hall capacity in 1882 was around 4,500 seats: 2,000 at the Gaiety, 1,000 at the George, 1,000 at the King's Head and about 500 at the Clarence. Alternative entertainment included both civic and private establishments representing a formidable challenge to music hall: the Theatre Royal (a drama theatre) had seating capacity for 1,700, while the two concert halls, the Public Hall and the Guild Hall, had total seating capacity for 4,564. In addition, there was an unspecified number of seats at the permanent and visiting circuses.

As the music hall grew in popularity and respectability, the original arrangement of a large hall with tables at which drink was served changed to that of the drink being served in separate bars and a drink-free auditorium. There was an ongoing trend towards respectability in the music halls. The popularity of music hall soared during the late Victorian and Edwardian eras in the plentiful and purpose-built new variety theatres with their red-brick, terracotta and copper-domed exteriors, cherubs and allegorical figures, curtained boxes, gilt mirrors and decorative plasterwork adorning the auditoriums. Nationally, there grew up from about 1870 a chain of large, well-equipped provincial theatres and music halls served by the national railway network, to house touring productions of all types.

During the last decade of the nineteenth century, Preston's Gaiety music hall increasingly staged dramatic performances and revues. Preston was inconsistently devoid of a variety theatre to accommodate the golden years of legendary music hall stars touring England's lavishly appointed new variety theatres, but eventually caught up in 1905 with the preeminent form of entertainment of the period with the opening of the Royal Hippodrome, an event that ended a sixteen-year hiatus in music hall provision in Preston and preceded the building of three variety theatres.

The Manchester-based firm of W. H. Broadhead & Sons played a major role in the establishment of music hall in north-west England, including Preston. They maintained that the respectable citizen could take his wife and children to any of its productions, find them free from vulgarity and at a price well within his means. Respectability was the keynote for all classes and, unlike the Victorian music hall, reliance on alcohol as a source of funding was less important. Their theatrical business really began when William Birch Broadhead managed to persuade his father to invest his capital in a theatre in Manchester. He earmarked sites for his theatres and the first theatre to be built was the Royal Osborne Theatre, Oldham Road, Manchester, opening on 13 April 1896. It was followed by the construction of fourteen theatres in Ashton-under-Lyne, Bury, Eccles, Liverpool, Manchester, Preston and Salford. In 1909, he opened the Palais-de-Danse at Ashton-under-Lyne

and in the same year acquired the Winter Gardens, Morecambe. Three years later he purchased the Lyceum theatre, Eccles, later renamed the Crown.

The Broadhead syndicate had the financial resources to exploit the opportunity that a town without a clearly recognisable music hall presented, and extended their empire from their home patch in the Manchester area by opening two music halls in Preston: the Royal Hippodrome in 1905 and the King's Palace Theatre in 1913.

At the opening night of the Royal Hippodrome, on 16 January 1905, 'there were good houses for both twice nightly performances'. The theatre was managed by J. Freeman, who came from Broadhead's Queen's Park Hippodrome, Manchester. A final inspection of the premises took place on 14 January 1905, when Mr W. P. Park, the chairman of the inspection committee, complimented Mr Broadhead on his enterprise and, after Mr Broadhead agreed to some minor changes, a licence was granted. That night the theatre was thrown open for inspection by the general public and many thousands of Prestonians passed through the entrance. Monday 16 January brought blizzards, but this did not prevent the formal opening matinee performance, with a full house and standing room only. The orchestra played the national anthem and as the stage was revealed a hearty round of cheers resounded throughout the house.

The type of enthusiasm generated for the opening indicates that Broadhead was fulfilling a definite need. According to press reporting, comments were passed that

it certainly filled a long-felt gap in the town's entertainment provision ... Time and again has a thoroughly up-to-date music hall and variety theatre been promised for Preston but it was not until some eight or nine months ago that definite arrangements for the construction of such a building was brought to the notice of the public. A most substantial and pretty Hippodrome is certainly a decided acquisition.[33]

'All 2,500 seats command a fine view of the stage and a spacious waiting room was provided for the benefit of the second house patrons.'[34] The level of refinement is in accordance with the findings of Russell that variety theatres were now more like the nationally established sumptuous drama theatres: 'Music hall with neoclassical exteriors and an array of exotic interiors increasingly came to resemble legitimate theatres.'[35]

The King's Palace Theatre, Titbebarn Street, was the last of the theatres to be built by William Henry Broadhead's building firm. At the time of the opening of the theatre in February 1913, William Henry Broadhead publicly proclaimed his latest creation in glowing terms, stating that 'another Messrs Broadhead and Sons achievement is the raising of magnificent halls for the delectation of the people. This is the most up-to-date theatre in Lancashire offering opera from the Grand Junction, Manchester and pantomime from the Pavilion, Liverpool.'[36]

Preston Compared with Other Lancashire Towns

Preston's three variety theatres of the twentieth century – the Royal Hippodrome (1905), the Empire Theatre (1911) and the King's Palace (1913) – were all opened during the town's golden years of variety. With the provision of live theatre at Preston's remodelled Theatre Royal and Gaiety Palace Theatre, each of 1882, Preston sustained a total of five live theatres during the first two decades of the twentieth century.

The Preston model can be usefully compared with other similar Lancashire towns. Two other textile towns, Bolton and Blackburn, each had at least one legitimate theatre and purpose-built music hall at the turn of the century. At Bolton (population 115,002 in 1891), the rebuilt Victoria Theatre of Varieties operated as a music hall from 1882 and so did the Grand Cirque, opened in 1894. The Empire Theatre of Varieties opened in 1908 and became the Hippodrome.

At Blackburn (population 120,064 in 1891), two theatres opened in the late eighteenth century. The earliest drama theatre was the Theatre Royal, Ainsworth Street, which opened as early as around 1775. It became the Theatre Royal and Opera House in 1818, with three entrances, a gallery and a pit. The pit and the gallery, the latter colloquially known as 'the Gods' in most theatres, offered wooden bench seats for the less well-off clientele. The theatre was reconstructed in 1886 and renovated in 1909. The 1909 embodiment offered luxury furnished saloons, seating capacity for 1,687, and standing room for 700 and yet another change of name to the Royal Hippodrome and Opera House, presenting the genre of music hall. The New Theatre opened in 1787, utilising the old Assembly Rooms in Market Street Lane. It successively became the Alhambra Palace, the Royalty and New Royalty Theatre. The final incarnation saw this theatre as the Lyceum Theatre of Varieties, a music hall which closed in 1902 due to a problem with licensing.

The Prince's Theatre, Jubilee Street, Blackburn, opened around 1890 and was to be rebuilt as the New Prince's Theatre in 1906. It was renamed the Grand in December 1931 and closed as a variety theatre in 1956. Next door to the Grand Theatre, the Palace Music Hall fronting the Boulevard opened on 11 December 1899 'with a first-class variety bill'. It reopened as part of the Macnaghten Circuit in September 1900. The Palace catered for the working class, who took advantage of the largest 'gods' in the county. The gallery had capacity for 1,000, and with patrons paying the princely sum of 2*d* a ticket they clearly took up the words of the well-known song 'Let's All Go to the Music Hall'. But, as a lesson to the rowdy elements, the manager on one occasion closed down the entire gallery. The last of the Blackburn music halls opened in 1911 as The Olympia, handsomely decorated with a mahogany foyer and entrance hall lit by eight flame arc lamps and no less than thirty-four private boxes to welcome families and the more affluent members of Blackburn society.

Elsewhere, in similar-sized Lancashire textile towns, the trend for music hall to adopt an image of respectability is illustrated in a speech given by Frank Macnaghten at the opening of the Burnley Palace Hippodrome in 1908:

I am often asked why I call my halls, Palaces and Hippodromes. This is to draw a distinction between the old music hall of the past, frequented by men only, and the new Vaudeville entertainment of the present day, to be patronised by women and children ... The old music hall is in the transition stage from the singing room to the new Vaudeville Variety theatre.

Indeed, Macnaghten's slogan heralded the respectability of variety – 'Theatres of Variety dedicated increasingly to the ideal of family entertainment'.

Changing Fortunes and Counter Attractions to Music Hall

The First World War was the last stand of music hall exuberance, and Florrie Forde boosted morale with the rallying song 'Pack up Your Troubles in Your Old Kit Bag' when she appeared at the Royal Hippodrome in October 1917. This was Forde's second visit to the Royal Hippodrome, Preston, showing it to be on the established circuit of music hall icons such as Lloyd, Forde and many others who appeared on the Preston stage between 1911 and 1918. Tragically, this was at a time when the 'Preston Pals' and other young men of the town would have headed off to war from Preston railway station with the utmost valour, no doubt having adopted the words of the music hall song to 'pack up your troubles in your old kit bag and smile, smile, smile'. As we now know, there was nothing to smile about; many of them sadly had a one-way ticket to northern France and would never return home again.

In 1911 Preston had four live theatres, with music hall at the Royal Hippodrome and Empire Theatre and drama on stage at the New Prince's Theatre and at the Theatre Royal, though no bridges would be built between theatre and the emerging cinema industry. The one exception to this was the Royal Hippodrome, which remained a live theatre throughout its existence, notwithstanding that early programming featured the Bioscope for the projection of films.

Preston's music halls and theatres were well into overproduction, and profits reduced by 1913. The huge King's Palace (capacity 2,500) theatre never really justified the investment, giving credence to the objections and fears of rival theatre owners concerning excessive provision of theatres at the time of the opening of this, the last of the Preston music halls, in February 1913.

Music hall at the King's Palace was suspended after 1917 when it operated mainly as a cinema with occasional stage shows. In the 1920s, the theatre was advertised as 'the King's Palace of Music and Pictures: one continuous performance, come what time you like stay as long as you like'. Such was the popularity of cinema that on Christmas Day 1922 the Palace presented three performances of *The Three Musketeers*, starring Douglas Fairbanks. Also during 1922, the Palace claimed the 'first screen play made in natural colours – *The Glorious Adventure*'. The Broadheads set the trend for continuous film performances, adopted nationally with double-feature programmes.

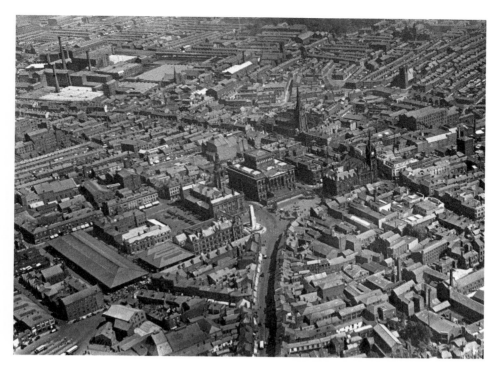

Aerial view of Preston in 1929, at a time when there were three music halls in Preston – the Royal Hippodrome, the Empire Theatre and the King's Palace. (Courtesy of Preston Digital Archive)

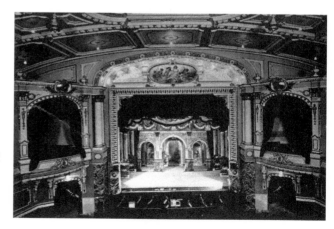

The splendid auditorium of the King's Palace Theatre, Preston, at the time of its opening in 1913. (Author's collection)

Furthermore, during the 1920s the owner of the King's Palace, William Henry Broadhead, resisted a £250,000 offer from a film distributor wanting to purchase the whole chain of his north-west-based theatres as cinema outlets. His son Percy persuaded him that he was the only man in the country personally to own seventeen

theatres and he should retain them. It was resolved that Broadhead's magnificent halls for the delectation of the people would be around a little longer. Ironically, on 13 January 1930 the great Scottish music hall star Harry Lauder starred in *Auld Lang Zyne* at the Kings' Palace; albeit not on stage in the flesh but on celluloid.[37]

Following the death of William Henry Broadhead, the Broadheads put up for auction their two Preston theatres and the Winter Gardens Theatre, Morecambe. On 5 April 1933, the King's Palace was advertised as a 'talking picture theatre', with a Bioscope chamber and rewinding room, dramatic and music, singing and dancing licence, ten dressing rooms, seating 2,340 in the stall, pit and balcony. Neither Preston theatre was sold, although the Royal Hippodrome was sold during 1939 to Claude Talbot Entertainments, reopening in 1941. The King's Palace reverted back to a full-time commercial live theatre around 1930 and continued to be managed by the Broadhead family until the final curtain was lowered in 1955.

Between the wars, the changing social conditions and the economy impacted on Preston's extant theatres. The roaring twenties was a decade of merriment, hedonism, frivolity and dance and in some ways can be likened to the swinging sixties. Dancing became extremely popular during the interwar years, and, with several dance halls in Preston, there was now a good chance of meeting the opposite sex in a more convivial atmosphere.

Theatre programmes not only illustrate the type of productions but also demonstrate rival leisure forms by giving an insight into the commercial life of Preston and veiled threats to the variety theatre. For example, in the 1920s gramophones and wax records could be obtained from Mosley, Friargate. For an evening out you could phone for a charabanc or purchase a Morris motorcar from Loxham's Garage for £162 or obtain the latest song sheet or a piano from Greenwoods, Lune Street.

Indeed, counter attractions to the theatres and music halls included radio and the playing of gramophone records, which were enjoyed at home. The *Gramophone Review of 1928* stated, 'Why, we ask ourselves, should we go out in the cold and wet, into crowds, perhaps to see some entertainment that we cannot be sure of enjoying, when we have a comfortable chair and fifteen records of Rigoletto to entrance us?'

The legendary Gracie Fields trod the Hippodrome stage in a revue with her husband Archie Pitt in November 1922, and George Formby played the Empire Theatre in 1929 during its penultimate year as a live theatre. Both artists became enormously popular in film, radio and records and these media indirectly posed yet another threat to live theatre. The depression of the 1930s was felt between 1929 and 1933 and saw unemployment in the town of between 5,000 and 10,000, and thus economic restraints adversely affected the entertainment industry.

The biggest threat to live theatre was the cinema industry, compounded in 1929 with the arrival of the first talkies. Furthermore, during the peak of the cinema industry during the 1930s/40s, Preston had a minimum of eighteen cinemas open at the same time, which duly impacted on the growth and demise of music hall. By 1929 the Hippodrome was competing with the first talkies, and to counter this threat the theatre management adopted the slogan 'living artists not talking pictures'.

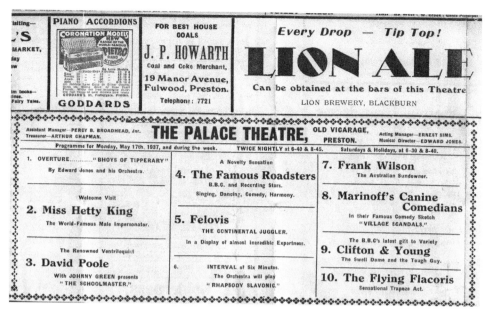

Above: A typical bill of fare at the King's Palace Variety Theatre, Preston. Top of the bill in May 1937 was Hetty King. (Author's collection)

Towards the end of the 1930s the employment situation in the town was improving, but a more buoyant economy was to be offset by the dark clouds of war one year later. Despite the gloomy prospects and counter attractions, the variety theatre remained popular before the Second World War, with famous names topping the bill as a more refined and spectacular version of music hall, presented in huge theatres including the King's Palace Theatre.

Keep the Home Fires Burning

During the Second World War, iconic stars like Gracie Fields and Vera Lynn raised the troops' morale and brought hope to the nation. Throughout the country the theatre was affected by six years of war, the trauma of bereavement and the problem of reintegrating services into a society of economic and political weakness. At the reopening of the Royal Hippodrome in 1941, Claude Talbot pledged to carry on 'in the same old tradition with the best of variety and musical comedy and in the same atmosphere of comfort and cheeriness that made the old Hippodrome so popular'.

Theatre programmes at the King's Palace theatre poignantly reminded patrons,

Please bring your gas mask with you. A.R.P. Notice: Should there be an air raid warning the manager will announce the same from the stage so that patrons may leave the building if desired, or stay and see the whole show through, as the

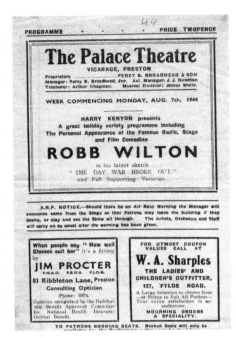

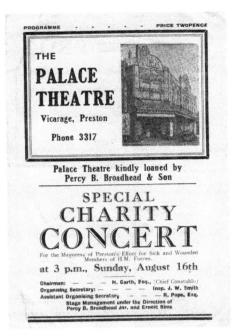

Above: During the Second World War the King's Palace defied the Nazi threat and continued with twice-nightly performances featuring Rob Wilton and his famous catchphrase – 'The Day War Broke Out' (note the ARP warning endorsed on the programme). (Author's collection)

Above: The atmosphere of wartime theatre in Preston is encapsulated by the theatre programmes of the time. An all-star variety matinee took place at the King's Palace on 16 August 1940 as the Mayoress of Preston's effort for sick and wounded members of the armed forces. (Author's collection)

artists, orchestra and staff will carry on as usual after the warning has been given. The artists, orchestra and staff will carry on as usual after the warning has been given. Reduced prices for members of H.M. Forces.

From Elephants to Nude Ladies

After the war, Claude Talbot brought musicals, variety, revue, circus and drama to the stage of the Hippodrome. Traditional circuses continued to feature in the music halls during the late Victorian era and well into the twentieth century, reaching their destination using special circus trains. The circus parade was a natural advertisement for the circus and attracted huge crowds, who lined the processional route to enjoy the spectacle of a procession of elephants linked trunk to tail, being led from the railway station to their theatre. Billy Seagar was principal trumpet in the theatre band at the King's Palace, and after a circus production he told his wife Ivy, 'I have been blowin' my bloomin' brains out all night for a flippin' zebra and

Janet Munroe began her film career with the Salberg Players and regularly played the Royal Hippodrome before starring in several films with Tommy Steel, including *Tommy the Toreador*. (Author's collection)

The well-known actors John Barron and Janet Munroe starred in this Salberg Players production of *Pick-Up Girl*, presented at the Preston Royal Hippodrome. (Author's collection)

'Evans above', it's Norman Evans at the Palace!. (Author's collection)

Cinderella – a popular pantomime at the Preston Royal Hippodrome.

an elephant put its foot down so hard it made a hole in the stage and nearly ended up in the band room!'

At the Royal Hippodrome, repertory was presented and widely acclaimed during the late 1940/50s. The theatre got a major post-war boost on 14 July 1947, when Reginald Salberg presented a series of plays which were scheduled to last for four weeks, beginning with *The Hasty Heart*. It must have been a favourable public reaction because, after the initial run, Salberg stayed at the Hippodrome for eight years. The popularity of the Salberg Players shows the repertory trend and how the stage was adapting during the late 1940s. Several established actors, including Leonard Rossiter and Janet Munroe, learned their profession on the Preston repertory stage in the 1940s, long before becoming internationally famous as television and film stars. Terence Rattigan's *The Winslow Boy*, with its many examples of class-based language and a proliferation of 'thanks awfully', was typical of Salberg productions at the Hippodrome.

ROYAL HIPPODROME
PRESTON

Proprietors Talbots' Entertainments Ltd
Managing Director and Licensee ... Claude Talbot
Manager Robert Winlow
Telephone Preston 3360

Week Commencing
MONDAY, 18th JANUARY, 1954

1904 50th 1954
ANNIVERSARY

In commemoration of the exciting years In the life of this theatre, we are proud to present . . .

GRAND
STAR
VARIETY

In 1954 the Royal Hippodrome celebrated its fiftieth anniversary with a grand variety show. (Author's collection)

At both the Preston Hippodrome and the Palace there was a resurgence of interest in variety during the 1940s, and topping the bill at that time were artists of such calibre as Frank Randle, Richard Tauber, Norman Evans, Gracie Fields and George Formby. Frank Randle enjoyed a reputation as 'the bad boy of Northern comedy', with massive success on stage and screen. Blackpool Watch Committee banned his show *Randle's Scandles*, regarding it as obscene. In revenge Randle hired an aeroplane and dropped a load of toilet rolls onto the town. Randle's earthy comedy made him a hero with working-class audiences. Indeed, Randle saw himself as the people's comedian.

The Preston Hippodrome presented eclectic programming of variety, revue, musicals, opera, pantomime and drama while the King's Palace essentially remained as a variety theatre offering variety and revue. At both of Preston's live theatres, pantomime was always the Christmas attraction and a national institution with a flavour of its own.

American musicals such as *Oklahoma* in 1947 helped to light up the post-war gloom at the Hippodrome at a time when the talkies had become a real rival to the theatre. *Oklahoma*'s success paved the way for more American musicals, including the 1950s productions of *Carousel*, *South Pacific* and *The King and I*.

Newcomers on the Hippodrome's stage during 1955 included young Shirley Bassey, also set to achieve international stardom. In the mid-1950s, third-rate revues at the King's Palace featured the infamous 'Jane' and the display of nude women on stage, but this desperate measure did little to attract declining audiences.

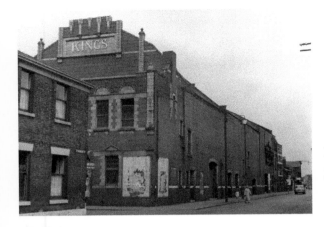

No more 'peaches and screams' at the King's Palace Variety Theatre, Tithebarn Street. (Courtesy of Preston Digital Archive)

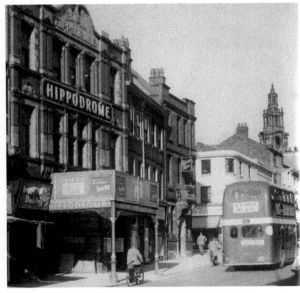

Preston's Royal Hippodrome awaits its ultimate fate in 1958 – demolition! (Courtesy of Preston Digital Archive)

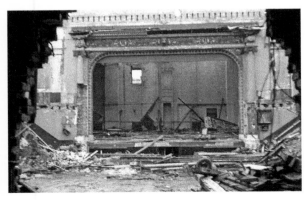

The final curtain call was taken at the Royal Hippodrome, Preston, in 1958. (Courtesy of Preston Digital Archive)

In fact, the girlie shows were only playing to an audience of about 100 in the huge King's Palace Theatre with its capacity for over 2,500; clearly the writing was on the wall.

The Final Curtain

Audience taste and changing social considerations impacted on both the variety and cinema industry during the early 1950s. Rock and roll performers initially topped music hall bills and attracted a young audience who had little interest in the music hall acts. Furthermore, people were happier to go for a game of bingo, enjoy a pint in a nightclub with live entertainment or dance the night away at the local 'Mecca', and all these functions were provided in an increasing number of old cinemas and theatres while others became garages or supermarkets. The King's Palace closed with a revue called *Peaches and Screams*, featuring Ted Lune, in February 1955.

Meanwhile, two years later at the Royal Hippodrome, manager Talbot went on stage and addressed the biggest audience in years. Sadly, he announced the almost inevitable closure of Preston Royal Hippodrome by stating, 'The date 25 May 1957 should be remembered with shame by every citizen of this town who claims to enjoy the theatre. I don't think there will ever be a live theatre in Preston again.' The Royal Hippodrome was the last large commercial theatre to close in Preston and was demolished in 1958.

The ultimate cessation of the variety theatres of Britain was mainly due to competition from television, which became very popular after the queen's coronation was televised. In 1957, the playwright John Osborne delivered this elegy: 'The music hall is dying, and with it, a significant part of England. Some of the heart of England has gone; something that once belonged to everyone, for this was truly a folk art.' This downward spiral effectively culminated in the music hall industry being finally confined to the annals of social history during the mid-twentieth century.

The comedy legend Ken Dodd once told me that he never played the Preston's King's Palace, though he wished he had. Northern comedy had its origins in music hall, and Doddy is one of the stocks of generic Northern music hall performers who learnt his trade in the variety theatres as distinct from television. In my view he is the last of the genre of great traditional music hall comics, and he still tours the nation's theatres at the time of writing. Ken's love of live theatre is borne out by still being a performer and delighting audiences everywhere he goes: 'A lot of men retire because they have had enough but I'm still stage struck.' In fact, Ken's shows usually start at 7.30 p.m. and finish well after midnight, so bring along your sleeping bag. According to Ken 'there is nothing like a good laugh for airing the lungs and exercising the chuckle muscles', and who would dare argue with that ideology?

The Rise and Fall of an Empire

The demolition of the once proud Empire Theatre in 1976 represents not only the end of an era but also the 'End of an Empire'. The Preston Empire Theatre, Church Street, opened in 1911 at the height of colonialism and the British Empire and during the reign of King George V. In the centre of the proscenium arch of the newly built theatre, an imperial crown surmounted an emblem of empire. Elsewhere, the contemporary music halls of the Edwardian era were appropriately named Empires, Palaces and Theatre Royals. Today, these names are no longer fashionable and are purely symbolic of long-lost empires in a lost world.

The Empire Theatre is of particular interest in charting the rise and fall of the music hall theatre in the twentieth century. The name of the building, its

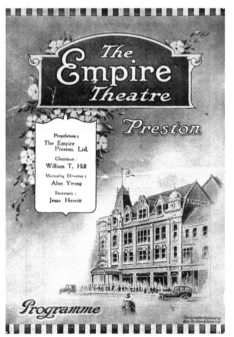

architecture and performance style were typical of the music halls built during the late Victorian and Edwardian eras. In 1930 the Empire became a full-time cinema, and, prior to demolition, a bingo hall. It thus characterises the changing role of the theatre in twentieth-century Preston and again illustrates how the cinema industry impacted on live theatres and music hall with the coming of the talkies. The social and economic history of the growth and demise of music halls and theatres is significant and no less so in Preston. Therefore, let us dust away the cobwebs and the ghosts of yesteryear, and the gruesome sound of pneumatic drills reducing the Empire to a pile of dust and rubble, by way of a case study of this once glorious theatre with the spotlight firmly fixed on the 'Rise and Fall of an Empire'.

The Rise of an Empire

The Empire Theatre opened for the first time on 22 May 1911 with a capacity audience of 2,500. The opening night featured variety, with typical music hall acts such as Harry Tate's Company, which included Elsie Hulbert's Clog Dancers, vocalist Marie Schultz and two comedians. Patrons paid from 4*d* in the gallery to 10*s* 6*d* for a four-seat box.

Like a sign of things to come, Bioscope presentations featured on the opening night, and as early as August 1911 a week of films was shown. The primitive Bioscope intervals at Preston's first music halls and circuses evolved into cinema and became a source of major opposition to music hall during the twentieth century. Notwithstanding the cinema threat, one contemporary writer stated, 'The opposition of skating-rinks and electric theatres has been keenly felt in certain quarters, but the rivalry of these forms of amusement to the variety theatre is hardly likely to be permanent and the dawn of 1910 brings with it the prospect of more settled conditions.'

The *Lancashire Daily Post* extolled the virtues of the new Preston Empire:

So unique in design, so picturesque in effect, so comfortable and commodious in every detail, and so perfectly equipped in every way is Preston's new house of entertainment, that it may be claimed to be the finest ever erected in the provinces,

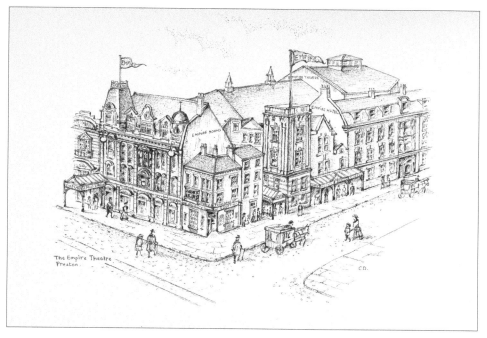

The Empire Music Hall by Christine Dodding, portraying it as it would have looked at the time of its opening in May 1911.

even challenging many of the most recent variety houses in the Metropolis. Proud Preston has yet another just cause for pride in the possession of a theatre of varieties that has clearly made quite a stir in theatrical circles.

Architectural Considerations

The Empire was designed by Preston architect and managing director Edwin Bush, and the general manager was Mr E. P. Morgan, a former manager of the Hippodrome Theatre, Manchester. The subsidiary blocks of the scheme included shops on Church Street and chambers on three upper floors and the Empire Hotel, Tithebarn Street, an adjunct of the theatre.

A full description of the theatre was reported in *The Era* on 27 May 1911. An abridged account follows, reflecting further on the history of music hall, and yields particular impetus to the changing role of the variety theatre.

> The design of the theatre was in the Renaissance style of Louis XIV. There was a view of the stage from every part of the house. Entrance to the stage from the street is so ample in width and height that a motor car, fire engine or 'coach and four' could drive straight across the stage in full view of the audience. Because of its many exits and elaborate fire precautions it was said to be the safest building of its kind in the kingdom. Entering the auditorium from the circle foyer, the bold design of the proscenium immediately attracts the eye. In the centre of the arch, an Imperial crown surmounts an emblem of Empire. The proscenium is flanked by two Georgian stage boxes ... Each tier of boxes is crowned with an ornamental dome in line with the circle and gallery. In depth width and design the stage resembled that of 'The Theatre Royal', Manchester ... The cost of the whole scheme is £65,000. The venture is bold and praiseworthy, the proprietors having faith in the good people of Preston to crown their enterprise with the hallmark of appreciation. A determined effort is to be made to exclude rigidly from all performances that bugbear of the variety stage, doubtful humour, and to present at all times clean, wholesome amusement of the highest quality obtainable.

Audience Composition

Throughout the north-west, audiences in the second half of the Victorian era typically comprised mainly working-class men. Preston was especially popular with young textile employees and manual and engineering workers, representing the dominant industries in the town at the beginning of the twentieth century.

At the beginning of the twentieth century, theatre owners were encouraging women and family members to attend the music halls. This gradually made them more appealing to the middle classes; also, music hall performers in the new theatres had begun to attract a wider audience. Seats at the Empire were usually

priced between 4*d* and 1*s* 6*d* in 1911 compared with the Royal Hippodrome prices of 2*s* in the circle, 1*s* in the stalls, and 3*d* in the pit. In most theatres, the most expensive seats were in the dress circle and stalls while the lower-priced tickets were in the gallery and the pit, the latter situated behind the front stalls.

During the twentieth century, music hall progressed to become a social event attended by the family, friends and work colleagues. This evolved because of a decline in religious observance and an increasingly relaxed social atmosphere.

At the Preston Hippodrome, the level of respectability of the late Victorian era was transferred to the new theatre. At the commencement of a performance, the manager paraded all the staff who dealt with the public and inspected their hands, nails and general appearance, insisting that the hands, faces and hairstyles of the box office staff and programme sellers had to be up to the standards expected by patrons at that time.[38] This insistence on making theatre staff look as smart as good domestic servants lends some support to Russell's view that there was an attempt to attract a wider social strata in music halls after 1890: 'There is implicit evidence that from the 1890s significant sections of the middle class began to attend. They included clerks, teachers, managers and even some professionals with their families.'[39] A 1920s Empire Theatre programme in my collection has the following written pencil inscription on the cover, perhaps written by an inconsolable spouse working an early morning shift at the mill: 'Your supper's in the oven.'

Get the Habit – Twice Nightly

So said the double entendre advertising propaganda towards the end of the reign of Queen Victoria – would she have been amused? I somehow doubt it; nevertheless, the country went twice nightly! The Empire capitalised on this advertising slogan to attract regular patrons and the King's Palace had the performance times of 6.40 and 9 as a permanent inscription on its terracotta exterior. The music hall industry graduated from once-nightly variety performances to twice-nightly performances during the late Victorian and Edwardian era. The revived music hall falls in line with Russell's view: 'Further efforts to increase profitability resulted in attempts at raising performers' productivity through the large-scale utilisation from about 1900 of both the twice-nightly system and the matinee ... The growth of a matinee performance again suggests the increased attendance of a slightly more leisured class.'[40]

The twentieth-century variety theatres of Preston presented, for the first time, twice-nightly performances, and at least two matinees a week, making the performances more attractive to both to women and to textile and engineering workers on shift work. This was a time when families had the opportunity to have a pleasant night out in Preston, put on their best clothes and meet their friends and pay a visit to the new variety theatres. Music hall visits were social events attended by the family, friends and work colleagues. That twice-nightly performances became so common is perhaps testimony to the increasing patronage of a more sophisticated audience and

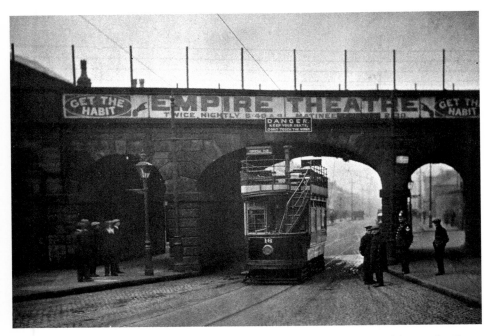

Above: A police sergeant watches on as a Preston tram passes under Fylde Road railway bridge with clearance so restricted that the sign warns passengers to 'keep your seats and don't touch the wires'. Additionally, passengers are urged to 'Get the habit at the Empire Theatre – Twice Nightly at 6.40 and 9'. (Courtesy of Preston Digital Archive)

propaganda by theatre owners that clearly aimed to attract the middle classes with changing performance styles that progressed from variety to extended drama seasons.

Performance Styles

Music halls were originally licensed by the local authority for music and dancing only and were not allowed to play dialogue in play or sketch form. Agreement concerning the issue of sketches and dramatic performances in music hall was reached in 1912, and the music halls then came under the jurisdiction of the Lord Chamberlain.

The range of types of entertainment that gradually displaced music hall and the variety theatres in Preston generally accords with national trends, with generic music hall successively phasing from music hall to revue (sketches), presented for the first time around the time of the First World War. According to Rutherford (1986), sketches were 'positively contributing to the music hall's aspirations to be called variety theatres from the 1870s onwards' and 'during the 1890s *The Era* was recurrently arguing that sketches were ideal for audiences who were in a transitional state … moving to something better'.[41] It was not sufficient that the theatre should be a mere place of entertainment presenting just generic music

hall. This dramatically increased the scope of entertainment offered at the nation's theatres and was mirrored at Preston's Hippodrome and Empire theatres, and from then on Shaw and Shakespeare were to be familiar to variety audiences. The spread of American culture was pertinent too, with American ragtime increasingly staged at Preston's variety theatres, including the Empire. In 1912, *Everybody's Doing It* at the Empire duly acknowledged the arrival of ragtime.

King Edward died on 6 May 1910, and, following the outbreak of war in early August 1914, the music hall was transformed. This was to be the last stand of music hall exuberance at the Empire, with leading music hall artists of the day topping the bill. On 15 April 1912, the day the *Titanic* sank, the Empire was presenting Hetty King, billed as 'the first visit to Preston of the world famous male impersonator'. A slump in the business corresponded with the impact of the German offensive, darkened streets, the restriction on trains and the dearth of taxis, the curfew and finally the abundance of taxes both theatrical and general. In the depth of war, like a breath of fresh air, Lily Langtree trod the Empire stage on 4 September 1917.

After the First World War, the Empire presented an ever more pre-packaged form of entertainment, embracing an assorted range of touring musical comedy, opera, operetta, melodrama, revue and variety shows. Gone were the days of the spontaneity and interaction of the music hall audiences, who were now expected to be quiet, respectable and courteous while performances were under way.

On Monday 15 November 1920, the Empire programme boasted a return visit from the famous Allington Charnley Grand Opera Company, the largest touring opera company in the world, with over 100 artists and a full orchestra. They presented a different opera each night, ranging from Gounod's *Faust* to Wagner's *Tannhäuser*. During the week commencing 13 February 1922, the Royal Carl Rosa Opera Company staged *The Tales of Hoffman, Faust, Carmen, Tannhäuser, Cavalleria rusticana* and *Pagliacci, Madama Butterfly* and *The Bohemian Girl*.

The tremendous appeal of light opera and musical comedy in the variety theatres was a tribute to the refinement of its devotees throughout the 1920s. Typical touring productions included the musical comedy *Kissing Time*, from the Winter Garden Theatre, London, and *Lionel and Clarissa*, direct from the Lyric Opera House, London. Robert Courtneidge's company featured *The Arcadians* at the Preston Empire, starring Tilly Foulds, J. E. Coyle and Fred Evison. Every English-speaking country in the world was visited, with huge success, and the production was translated into practically every known language. *The Arcadians* was reputed to be the greatest of all musical plays. Extracts from the original Preston Empire programme show that it 'introduced playgoers to Arcadia', where 'everybody was gentle and kind and truthful, and lying was unknown'. Lewis Waller's *Monsieur Beaucaire* (1902) was one of his most financially successful productions. It was presented at the Empire Theatre with Gerald Lawrence in the principal role.

When the Edwardian period began in February 1901, England was well covered by touring companies. The actor-managers visiting Preston gradually built up their own companies, and theatrical circuits regularly played both Preston's Theatre Royal and the Empire Theatre throughout the Victorian era. The provincial theatre thus became

Above and below: An Empire Theatre programme featuring a week of the Allington Charnley Grand Opera Company in 1920. The actual programme is inconspicuous amid a whole plethora of local advertisements. (Author's collection)

a mirror of the London theatre. The English theatre had been strongly garrisoned by Beerolm Tree, Frank Forbes-Robertson, Arthur Bourchier, Bransby Williams, Sir Frank Benson, Sir Henry Irving and other actor-managers, many of whom visited Preston with their respective companies.

A season of plays touring the provinces from London starred the distinguished actor Frank Forbes-Robertson for six nights, commencing 17 July 1922. It was billed as a personal visit of the distinguished actor Frank Forbes-Robertson in a new romantic play prior to its London production: *The Call of the Road* by George Norman and David Ellis, adapted from Tom Gallon's famous novel *The Great Gay Road*. It was described in the theatre programme: 'And of course there is a

love interest; not the usual sickly, sentimental tosh, but as Backus, calls it, good love making. The love of a man for a maid and the wonderful love of one man for another.' Gosh, this was 1922; long before the so-called permissive society!

There was no greater Shakespearean name touring the provinces in the 1920s than that of Sir Frank Benson and his company. Sir Frank appeared in all three plays presented at the Empire during the week commencing 29 October 1923; as Shylock in the *Merchant of Venice*, Caliban in *The Tempest* and Banquo in *Macbeth*. For these performances, admission charges ranged from 6d for a balcony seat to 26s for a box seat. Sir Frank Benson's passionate enthusiasm kept Shakespeare alive in the provinces and he returned to the Empire on 17 November 1924, when eight plays were presented. It is acknowledged that Shakespearian productions drew consistently good audiences in the period and were appreciated by both the working- and middle-class audiences.

Intellectual stimulation and detailed analysis were not a prerequisite for attending the theatre. Both middle and working classes went to the Empire to be entertained; 'all the British theatre-goer wanted was legs and tomfoolery'. So said Henry Arthur Jones in 1906 while commenting upon the supposed decline of British theatre.

Leading dramatists, including Shaw, began to introduce plays with philosophic ideas, dealing with the tribulations of real people, passions and emotions. Playgoers frequently went to see the star actor, who was often also an actor-manager. Fred Terry was another actor-manager who performed in Preston, with his lovely wife Julia Neilson. At Preston he played the illusive Sir Percy Blakeney in *The Scarlet Pimpernel* during the week commencing 21 January 1924.

Throughout the 1920s, musical comedy, revue, opera and drama sustained live theatre at the Preston Empire and modern touring companies gradually displaced the nineteenth-century actor-manager. However, the theatre continually had to compete with two other live theatres in Preston alone. Furthermore, between the wars the changing social conditions and the economy impacted on Preston's extant theatres.

Moreover, the moving picture found that it could perform all the plays and proceeded in the post-war years to put out of business certain theatres that had staged spectacular melodrama. Nevertheless, Shakespeare, melodrama and revue were sustained on the theatrical roller coaster that was to epitomise the Preston Empire during its last decade as a live theatre. The year 1924 was the year of George Bernard Shaw and Noel Coward, and society drama was often built around a shameful secret and romantic intrigue.

Popular musical plays of the period staged by the two Preston amateur operatic societies during the 1920s included *The Toreador*, 1922; *Floradora*, 1922; *San Toy*, 1925; *The Belle of New York*, 1924; and *A Chinese Honeymoon*, 1927. Many of these musicals have faded into obscurity, with the exception of one joyful evergreen: *The Merry Widow*, which delighted the audiences at the Preston Empire. *The Times'* critic of the day called Franz Lehar's famous work 'the most satisfying individual piece of lyric work that has appeared on our lyric stage for some time'. *The Merry Widow* is still as popular as ever to this day.

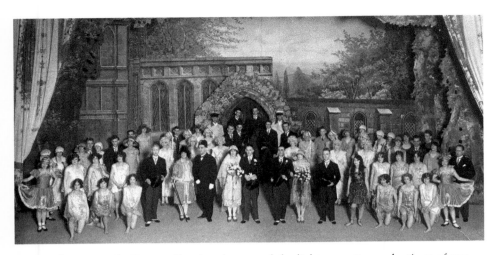

During the 1920s, the Preston Empire also staged the light operetta productions of two of the town's first local amateur societies, the Preston Light Opera Company and the Preston and District Amateur Operatic Society.

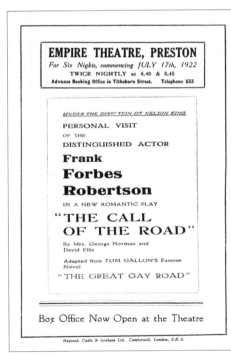

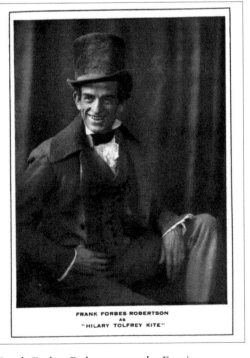

A personal visit of the distinguished actor Frank Forbes-Robertson to the Empire Theatre, 17 July 1922. (Author's collection)

Coming away from the Preston Empire humming the airs of *San Toy*, *The Arcadians* and *The Quaker Girl* in the 1920s belongs to a different age, and, though there have been efforts to resurrect them, those musical comedies have probably gone forever. This probably applies not only to the type of early twentieth-century musicals staged at the Empire but perhaps also to certain mid-twentieth-century musicals, including such stock-in-trade musicals as *The Desert Song* and *The Student Prince*, which no longer seem to be considered in vogue and are seldom staged by professional companies. The first performance of *The Student Prince* was presented at the Empire on 24 March 1930. Produced under the direction of Robert Courtneidge, it was presented by Macdonald and Young and described as a spectacular musical comedy from His Majesty's Theatre in London.

Regrettably, six years prior to this production, in August 1924 the writing was already on the wall for the Preston Empire. Alan Young, the managing director of the theatre in 1924, attempted to analyse the lack of enthusiasm for the theatre, giving veiled hints of the Empire going over to cinema while alluding to the quality of different styles of entertainment. To put his overall comments into context, an abridged version of his statement appears below.

The Fall of an Empire

Preston has a curious record in regard to its support of drama and it is not a good one. Sometime before the war the town had ceased to become one of the regular patrons of the theatre as distinct from the music hall and cinema, and though a valiant effort has been made to revive interest locally, an effort which has at time times shown splendid promise, there are unmistakable signs that the public response is by no means what it should be. As a fact there is a very real danger of Preston being struck off the visiting list of more than one famous theatrical producer, for the measure of support accorded some of the very finest productions recently has been so disappointing as to result in a heavy loss after a week's show here. The same thing happened in musical circles on the occasion of the recent visit of Sir Thomas Beecham and his famous orchestra and the only inference that can be drawn is that Preston is losing the taste for good music and plays ... The indifferent patronage for recent productions is heartbreaking for any management. Surely there is room for entertainment of a higher type than the red-nosed comedian.[42]

The decision as to whether the Empire theatre should be turned into a picture palace has ended as lovers of the legitimate theatre fervently hoped it would, but it remains to be seen whether the subject has been dropped permanently or merely for another year. It has been raised before this week's meeting of the theatre shareholders and obviously the decision must turn upon the measure of support accorded the Empire management in their wholehearted endeavour to stimulate the townspeople for good plays and first class new productions in musical comedy and the like. No business can go on forever without making a

profit, but there is every justification for the optimism of the management that when trade conditions return to normal, locally there will be better times for the Empire. It is all a question of success or otherwise in in gauging the public taste, but it is a tremendously difficult job for anyone to undertake, either in London or the provinces. Still the task has been narrowed down by the exclusion of variety shows from future entertainment at the Empire. Recent experience has shown that the day of the single turn is well nigh ended, at least as a really first class entertainment, and as the future booking of plays to be put on at the Empire indicate, it is clear that the management are anxious that Preston should have the very best productions that can be secured for the provinces.[43]

Accordingly, dramatic productions could thereafter be enjoyed at the Preston Empire in an attempt try and ensure its future as a live theatre.

The Empire would not have been granted a licence to stage productions of plays that might be considered to be indecent; to contain offensive personalities; to represent in an invidious manner a living person, or a person recently dead; to do violence to the sentiment of religious reverence; to be calculated to conduce a crime or vice; to be calculated to impair friendly relations with a foreign power; or to be calculated to cause a breach of the peace (Parliamentary Joint Select Committee on the Licensing of Plays 1909).

Nevertheless, the Empire also began to feature controversial plays; 'The Denville Habit Grows,' said the advertising propaganda when the Denville Stock Company presented *A Sinner in Paradise* at the Empire on Monday 14 June 1926 at 6.40 p.m. and 8.45 p.m. Admission charges were cheap by normal standards and ranged from 9s 4d in the lower boxes to 4d on the balcony. The programme stated that the Val Gurney play 'will make you talk for weeks. The interest of the play starts with the rise of the curtain, so patrons are respectfully invited to take their seat early.' In the same year, 1926, the renowned Ivor Novello emerged from the Empire's stage door dressed in a black coat, white silk scarf, white gloves and top hat, having appeared in a play called *The Rat*.

George Bernard Shaw's controversial play *Mrs Warren's Profession* was about the social conditions that fostered prostitution, the scandal of underpaid virtue and overpaid vice. By 3 December 1928, *Mrs Warren's Profession* featured at the Preston Empire when the Macdona Players presented a week of the plays of Bernard Shaw direct from the Kingsway and Little theatres, London. The plays performed were *Pygmalion*, *The Doctor's Dilemma*, *You Never Can Tell*, *Mrs Warren's Profession*, and *Man and Superman*.

The traditional variety shows had finally bowed out, though revue as well as society drama and musicals featured during the last decade of live theatre at the Empire. George Robey starred in a period revue at the Empire on 31 January 1927, namely *Bits and Pieces*, also starring Marie Blanche. Noel Coward's *Bitter Sweet* and *The Lilac Domino* were both staged at the Preston Empire during the late 1920s. That music hall stalwart George Formby appeared live in a twice-nightly comedy revue at the Preston Empire, *Formby Night Out*, for the week

commencing 15 April 1929. The comic song was one of the central features of revue, and George Formby was one of the most popular exponents, with his risqué humour and characteristic comic preoccupation with sex.

The Empire Bows Out

Macdonald and Young presented a series of London musical comedies in the first half of 1930, including *Cinders* and *The Patsy*. The last three weeks of stage attractions at the theatre featured actor-manager Frank G. Cariello and his London players in a series of plays, including *Facing the Music*, *Lady Windermere's Fan* and *East Lynne*. It was billed as 'your last chance to see your favourite stars before the Empire goes over to talkies'. The final stage performance was duly reported in the *Lancashire Daily Post* on 4 August 1930:

> With the singing of Auld Lang Syne, the stage and audience linked over the footlights by the holding of hands, legitimate stagecraft took its farewell curtain at the Empire theatre on Saturday evening. Preston certainly bade farewell to the Empire as a theatre in worthy manner. Long before the first of the bi-nightly performances had concluded, there were long queues lined up at the pay boxes, and the foyers and stairways were thronged with those who had booked their seats. For the last show there was not an empty seat. Each box was occupied and through the rails of the gallery the occupants poked their faces, determined not to miss a single incident, however trifling, in what they regarded as the very last show.

With the passing of the Empire and the rhythm of 'I Want to Be Happy', which so epitomised the gay twenties, Britain would be at war again with Germany in less than a decade. The Empire was the third Preston theatre to transfer its permanent allegiance from the safety curtain of the theatre to the silver screen of cinema, and so ended one of the last bastions of music hall in Preston.

From Safety Curtain to Silver Screen

In August 1930, management at the Empire Theatre (formerly a music hall) substituted the silver screen for a safety curtain when it became a full-time cinema to coincide with the coming on the talkies and to capitalise on the large seating capacity of 2,120. During the next decade, the talkie phenomenon brought a new batch of second-generation art deco cinemas to Preston, given contemporary names like the Ritz, Plaza, and Empress.

The Empire reopened as a permanent cinema on 11 August 1930, featuring the film version of the *Phantom of the Opera* no less. This must have been considered a serious risk to health, as Red Cross nurses were in attendance and patrons of a nervous disposition were advised to 'attend the afternoon performances, so that

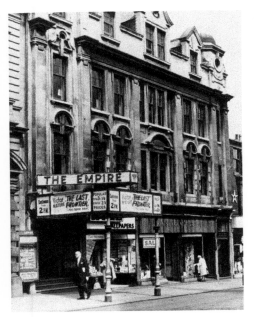

When the end of the Empire as a cinema was announced in 1964, the film showing that week was, somewhat poignantly, *The Last Frontier* starring Victor Mature. (Courtesy of Preston Digital Archive)

you will not be afraid to go home in the dark'. One of the most popular films to be shown at the Empire in the 1950s was *The Quiet Man*, starring John Wayne and Maureen O'Hara. I saw this film several times and enjoyed the opening shots of a quaint Irish steam engine on an equally quaint Irish branch line, the gorgeous Irish scenery and lovely music, all of which was in stark contrast to the climax of the movie, with the rugged John Wayne portrayed as an American ex-boxer reluctantly having a tough, prolonged fistfight and winning (naturally).

By the time of closure in 1964, the colonial British Empire was also dead and the group of countries that once formed the Commonwealth under the control of the sovereign state was rapidly dissipating. I was at the theatre to witness its last stages, and during the interval I pondered about the original fittings and the distinctive features of the Empire at the time of the opening.

Glancing round the vast auditorium, I noted that it had two tiers and two large stage boxes laden with gilded plasterwork and mythical cherubs gazing into space either side of the enormous proscenium. Access to the theatre from Church Street was by means of a long entrance corridor with an immaculate brass rail running its entire length, one side for going in and t'other for going out and where many a queue was formed during the theatre's heyday. At the end of the corridor stood the box office, with steps down into the stalls on the left and a grand marble staircase leading to the main circle foyer on the right of the box office. Apart from the provision of the super-wide screen and being denied access to 'the Gods', apparently for safety reasons, it was clear that very little had changed since those halcyon days of music hall.

The next and final change irreversibly transformed the building when the Empire Cinema finally transferred its allegiance to bingo in 1964. On 1 August that year, Pat Phoenix (Elsie Tanner of *Coronation Street*) graced the old stage once more to open the Empire Bingo Club, which ran for a decade. Ironically, the building was demolished in 1976 by a certain Albert Sparks and his team. The site of the former music hall has now been lost without trace and absorbed into apartments, which are appropriately known today as Empire House.

Colloquially speaking, the Empire Theatre was my very own Empire, where I marvelled at the epic film *The Robe* and Cecil B. DeMille's blockbuster film *The Ten*

Commandments in the late 1950s. Classic war films of the 1950s, including *The Dam Busters* and *The Cruel Sea*, tended to show the war as Britain's finest hour. However, the biggest thrill was to be in the audience to watch a nostalgic and somewhat surreal stage production of Stephen Romberg's *The Student Prince* in 1964. This window of opportunity arose when the Preston Musical Comedy Society persuaded the theatre management to reinstate the cinema as a theatre. The stage equipment tabs, safety curtain, orchestra pit and dressing rooms had lain dormant with no likelihood of resuscitation, but remarkably all of this was brought back to life from 4 to 9 May 1964. 'Raise the tabs, maestro take your cue.' The old Empire was reborn as a live theatre but the final awakening was for all too short a period. This was to be my very own journey into the history of Preston's entertainment industry to absorb the traditions of music hall and the variety theatre that was to inspire so much of my research.

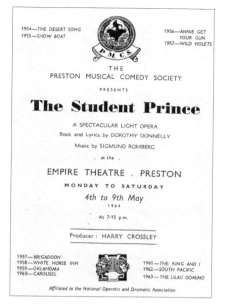

The Empire Theatre staged a full stage production of *The Student Prince* in 1964. (Author's collection)

The fall of an Empire. (Courtesy of Preston Digital Archive)

12

By Steam Train to the Music Hall

One Saturday afternoon during the 1920s, little Margaret Finch of Grimsargh inserted the princely sum of one penny into a Nestlé chocolate dispenser on Grimsargh railway station platform before catching the Longridge branch line train into Preston to see a performance of J. M. Barrie's *Peter Pan* played at the old Empire Theatre on Church Street. However, it was not only young Margaret that used the local branch line to visit the variety theatres, for the developing railway network that began in 1838 provided new horizons for all classes of people from far and wide who enjoyed the coming of the first music halls, theatres and circuses. Preston soon became a major junction, with considerable railway development at the time of late nineteenth-century railway mania. In Preston, the advent of the railways coincided with entertainment at the Theatre Royal and the emergence of the concert rooms or music halls of the 1840/50s.

Throughout Lancashire there is evidence that the Victorian music hall industry was closely associated with the railway network. Certainly railway companies, including the Furness Railway, offered favourable terms for travelling music hall artists:

On or after 1 October 1897, parties of music hall artists and their assistants, numbering five persons and upwards, will be conveyed distances above 20 miles at the undermentioned rates:
single journey – three fourths of the ordinary single fare, return journey – ordinary single fare and one half.
The tickets to be made available until the end of the tour; ordinary paper tickets will be issued to stations endorsed, music hall artists, only one half the ordinary cloak room charges are to be made to music hall artists. Luggage will be a minimum of one penny per package.

Long before the motor car revolution, the Victorian and Edwardian variety theatres began to feature international performances on a lavish scale, increasingly served by the railway, with improved mobility for scenery, costumes, animals and equipment. In addition, touring syndicates and theatre crew utilised the national railway network to visit the provinces, as did renowned music hall artists such as Marie Lloyd.

'Oh Mr Porter, What Shall I Do?'

Marie Lloyd's famous music hall repertoire included the railway-oriented song 'Oh Mr Porter, What Shall I Do? I wanted to go to Birmingham but they put me off at Crewe!' Fortunately, however, she caught the right train to Preston when she topped the bill at Preston's Royal Hippodrome on 30 October 1911. The *Lancashire Daily Post* gave a favourable report:

> Marie Lloyd heads a capital bill of fare at the Hippodrome this week and had a flattering reception at the matinee yesterday afternoon and in the two evening performances, large audiences appearing to hear the Queen of Comediennes. She did not disappoint her admirers. Bright and vivacious and tricky and smart in song and action, she soon won favour, varying her songs for each performance and introducing new ones among old favourites. A catchy couple of numbers which tickled the fancy of the audience immensely yesterday were 'Put on your slippers you're here for the night', and 'I haven't had a cuddle for a long time'.

Marie Lloyd sang a famous song, 'Oh Mr Porter, What Shall I Do?', at the Royal Hippodrome in 1911.

Marie Lloyd recaptured the music hall atmosphere at Preston and in the absence of adverse reporting it sounds likely that her broad humour and double entendre was acceptable to all classes, including the respectable lower-middle classes. The generic music hall cast included comedians, a vocalist and dancer, an acrobatic comedian and a Houdini-style Carl Mysto, 'the monarch of the manacles'. Lloyd was billed as the greatest success ever scored at the Hippodrome.

Notable entertainers and touring companies continued to have great reliance on the railways during the first half of the twentieth century while visiting the variety theatres and other seats of entertainment in Preston, including the old Preston Public Hall.

Many distinguished soloists and musicians featured in concert performances at the original Corn Exchange and its successor, the Public Hall of 1882. Captain J. Norwood presented his annual concerts for a period of forty years, attracting artists of the calibre of Dame Clara Butt, who gave a concert on 21 November 1900 while engaged on a national tour.

Paul Robeson, the great American bass singer, actor and activist, visited Preston in the late 1930s and gave a memorable performance while being accommodated at the Park Hotel, overlooking Preston's Miller Park. The extant impressive-looking building was sold by British Railway promptly after nationalisation. Robeson

probably travelled to Preston by the famous streamlined train the Coronation Scot, which ceased to run with the outbreak of the Second World War and would have passed through Preston on the West Coast Main Line.

An example of how the railways were used by famous entertainers. This first-class Coronation Scot luncheon menu is signed by Paul Robeson and dated 20 May 1938. (Courtesy of Mike Atherton)

Ladies and gentlemen, by way of an encore and commensurate with the age of the variety theatres, we proudly present for your delight and delectation a splendid portfolio of period steam trains that once conveyed passengers to the music halls of Preston and further afield.

How the Royal
Hippodrome and
Friargate would
have looked at
the time of Marie
Lloyd's visit to the
theatre in 1911.
(Courtesy of Linda
Barton)

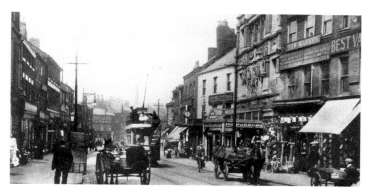

The newly rebuilt
Royal Scot 4-6-0
No. 6135 *The
East Lancashire
Regiment* at its
naming ceremony
at Preston station in
1947. (Photograph
by Douglas Willacy,
Courtesy of Martin
Willacy)

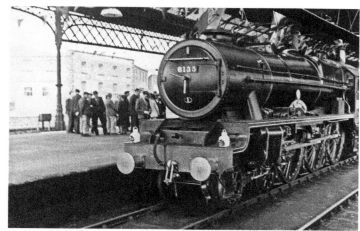

LMS Patriot No.
5515 *Caernarvon*
at Preston station in
1938. (Courtesy of
Frank Dean/Peter
Fitton Collection)

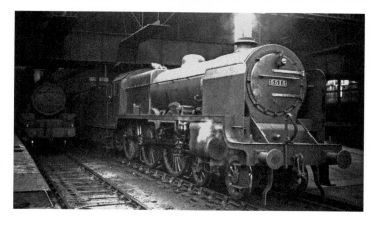

Above: Programme featuring London's famous London Metropolitan Music Hall.

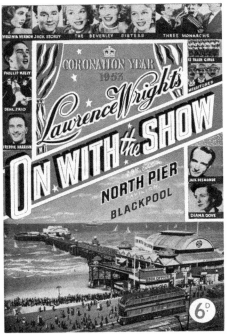

Above and below: Blackpool theatre programmes of the 1950s and 1960s.

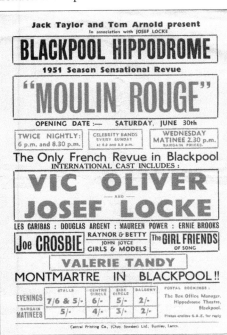

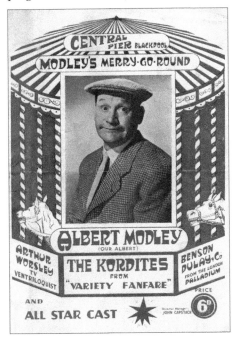

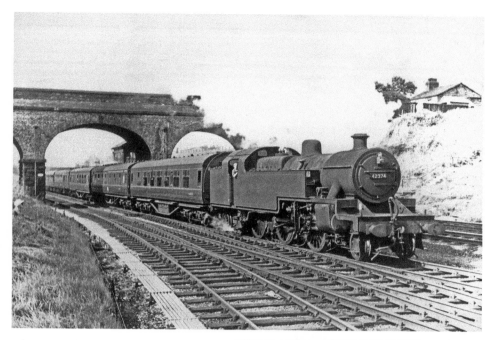

Above: Fowler Class 4 2-6-4 No. 42374 at Farington Junction with the 4.22 p.m. Preston–Wigan local service. (Courtesy of Stan Withers)

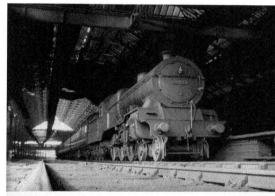

Let's all go (by train) to the music hall.

Right top is LMS No. 10437 at Preston station on 3 August 1935, with a Manchester-bound train. Right bottom is LMS Jubilee No. 5552 *Silver Jubilee* below Preston signal gantry during August 1937. (Courtesy of Frank Dean/Peter Fitton Collection)

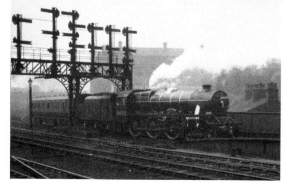

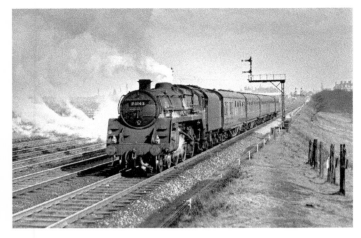

Standard Class
No. 73143 passes
Ribble Sidings south
of Preston with a
Blackpool Central to
Manchester Victoria
train on 4 April 1964.
(Courtesy of Peter
Fitton)

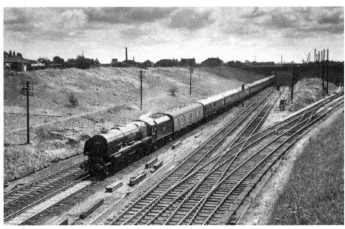

Coronation Pacific
No. 46254 on
Down Birmingham
to Glasgow at
Farrington Curve on
27 June 1961.
(Courtesy of Peter
Fitton)

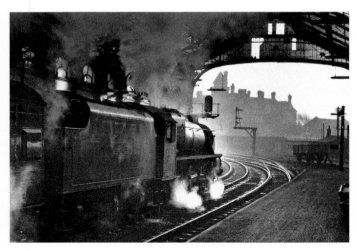

The impressive
architecture of
the Park Hotel is
framed by the station
building as Stanier
Class 5 No. 44926
departs Preston
with a Blackpool–
Liverpool train on
3 January 1964.
(Courtesy of Peter
Fitton)

More examples of the national music hall scene during the 1950s. Featured are productions at the Victoria Palace, London, starring The Crazy Gang; the Winter Gardens Pavilion in Blackpool, starring Tommy Cooper; and the Manchester Hippodrome's production of the Christmas pantomime of Puss in Boots on 31 December 1956.

13

By Tram to Preston's Pleasure Gardens

This chapter examines Preston's Pleasure Gardens, which opened as 'the Preston Nursery and Pleasure Gardens Company Limited', situated in New Hall Lane on a site now occupied by the Farringdon Park housing estate. The cotton industry reached its peak in the decade before the First World War, employing 30,000 people before the gradual onset of the industry's decline from around 1920 to the 1950s, when the industry was in turmoil. The town's working-class community and indeed other classes of society may by this point have found some time to visit the travelling fairs, menageries and circuses, or perhaps go further afield by train throughout the Victorian era. Suburban Victorian pleasure gardens such as at Preston were often served by the railway and local tramway network.

The concept of the pleasure garden has existed in many European cities for several centuries, and the idea led to many being opened throughout England during the eighteenth and nineteenth centuries. In London they included the stylish Vauxhall Gardens, first established in 1732. The English pleasure garden was fashionable throughout the Georgian period and reached its zenith in the Victorian era, when many contemporary pleasure gardens emerged in towns and cities, mostly generating widespread interest and national popularity. The formation of the old-fashioned gardens fundamentally differed from municipal parks insofar as they served as large-scale entertainment venues, and typical of the genre was the Preston Pleasure Gardens. The generic term pleasure garden was universal, though latterly Preston's was also known as Vauxhall Park, probably after its London counterpart.

Throughout the 1870/80s, Preston Pleasure Gardens competed with the popular pub concert rooms and, to a lesser extent, the legitimate theatre. However, there is little doubt that, at the height of its short-lived popularity in the Victorian era, an eclectic range of entertainment prevailed at this particular Preston hub of pleasure too. The attractions included football, boxing, dancing, military and brass bands and a zoo, as well as gardens and woodland walks. In addition, there were many spectacular ephemeral attractions, including balloon ascents and parachute descents, horticultural events, pageants, travelling menageries, music hall and circus performers and large-scale spectacles such as full-scale battle re-enactments and frequent firework displays.

The Origin and Development of Preston Pleasure Gardens

During the last years of the seventeenth century, the Farringtons, of the long since demolished Farrington Hall, Ribbleton, sold their estate to the Hesketh family of Rufford. In 1855, Preston Cemetery became a feature of the living landscape when Sir Thomas Hesketh sold over 40 acres and the newly consecrated ground hosted its first interment. Preston's Victorian Pleasure Gardens began to materialise after the remaining 43 acres of the estate, which was adjacent to the cemetery, was acquired by a James Huddart as the Farrington Hall Nursery. Preston Pleasure Gardens gradually became established within its parameters. The gardens were accordingly described by the Victorian historian and journalist Anthony Hewitson in his 1883 *History of Preston*: 'This land was sold in 1875 to the Preston Nursery and Pleasure Gardens Company Ltd.'

Shareholders were invited to pay £50 a share to raise capital of £20,000, and the proposal to develop the 90-acre site as a major public attraction became a reality. After being purchased, the company created the gardens and nursery as a leading attraction and greatly enhanced the natural features. Up to 8 miles of pathways were laid out and the wooded dingle at the eastern extremity of the site was rendered accessible to the public for the first time. The rocky, stream-lined gorge known as 'the Dingle' was redesigned with a cascading waterfall, and the natural fauna and flora, including a wealth of luscious green ferns, were utilised to enhance the development.

During Whitsuntide 1877, the site was officially opened to the public, who were welcomed on site to explore the gardens and wooded Dingle. Over the next decade, hundreds of thousands of Prestonians were to be enticed to walk past the lodge and through the new entrance gates on New Hall Lane as the nursery and gardens were gradually transformed into the pleasure gardens. The attractions included numerous greenhouses and a conservatory measuring 120 feet by 30 feet, which was said to make it one of the largest in northern England. Other popular attractions included a large dancing platform where patrons danced, twirled and swayed on 'the monster open-air platform' to the accompaniment of a military band directed by Captain J. Norwood. The Band of the Grenadier Guards provided additional musical entertainment and the Whitsuntide event was rounded off with a firework display, all emblematic of the style of entertainment provided at the English pleasure garden.

During July 1878, the Royal Horticultural Society held a grand provincial open-air show in the grounds, with planned variety and circus-style performances by high-wire walker 'Signore Jerome', balloon rides and Punch and Judy shows. Unfortunately, this prestigious event was ruined by bad weather and proved to be a financial disaster for the company; albeit the event was considered to be one of the finest horticultural events ever held in the provinces.

Alas, the uncertain commercial viability of the company had been compounded by a series of wet seasons and economic constraints, leading to the Preston Nursery and PPG going into liquidation in 1879.

A large section of the nursery was sold at auction in September 1880. However, during 1882 the pleasure garden was revived by another syndicate with ambitious proposals for the pleasure gardens. The pleasure gardens were now attracting around 4,500 patrons most weeks and probably reached their heyday during the same Preston Guild year, 1882, when several thousand people visited the attraction.

Tramcars were not only an important stimulus to the social and economic development of the town's outer suburbs but also meant that the public could now attend the out-of-town entertainment at Preston Pleasure Gardens as well as sporting fixtures at Preston North End and the new music halls of the Edwardian era. Preston's first horse-drawn tramway was opened on 20 March 1879 by the Preston Tramways Company and was sanctioned by Preston Corporation. Under the provisions of the Tramways Act 1870, the corporation was not itself permitted to undertake the actual operation. The new tramway was about 2½ miles long, with an original gauge of 3 feet 6 inches, replacing a horse bus service operated by Richard Veers that ran from the town centre to Fulwood Barracks. This first tramway was worked by six single-decker cars and twenty-five horses.

On 14 April 1882, work commenced on the expansion of the tramway network with the provision of two new routes to be worked by an augmented fleet of eight double-decker trams; one route ran from the town hall to Ashton-on-Ribble, and the other took a three-mile route linking the pleasure gardens and railway station with a Fishergate Hill terminus situated by the river near the Regetta Inn, an interesting old hostelry demolished in 1912 to make way for the Penwortham New Bridge spanning the Ribble.

The pleasure gardens venture was conveniently served by the tramway circuit, with the terminus next to the lodge and entrance gates. The gardens featured prominently in the Guild events and festivities. In fact, the new horse-drawn tram service was inaugurated to coincide with the late summer Preston Guild events of 1882, when the gardens attracted visitors from far and wide. It was promoted as being accessible by a combination of rail and the established tramway network – a spark for the modern transport interchange: 'tram cars from all the railway platforms, direct to the (pleasure garden) gates, every few minutes ... the new tram cars will, if possible, run every quarter hour after the processions have passed. Fare from Preston to the gardens 3*d*.'

Coinciding with the Preston Guild, the pleasure gardens featured all sorts of bizarre and extravagant events. They included famed stars of the circus ring, spectacular full-scale pageants and a pyrotechnic production, namely *The Bombardment of Alexandria*. There was 'a revolutionary balloon ascent by the celebrated aeronaut Captain Morton' and 'a grand display of fireworks plus an engagement of a first-class military band'. By contrast, tranquil woodland walks were offered through the Dingle – 'now illuminated by Brush electric lights'. The publicity also mentioned 'dancing on the extensive platform, specially reconstructed; entertainment daily in the crystal pavilion'. Furthermore, topping the bill during Guild Week was the legendary 'African Prince of the high wire Blondin'. The 'hero of Niagra' and famed tightrope walker Blondin had already visited Preston when he appeared at the Preston Theatre Royal on 14 September 1861.

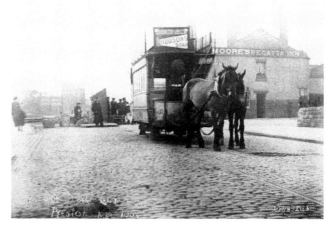

A horse-drawn tram pauses at the terminus alongside the Regatta Inn, Fishergate Hill, Preston, before commencing the 3-mile trek to the pleasure gardens. (Courtesy of Linda Barton)

The entrance to Preston Pleasure Gardens in New Hall Lane in 1906. (Courtesy of Preston Digital Archive/David Eaves' Collection)

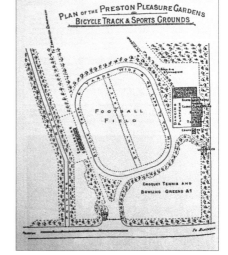

Plan of the Preston pleasure gardens during the late Victorian era. (Courtesy of Tony Worrall)

Preston Pleasure Gardens.

———:o:———

The most charming resort in Lancashire.

44 ACRES IN EXTENT.

Miles of walks in the gardens and woods.

Large Ornamental Lakes and Waterfalls.

Lovely Dingle, with splendid Woodland Scenery and Views of the Valley of the Ribble.

MONSTRE OPEN–AIR DANCING PLATFORM.

Large Covered Pavilion.

MAGNIFICENT BICYCLE TRACK.

THE FINEST FOOTBALL GROUND IN ENGLAND.

Large collection of rare Birds and Animals.

EXTENSIVE STABLING, AND EVERY ACCOMMODATION FOR GALAS OR DEMONSTRATIONS.

Tram Cars from all the railway platforms, direct to the gates, every few minutes.

Above: What's on at Preston Pleasure Gardens. (Courtesy of Tony Worrall)

For Sunday 20 August 1884 the accounts show an attendance of 2,853, with gate money of £36 2s 9d. The venture had by now established itself as a gateway to paradise, with something for everybody. There were regular sporting events such as football – with the gardens' own football team, known as 'the Preston Zingari' – boxing, cycling, bowling greens, archery and croquet lawns, a lake with pleasure boats and recreational gardens and refreshments. Boxing bouts featured 'Jim Mace the champion pugilist of the world sparring with the Australian champion, Slade'. Meanwhile, local lad Billie Ellis of Preston took a beating from Gus Porter of Manchester. In 1885, a 'New Dancing Pavilion with hot water making it very comfortable room at all times' became yet another attraction.

Preston's First and Last Permanent Zoo

A special attraction at the pleasure gardens was a zoological garden, managed in 1884 by the distinguished Norfolk naturalist and author Arthur Patterson. Over 200 birds and animals representing 100 species were accommodated in the zoo. Moreover, the range of animals probably came as a complete surprise to an unsuspecting public, who now got their first look at strange and exotic animals from all over the world. The menagerie included seals; five species of monkey, one of whom was called Bully the Monkey; a crazy-looking toucan; hungry vultures; and Peter the Baboon. There were even one or two guest appearances, including Jumbo II, the mighty elephant who stayed at the zoo for two months. It was reported of the elephant that 'thousands have seen him and gone away delighted'. Jumbo II was, for one reason or another, substituted by two camels that gave short rides in between the humps.

Unfortunately, records suggest that the animals had a low survival rate. During the week ending 27 August 1884, the manager presented his report to staff: 'Gentlemen, the following deaths have occurred since the last report, one toucan suffering from a swollen eye and a cold (this is the bird that was so addicted to fits on its arrival), one large cockatoo has died of asthma and one half-moon parakeet of inflammation of the lungs.' A post mortem was carried out into a seal's death:

Gentlemen, I report the death of a seal that has been dying for weeks, very likely since incarceration. On opening the stomach I found a variety of thread worms and would advise the company to waste no more money over seals. The experience of last year (when several died) and of this would go to prove that either something in the place itself or the animal's requirement is inadequate. I would advise that nothing be put in that hole for several reasons; the sum value of one seal would go to purchase two fallow deer and perhaps a pair of red deer and these would cost but a fraction of the cost of the seal.

Nevertheless, the writing was on the wall, not only for the wretched seal confined to its inglorious hole but also for the zoological aspect of the gardens.

The zoo closed in 1885, and Arthur Patterson moved back to Great Yarmouth, mentioning his experiences at Preston in his book *Nature in East Norfolk*. 'I tried to better myself by undertaking the management of a small zoo in Lancashire. I tried to bring order out of chaos and succeeded, though there was so much mismanagement amongst the directors ... that I found myself back in Yarmouth again.' So came to an end Preston's first and last permanent zoo.

Beryl Tooley wrote about her great-grandfather in her book *John Knowlittle* – Patterson's pseudonym – in which she records,

The zoo had been mismanaged for some time, and having become very run down, Arthur's job was to try to get it back into some sort of order. By careful dieting and sanitary methods, he reduced the loss of seven animals a week to an average of one death per month. Arthur made a feature of feeding the seals and monkeys, and in part of the winter garden – a large, glass building in which grew trees – he introduced white herons, cockatoos, peafowl and doves and called it 'The Great White Aviary'. He constructed other aviaries in the building, decorated the monkey cages with a trapeze and added to the zoo a collection of Barbary apes, a flock of demoiselle cranes, a Mexican tiger-cat, Coali Mundi and a fox. Arthur took an assistant – John 'Menagerie Jack' Evers – a hard-working lad who paid his mother's rent by breeding and selling guinea pigs and rabbits. John took over as keeper when Arthur left in 1884 until the zoo closed down in 1885 and he obtained work in Manchester.

The year 1885 saw yet another chapter in the history of Preston Pleasure Gardens, when they were leased by agent Thomas Shuttleworth on behalf of the lessor Thomas Horrocks Miller, of Singleton Park, Poulton-le-Fylde, to Messrs Janet, James and William Oakey of Preston. A press release at the time stated that 'several additional improvements have been made. The most important of these is the warming of the new dancing pavilion with hot water making it comfortable at all times. The arrangements both in the zoological and horticultural departments are such as are done to increase the pleasures and profit of all visitors. Messrs J. J. & W. Oakey will personally supervise the management.'

During Easter 1885 there was a grand fête, with the newspapers advertising implausible acts: 'Special engagement of Monsieur Descombes and Madame Laura

– a wonderful global performance: introducing juggling with tops, knives, torches, flags, balls, plates and finishing with Monsieur Descombes balancing a monster full rigged ship of war on his chin and firing a volley of 48 guns at the same time.' (How could he possibly manage that?)

'Also Madame Laura, without exaggeration the perfect and graceful lady – invisible wire equilibrist and manipulator – will perform some daring and extraordinary feats consisting of Japanese balancing, juggling and other evolutions. The gardens will be illuminated each evening with Chinese lanterns and coloured lights.' The day's events were typically concluded 'at 9 p.m. [with] a magnificent display of fireworks'. As a special Easter treat, admission prices for the 1885 event were probably just about affordable for the populace, the majority of whom would probably be textile workers and their families: 3*d* for Good Friday and Easter Sunday, with children half-price.

Professor Higgins and a Hot-Air Balloon

An Easter attraction at the pleasure gardens appeared in the *Preston Guardian* of 27 April 1899, which featured a detailed account of a combined balloon ascent and parachute descent by a certain Professor Higgins. The propaganda began by stating that

> the gardens now are charming. The trees are now bursting into leaf and the dingle, with its richly wooded slopes is one of the prettiest spots in the Preston district. The proprietors of the gardens spared no money to make the gardens attractive. On Sunday the Band of the Royal Sussex Regiment played Sacred selections. In the early part of the afternoon there was dancing.
>
> On Monday Professor Higgins made a parachute descent and the gardens were crowded. The preparations for the descent were in progress from the morning; large pipes were laid from the gas main and the balloon was gradually inflated. The parachute which contains a wicker basket was attached to the side of the balloon. The Professor, amid a round of applause from the thousands of spectators assembled got hold of the ring and the ropes of the parachute. The manager cried, 'let go' and the balloon rose into the air and rose about 2,000 feet and drifted in the direction of Salmesbury. The Professor let go of the balloon and descended with rapidity some yards, the parachute then expanded and the Professor gracefully descended into a field. The balloon fell in about fifteen minutes in the neighborhood of Cuerdale. The Professor on returning to the gardens was cheered and he made a brief speech. In the evening there were fireworks in the gardens.

Significantly, all of the foregoing attractions exemplify the style of mainstream entertainment at this venue which personified the contemporary national pleasure garden.

Departure of the Pleasure Gardens and Arrival and Departure of the Preston Speedway

During the late Victorian era, travel was more affordable and rail travel increasingly popular. The seaside was becoming increasingly attractive as the place to be for prolonged holidays, especially during wakes weeks, in preference to a day spent at the pleasure gardens. Victorian pleasure gardens also had to compete with the growing number of established municipal parks with free access. As happened elsewhere, English pleasure gardens were no longer in vogue and the Preston enterprise closed again for a period, owing to financial difficulties.

However, by 1904, Barrett's Leisure Directory referred to the leisure venue by the now familiar name of Farringdon Park, proclaiming it to be 'the most charming resort for extensive open-air gatherings in north-east Lancashire, incorporating a new half mile trotting track and racecourse, football ground and dancing pavilion'. By now the old horse-drawn trams serving Preston and Farringdon Park had been replaced by a fleet of thirty maroon-and-cream double-deck electric tram cars, which were manufactured by Dick, Kerr and English Electric at Preston. Their introduction led to the expansion and development of the outer suburbs and the continuance of services to Farringdon Park.

In 1925, Preston Grasshoppers Rugby became the tenants of the Pleasure Gardens site and four years later a motorcycle syndicate took out a subtenancy from the rugby club. The site became a motorcycle speedway between 1929 and 1932, managed by 'Preston Speedways Ltd', playing host to many international riders of great repute. The speedway attracted huge attendances of up to 14,000 and unfortunately there were several fatal accidents.

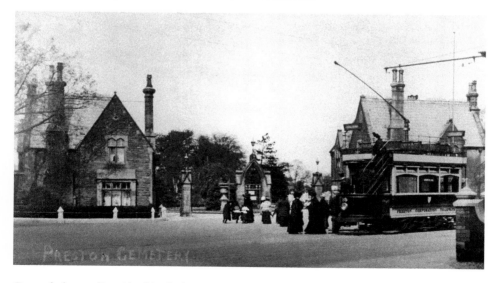

One of the earliest double-decker trams that replaced the horse-drawn trams is here pictured around 1910 at the gates of the old cemetery. (Courtesy of Preston Digital Archives/David Eaves' Collection)

On a brighter note, music hall celebrity George Formby won a challenge race while riding a two-stroke machine, his timing for the three laps of three-quarters of a mile being one minute and forty-five seconds; one way or another, it 'turned out nice again' for George. The film bearing his famous catchphrase was shot on location at Messrs Horrocks's mill at Crewdson, and some cotton workers appeared as extras.

In his memoirs, the late Arthur Edward Crook described his visits to the Preston Speedway, which are reproduced hereunder with the kind permission of his daughter Helen Crook:

> The track was at the Grasshopper Rugby Club. The ground was in the centre and the dirt track around the outer perimeter. The riders were stars like Joe Abbot styled the Cock of the North, Ham Burrell, Broadside Burton, Tommy Price, Frank Varey and the Chiswell brothers. They raced on Saturday nights but practised on Thursday evenings and you could go and watch for nothing. Therefore every Thursday we trotted up New Hall Lane to watch our idols belting round the track, throwing up a cascade of cinders in their wake. When Whit fare was on at Preston you can see them having a go on the Wall of Death, occasionally they would pander to our whims and sign autographs ... I could hear the roar of the bikes in bed. We had to leave before practice finished because we had to be in bed by eight o'clock. Sadly the speedway did not create enough interest, money wise, and after a few seasons the speedway track was closed.

Indeed, economic depression and widespread unemployment in 1932 meant that the site was probably no longer viable. Preston Speedway was short-lived and, with urban expansion, the site was taken over by Preston Council for the housing of council tenants. Sadly, the former glories of Preston Pleasure Gardens slipped into the annals of history. The present-day parameters of the former 44-acre pleasure park and subsequent speedway today comprise Farringdon Park housing estate, though the woodland legacy of 'the Dingle' remains. In recent years there have been attempts to restore 'the Dingle' to some of its former glory. Stone steps and a fish pond have been uncovered by job creation schemes, and in May 1977 hundreds of people turned up to see the Mayor of Preston perform a reopening ceremony to mark the centenary of the opening of the pleasure gardens – a golden nugget of Preston's social history, long gone but not entirely forgotten.

14

From Dugout Canoes to Preston Dock

Preston has been a port since medieval times, and there is even evidence dating back to the Bronze Age of human activity and primitive boats using the Ribble. Immortalised in the Harris Museum at Preston is a major archaeological legacy consisting of thirty human skulls, mammal skeletons, a bronze spearhead and two dugout canoes. All of the aforementioned were discovered deep beneath the surface of the riverbed during construction of Preston's Albert Edward Dock, providing real evidence that the building of crude wooden ships has taken place at Preston since prehistory. Furthermore, there is abundant evidence that the Ribble was used by the Romans, Saxons and Vikings for inland penetration, exemplified by the famous discovery of the Cuerdale Hoard in 1824.

Almost a century before the official opening of the established Albert Edward Dock, the commercialisation of the first Port of Preston was contemplated in 1806, under the governance of the first of three Ribble Navigation Companies, the three covering the periods 1806–38, 1838–53 and 1853–83 respectively. The first company undertook to straighten, strengthen and deepen the river for shipping and to finance the work by land reclamation. Initially, large rocks were unearthed from the riverbed and the channel was reinforced with stone groynes and distinguished with beacons and buoys. The third such company was established with powers to reclaim more of the tidal stretches and mudflats of the river, with the creation of around 4,000 acres of arable farmland, and also, significantly, to implement radical measures that would see the Ribble channel diverted to facilitate the construction of the Albert Edward Dock, opening in 1892.

A new riverside quay was opened in 1825 to cater for an increase of shipping from fifty ships in 1805 to 400 in 1820, and in 1828 the first of a new generation of steamships, the *St David*, navigated the river. The *Preston Guardian* of 1845 provides an illuminating insight into what was then a busy port with plenty of activity and lots of tall sailing ships: 'The New [Victoria] Quay was so thronged that the schooners were obliged to lie three deep ... We observed twenty-two vessels at their stations.'

At the height of Preston's booming textile industry in 1848, thousands of spectators lined the banks of the Ribble to watch the arrival of the first 300-ton sailing vessel from New Orleans with cotton and corn from that same place. Commensurate with trade imports on this scale to the Port of Preston, a branch line was constructed from Preston railway station to serve the quay in 1846 and the Victoria bonded warehouse, the latter completed on the quay in 1843. The Preston Dock Branch Line, as it came to be known, was ultimately extended to serve the new docks in 1882 with 28 miles of sidings.

The (extant) single-line railway descended from the south-west of Preston station through a narrow, brick-lined cutting and short tunnel beneath Fishergate Hill, across Strand Road and into the dock estate. The railway became the property of the Ribble Navigation Company at the exchange sidings and here the company's own steam locomotives took over the train. In addition to the Victoria Quay, several local industries were subsequently served by the railway, including Dick, Kerr (later English Electric) on both sides of Strand Road and Page & Taylor's saw mills, the latter being reached by a level crossing over Watery Lane.

Preston also had its own shipbuilding industry, with several riverside yards manufacturing a range of wooden, iron and even concrete vessels as well as a shipbreaking yard throughout most of the nineteenth century. The Preston historian Whittle gives details of a wooden paddle steamer, the *Enterprise*, that was built on the banks of the Ribble just downstream from Fishergate Hill and launched at Preston on 23 May 1834. This particular vessel was later destined to become a famous 'ferry across the Mersey', operating between Woodside and Liverpool.

During the infamous cotton famine, which drastically hit Preston's major textile industry of spinning and weaving, the original port of Preston and associated industries provided employment for a male-dominated workforce, and during 1865 – at the end of the period of severe hardship and destitution – it was perhaps timely that a committee was convened to explore the future of the Ribble navigation. A survey was commissioned by Messrs Bell & Miller, who recommended that the river be straightened and that a wet dock be created as an alternative to an ailing textile industry, thus improving the overall economy. The diversion of the river and the construction of Preston Dock, however, did not transpire until the assent of an Act of Parliament in 1883.

Nevertheless, on 21 February 1865 a company trading as 'The Preston Iron Shipbuilding Company' built its first ship, the *Ada Wilson*, in the yard of the newly formed company, which was situated at the marsh end of the River Ribble. When launched, she was the biggest Preston-built ship to date; a two-mast screw-driven schooner weighing 500 tons, with an overall length of 200 feet and with accommodation for forty-two first-class passengers.

Preston Corporation has long played a part, along with the private sector, in the history of shipping on the Ribble. The Mayor of Preston and several members of the corporation were present to see Mrs Ada Wilson, the wife of the company's chairman, officially name the vessel. Unfortunately, due to a particularly high tide and a restraining chain being broken, her namesake collided with the opposite bank.

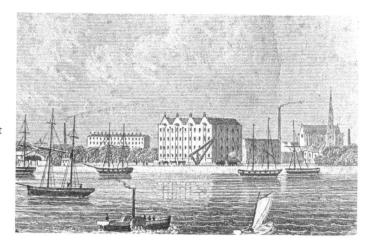

Early days of the Port of Preston, with the Victorian bonded warehouse (now demolished), built in 1843 (centre). (Courtesy of Stephen Sartin)

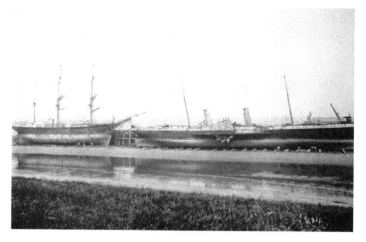

During the late Victorian era, the Ribble played host to a number of different types of ships that sailed to Preston for the last time to be broken up at the firm of T. W. Ward's Shipbreaking, Preston. Pictured are the *Carrie L. Smith* (left) and the paddle steamer *Donegal*.

Bagnall 0-6-2ST *Energy* shunting loose-fitted wagons on the Preston Dock system. The building behind is the Victorian bonded warehouse and beyond is the Strand Road GEC Works. (Courtesy of Stan Withers)

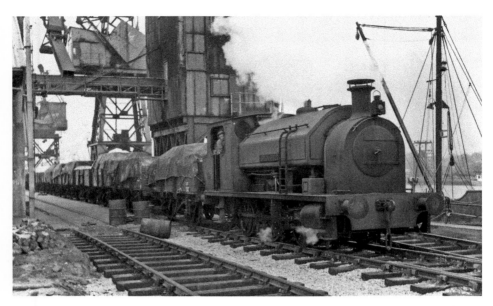

Bagnall 0-6-0ST *Conqueror* in its familiar habitat alongside the Preston Dock basin. (Courtesy of Stan Withers)

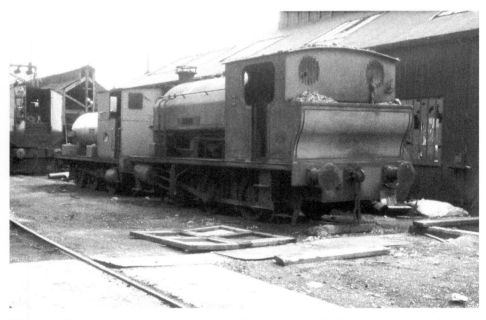

The smokeless locomotive *Duke* and Bagnall 0-6-0ST outside the engine shed on the dock estate. (Courtesy of David Eaves)

Fortunately no damage was caused and the incident was attributed to the incorrect angle of the slipway. The vessel's position was corrected and she was lined up against the quay in preparation for being towed to Liverpool to be fitted out.

At a celebration luncheon held at Preston's Red Lion public house, a co-director of the company expressed optimism for the future of the Port of Preston when he spoke about seeing the Ribble crowded with ships, stating that 'the Ribble is far better than the Clyde for navigation' and adding that the 'population of Preston would double itself in thirty years if docks were laid down'. Furthermore, he pronounced that if dry docks had been built during the period of the cotton famine then yet more of the town's workforce would have been gainfully employed. 'They [the corporation] would have wanted very little relief from the funds for distressed operatives. They would all have been found work in shipbuilding or the adjuncts thereof in Preston.'

During 1873 yet another firm, William Allsop & Sons Ltd, shipbuilders, engineers and iron founders, established three separate yards along the river. Shipbuilding and repairs at these yards generated work for up to 600 employees. At the peak of the industry it was not unusual for about five steamers, ranging from 50 to 1,000 tons, to be alongside on the gridlocks for repair. The other side of the business saw an eclectic range of brand new tugs, coasters, paddle steamers and barges launched down slipways into the river – there is today still evidence of one such slipway near to Penwortham Bridge. William Allsop & Sons Ltd continued trading until around 1905.

During 1907, Mr David Monk acquired the paddle steamer *The Marquis of Bute*, built in 1868 by Barclay, Curle & Co., to run pleasure trips from Preston along the Ribble. His business was not successful, however, and after making a few voyages, the vessel was broken up only one year later.

A plan put forward by Sir John Goode in 1882 examined the concept of a new dock. In the same year, Alderman Edward Garlick was elected mayor and it was he who became the main protagonist in the creation of the Albert Edward Dock and saw the scheme reach fruition. Preston Corporation became the owners of the Ribble Navigation Company after purchasing their assets for £72,500 in 1883.

The Ribble Navigation and Preston Dock Act 1883 gave the corporation the navigation rights to develop the dock as a major port. Before the work was inaugurated, the meandering River Ribble had taken an indirect course between Ashton Marsh and Penwortham, at times bordering what is now Strand Road and Watery Lane. Work commenced on the massive engineering project to divert and straighten the river for a distance of 2,800 yards. The purpose-built Albert Edward Dock was to occupy a 40-acre site created by reclamation of the original course of the river.

The first sod was cut on 11 October 1884 and on 17 July 1885 the Prince of Wales (later to become King Edward VII) laid the foundation stone for the new dock. The enormous undertaking necessitated the excavation of around 5 million cubic metres of solid rock, earth, sand and gravel to form the main wet dock basin and a 5-acre tidal basin. The latter was to be separated from the river by two huge sets of lock gates with a restricted 60-foot passage. On 21 May 1892, a temporary concrete dam was breached to allow the huge basin to fill with water for the first time.

The laying of the foundation stone by HRH the Prince of Wales for the new Albert Edward Dock, which took place on 17 July 1885. (Courtesy of Stephen Sartin)

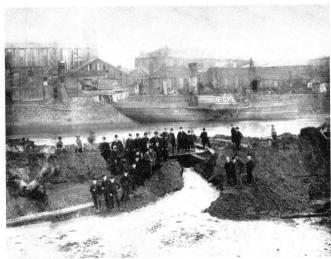

Engineers and officials witness the breaching of the dam during the construction of the diversion channel on 24 March 1888. Also illustrated is William Alsup's shipbuilding yard. (Courtesy of Preston Digital Archive)

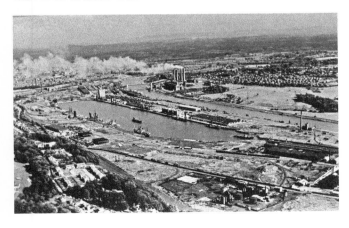

The Albert Edward Dock with the River Ribble and old power station. (Courtesy of Stephen Sartin)

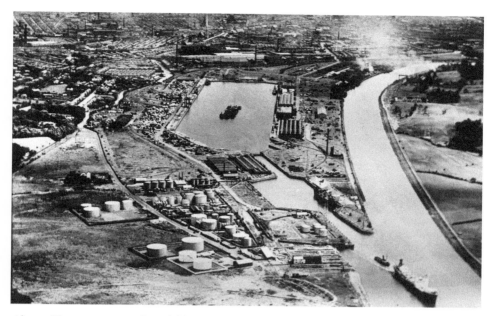

Above: The entrance to the tidal basin and main dock. (Courtesy of Stephen Sartin)

The Albert Edward Dock opened for commercial trading on 25 June 1892, immediately following the official opening ceremony, performed by Prince Albert, Duke of Edinburgh and second son of Queen Victoria. The steam yacht *Aline* played a prominent part in the ceremony and was the first vessel to enter the dock, with the royal party on board. The yacht headed a flotilla of private and commercial ships which included the *Hebe*, the first cargo vessel to use the dock, laden with cement. Preston was by now at the hub of the road and rail network and was also the administrative centre of Lancashire County Council, and trading augured well for the future. However, it was not all plain sailing during the dock's ninety-one years.

A continuing Preston Dock roller coaster ride saw the port handling 2.5 million tons of trade in 1968 but by the 1970s imports and exports had halved. Transport Ferry Services transferred their company to Cairnryan in 1974, one of several crucial trade setbacks for the ailing Port of Preston.

A formidable obstacle, of course, was that shipping along the course of the Ribble was always entirely tide-dependent. Moreover, the unceasing silting of the channel and estuary necessitated the constant attendance of a fleet of around five dredgers. The restricted tidal approach and poor trade figures led to crippling financial losses that were unsustainable. Preston Corporation made a decision to close the dock in October 1976, with the loss of 350 jobs, and to implement the drawn-out legal complexities that comprised the Preston Dock Closure Act 1981. On 31 October 1981, the melancholy distinction bequeathed to the last commercial vessel to use the dock was somewhat poignantly given to a sand dredger, the *Hoveringham V*, and the landlocked Port of Preston came to an end after almost a century of trading.

Two unidentified schooners are pictured berthed at the south wall of the main basin, in all probability carrying either China clay or timber, around 1920. (Courtesy of Preston Digital Archive)

A trading schooner and steam ships in the main Albert Edward Dock around 1925. (Courtesy of Preston Digital Archive)

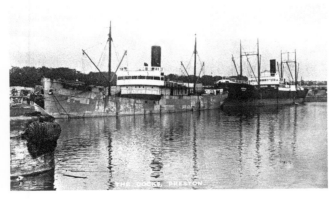

Two period ships in the Albert Edward Dock, which was the largest single dock basin in the UK. (Courtesy of Preston Digital Archive)

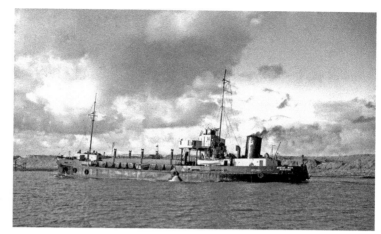

The steam sand pump *Robert Weir* sails down the Ribble to dredge the estuary. (Courtesy of John Barnett)

A tugboat meets a ship about to enter Preston Docks. (Courtesy of John Barnett)

Shipping on the Ribble. The *Bardic Ferry* at Freckleton on route to Preston Docks around 1971. (Author's collection)

Left: Prior to closure of Preston Dock in October 1981, only a few ships were using the facility including *Whest Trade* (top) and *Smarago* (*centre*). (Courtesy of Peter Fitton)

This page bottom & opposite, top: Many Prestonians will remember the former Isle of Man ferry TSS *Manxman*. This grand old vessel managed to circumnavigate the river to Preston Dock to become a floating nightclub. Above are two views of TSS *Manxman* off Lytham accompanied by a flotilla of yachts while en route to Preston Dock on 3 October 1982. (Courtesy of Peter Fitton)

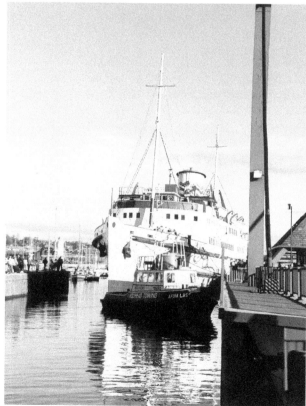

Sadly, the owners decided to relocate TSS *Manxman* and she left Preston Dock (right) on 4 November 1990 and was towed up the heavily silted channel to the open sea to Liverpool, and, eventually the scrapyard. (Courtesy of Peter Fitton)

To the Manor Born

Many years ago I walked, with my parents, along a public footpath overlooking Horse Shoe Bend close to the River Ribble between Preston and Grimsargh. Somewhere in my psyche I have the vaguest of recollections of seeing the forlorn shell of an imposing building awaiting its ultimate fate. This was what was left of Red Scar Manor shortly after the Second World War. Atmospherically, it seemed to be adorned with a shroud of mystery and antiquity as well as charm, belied by the march of progress. What was it really like in its heyday? An enchanting old English baronial-style manor house, with a resident butler and servants that echoed to the sound of both merriment and quiet dignity. It would only have needed a wandering minstrel at the door and a couple of falcons outside to complete an imagined distortion of the progress of time, and this time warp no doubt prompted me to dust away the cobwebs and recall the halcyon days of the manorial house and the country squire. Throughout the Victorian era, Red Scar Mansion, situated 3 miles to the north-east of Preston, became the home to three generations of the Cross Family, several of whom were born at the Manor House.

William Cross and His Love for Red Scar

The standard histories of Preston and Grimsargh tell us that the manorial rights of Grimsargh and Alston were long vested in the family of Hoghton and that the manor passed from the Hoghtons to the Cross family. The land had firstly been in the ownership of Sir Henry Hoghton, and then of his son, Sir Henry Philip Hoghton, Bart, each in turn Lord of the Manor of Alston. The manor was sold by Sir Henry Philip, Bart, to William Cross, seated at Red Scar, for the sum of £630 on 2 May 1803. William Cross was Lord of the Manor in 1807 and was succeeded by William Assheton Cross (1827), William Cross (1883) and Katherine Mary Cross (1916).

The Cross family, freemen of Preston, have figured in the Guild Rolls from 1700 to modern times. The family originated in Barton and Goosnargh and carried on business as tanners. There is no doubt they achieved high social status, but they were nevertheless sincere and genuine in their efforts to do well to others. Their devout religion was expressed in regular church worship and

successive generations of the family became closely linked with St Michael's church, Grimsargh. Two sisters, the Misses Mary and Margaret Cross, lived at 'The Hollies', Barton, close to the A6. They were known for their generosity and at considerable personal expense had the steep hill on Lancaster Road (A6) at Barton lowered. This was simply because the sight of horses pulling heavy loads to the top of the hill distressed them. Their compassion was duly recognised with an on-site memorial stone. Mary Cross also donated large sums of money to charities and founded the Royal Cross School for the Deaf, formerly situated at the top of Brockholes Brow in Preston.

John Cross, third son of William of Barton Mill, settled in Preston and became an attorney there. He was born in 1742 and in 1770 married Dorothea. Evidently maintaining family traditions, he was generally known in Preston as 'Honest John Cross'. William was born in 1771, and Dorothea died shortly thereafter, in

Painting of Red Scar in its tranquil setting above Horse Shoe Bend by Albert Woods. The extant copper beech tree left of the house today marks the site. The thatched section (right) was the oldest part of the building. (Author's collection)

August 1771. Following the death of his mother, the young William was brought up by his maternal aunt Mary (related to the Asshetons of Downham Hall, Clitheroe) and educated at Clitheroe Royal Grammar School. William studied law at Lincoln's Inn and while there he admired the London squares and was inspired to create one for Preston. On returning to Preston from his legal studies in London, William Cross became a notable lawyer and took up residence with his father in a house in Fishergate. This was about the time when the aristocratic upper and middle classes began to move away from the town-centre streets to other, more fashionable areas. Indeed, John Cross, who owned much of the land around the Avenham area, had commenced to build his own house in voguish Winckley Street, Preston.

On his father's death in 1799, William was appointed deputy protonotary and, together with his aunt Mary, moved into the newly completed house at No. 7 Winckley Street that had been built by his father. William purchased Town End Field – adjacent to his home – from Thomas Winckley and thus fulfilled his ambition by creating Winckley Square, which he divided into smaller plots and leased to local residents. Most of the early residents of Winckley Square were cotton manufacturers and members of the legal profession, and William was a welcome guest everywhere in the neighbourhood. During the twentieth century the square took on its present appearance, with winding paths and mature trees organised in the manner of J .C. Loudon.

Winckley Square was prosaically recalled by a writer in a contemporary journal published in 1861:

Chapel-street leads to Winckley-square, the garden part of which is large and sloping to a hollow, in which vegetables are cultivated and clothes hung out to dry. This piece of utilitarianism is scarcely called for, and must be an eyesore to the handsome houses at the upper end of the square, including Nos 20, 21, 22, and 23. At the corner of the square and Cross-street, the Philosophical buildings and Grammar School form a shewy pile in the Late Domestic Perpendicular style in fashion some few years back; full of movement, with bold projections and recesses, bosses and oriels, traceried window-heads and good carving. The Octagon turrets to the entrance of the Grammar School are surmounted by Moorish tops, and the deeply-recessed doorway is as massive as the entrance to a castle. The Philosophical buildings of themselves would have formed but an inconsiderable group, but these assimilated with the Grammar Schools, a noble pile is gained. This is an instance of the great advantage of clustering public buildings together. In the playground of the Grammar School we were sorry to see that the four corners were converted into open urinals by the boys. In the street, too, open channels are running with soapsuds across the pebble pavement, and a general want of scavenage is apparent. An Italian villa occupies the opposite corner of Cross-street, and a statue of Sir Robert Peel stands within the railings of the square at this point; so that want of neatness in the road and footways, and the planting of vegetables in the square, are blemishes to a very

good neighbourhood. Returning by Winckley-street, we pass the Coroner's and County Court offices, which are shabby, dirty, old buildings.

William Cross toured extensively on horseback, and 3 miles to the north-east of Preston at Grimsargh with Brockholes he discovered Red Scar Cottage, overlooking the 'sweet Ribble', as he called it. He fell in love with the area and purchased Red Scar in 1803, and commenced transforming the house into an impressive, imitative timber-and-plaster mansion. Professional advice was provided by a friend, Mr Rickman, a well-known architect. The completed house incorporated the original and mysterious thatched cottage of cruck construction, built in the late Jacobean architectural style, at the north-east end of the building. At one end of this, the oldest part of the building, there was a beautifully carved altar with two wooden candlesticks that was thought to have been a late medieval place of worship used by pilgrims. A door led to a small room behind the altar, which was very likely used as a retiring room for the preacher. Close by, another door opened into a tiny, pitch-black dungeon.

Following extensive research, the truth is that history books can throw little light on the true origins of Red Scar. The seventh volume of the *Victoria County History* (Farrer and Brownbill) states that the house probably dates from Elizabethan times but is so much restored and added to that few of its architectural features remain. Red Scar was enlarged and altered in 1798 (and again in 1840), when the library was added.

However, the deeds provide some clarification of what was reserved unto the Lord of the Manor of Alston:

All the woods and timber on the estate and all manner of mines, quarries and delfs – Power at all times, together with his workmen or agents, to enter the land and fell any timber and mine any mineral and cart them away – could erect any buildings or engines, sink any pits, make any drains or trenches, using any means whatsoever that might be necessary for the working of such mines etc. – had all manner of free warren [i.e. the right to take game) could enter the land to take to hunt hawk, kill fish, or take away all manner of game, fish and wild fowl. Could enter the land at any time to inspect the state or condition thereof – get clay for brick, sand and gravel and other materials for the making and repair of roads and carry them away 'making a reasonable satisfaction for the damage done thereby.

Before moving into Red Scar permanently, William spent his weekends working at the house, going to St Michael's church at Grimsargh on Sunday morning and often walking home through the woods via Elston. In the evening he would cross the Ribble, presumably by ferry, and go to evensong at Samlesbury church. Extracts from a letter from William at Red Scar to his friend, a Mr Gorst, dated 23 February 1804, express his sentiments:

Dear John, I am amusing myself here today with a few spade men, and after a good snack of oatcake and buttermilk I have prevailed upon myself to sit down

Above: The wooded entrance to Red Scar. (Courtesy of Preston Digital Archive)

for a few minutes, and cannot better employ them than in reminding you the scheme once laid down for you becoming my neighbour upon the banks of this sweet river ... The edge of the bank is very beautiful and commands a noble view of the river and valley.

Mr John Gorst was a great friend of William Cross who resided in Winckley Square and died in 1825.

William met and married Ellen Chaffers of Everton, Liverpool, in 1813, when he was forty-two years of age. They took up permanent residence at Red Scar, enjoying marital bliss amid the cherry blossoms of the woodland estate, savouring its beauty and purity. In correspondence to his friends, William wrote that 'no man ever had a more happy marriage'. William continued to be absorbed in his work for the various churches and in political work for the town but sadly, at the age of fifty-six, he caught a chill. This developed into inflammation of the lungs and his condition rapidly deteriorated. The doctor

bled him, which was said to be a common practice in those days, but he died on 4 June 1827.

Many townsfolk mourned his passing. A Canon Parkinson wrote,

> He loved beauty of every kind, whatever was beautiful because it was beautiful, Gothic architecture, music – Handel and Mozart – were his delight – the same in scenery. The will of his god was the law of his life, in small as in great occasions. No one ever heard from his lips a calumnious censure or ill-natured remark. He was never so happy as at home, but all his domestic pleasures were mixed up with religion and hallowed by it. If a child was born to him we find an entry in his Bible with the addition, '*Laus Deo*'.

With the help of her three sisters and staff, Ellen carried on the work of the estate and the raising of her family of four sons and two daughters. Ellen, along with the trustees appointed by William Cross, negotiated all the subsequent sales of the plots of land in Winckley Square. Ellen Cross outlived her two daughters and saw her four sons grow to manhood. Ellen died in 1849 and is buried together with William in the nearby chancel of St Michael's church, Grimsargh.

Following his father's death in 1827, his eldest son, William Assheton Cross, became the Lord of the Manor and married Katherine Matilda Winn. They had eight children (see family tree below). As Colonel William Cross he served in the Crimean War, and while at home he was interested in music, even building himself an organ. The organ was housed above the altar in a space known as the minstrels' gallery in the oldest part of the thatched building, and to further add to the overall mystique it was next to an ugly-looking death mask. One can imagine the colonel playing his organ in this setting, which all sounds quite bizarre! He was a keen astronomer and had two observatories built at Red Scar, where he installed some excellent scientific equipment and powerful telescopes. Day-to-day running of the estate saw him carrying out many improvements to the farms and implementing land drainage. He was a good and respected landlord and continued to buy farmland.

One of the four sons, the Reverend John Cross, became prebendary of Lincoln Cathedral. He was devoted to church architecture and invested £3,000 to rebuild Grimsargh church in 1868 in memory of his parents. As a boy he had been a pupil of Archdeacon Dodgson, the father of Lewis Carroll, and played a great part in improving church music. The Reverend Cross was fond of sailing his own yacht and published an account of his voyage to Iceland in 1853. The keen sailor would have a tale to tell to his future father-in-law, who just happened to be Admiral of the Fleet, Sir Phipps Hornby GCB.

His brother Richard Assheton Cross was born at Red Scar and went on to become a politician of distinction and a confidant to Queen Victoria. He represented Preston as a Conservative from 1857 to 1862 and later was returned as Member for South West Lancashire, having defeated Mr Gladstone. On the death of his eldest son, Thomas Richard, in 1873, Queen Victoria wrote to him:

I cannot remain for a moment silent without expressing my heartfelt, deepest sympathy in this hour of terrible affliction. You know my dear Lord Cross, that I took you on as a kind and faithful friend and that therefore I do feel most truly for you. It is inexplicable that a young and most promising, useful life should have been cut off when he could have been of such use to his sorrowing family and his country.

Lord Cross became 1st Viscount Cross, and between 1886 and 1892 he was Secretary of State for India.

Viscount Cross summarised his life in his family history, putting on record the following extract:

At the dissolution of Parliament in 1868, much to my surprise and greatly to my delight I was asked to stand for the division of south West Lancashire against Mr Gladstone, together with Mr Charles Turner, one of the former members. We had a tremendous battle and came off victorious, Mr Gladstone retiring to Greenwich. It was soon after the Election that we went to live at Eccle Riggs, which we afterwards enlarged in 1887 [which still stands today at Broughton in Furness, Cumbria]. Since that time my sayings and doings are public property. It does not rest with myself to say anything about them. I will only place on record

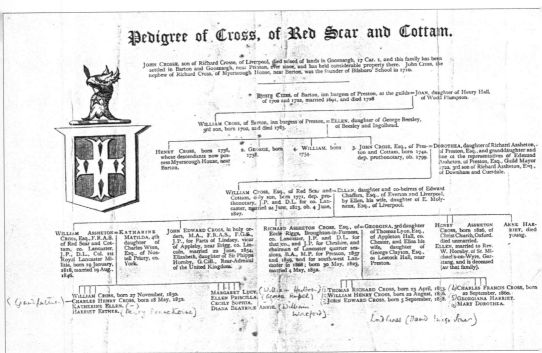

Pedigree of the Cross family. (Courtesy of Anthony Assheton Cross)

that altogether I have been a candidate at eight elections, six of them very hardly fought, and that I had the good fortune never to be beaten. That I have had a seat during the Cabinet during four administrations, and that I have received many favours from my Sovereign; as to my public life I will say no more. If you look back to my father's sayings, you will find a very accurate description of my own married life. I will conclude with the words which I find so constantly recorded in my father's diaries: '*Laus Deo*'.

Viscount Cross died in 1912 at the age of ninety years. He wrote of Ellen Dorothea and Anne Harriet, his two sisters, 'My sisters were both delightful, both good looking, both musical, both very fair artists. I have a lovely spray of pink hawthorn painted by Ellen and a group of fruit in sepia painted by Harriet. Both wrote very fair verses. Harriet died when only seventeen years old and is buried at Grimsargh. Shortly before her death she poignantly wrote a poem about her Bible.' Another of the sons, Henry Assheton Cross, also died young and unmarried, in 1851 at the age of twenty-five years. At the time of his death he was still a medical student at St George's Hospital, London. He was buried at St Michael's, Grimsargh, and left one year's income to his brothers in trust for 'such charities as they shall deem most expedient'.

William Assheton Cross died in January 1883 and his funeral service was duly reported in the *Preston Chronicle*:

With marked simplicity and an entire absence of ostentatious mourning, the obsequies of the late Colonel W. Assheton Cross, of Red Scar, Preston, were

A stylised caricature of Viscount Richard Assheton Cross. (Courtesy of Preston Digital Archive)

performed on Wednesday at Grimsargh Church. No invitations were sent out to the gentry and the attendants at the funeral beyond the relatives of the deceased comprised only of those gentlemen connected with Colonel Cross in his Magisterial work and one or two friends. Leaving Red Scar shortly after 12 o'clock the cortege proceeded slowly through the grounds and up the Longridge Road to Grimsargh Church. About twenty of the principal tenants on the estate walked in front of the hearse then, in the carriages which followed were Mr William Cross, the deceased's eldest son; his brothers, the Reverend Canon Cross and the Right Honourable Sir Richard Assheton Cross M.P., and his sons in law, Captain Pennethorne and Mr W. W. B. Hulton his brothers in law Mr Rowland Winn M.P. and Mr Edmund Winn and many prominent people. The coffin was received by the officiating clergyman, the Reverend Phipps Hornby, Curate of St. Michael's on Wyre, who preceded the remains reading as he went the Church of England Burial Service. A minor voluntary by Mozart was played and afterwards Mr Stothert played 'Dead March' in Saul. On the conclusion of the Service the coffin was carried to the Vault in the Churchyard, where lie the remains of Mrs Cross who died in April 1871. Friends gathered round the vault to take a farewell glance at the shell which contained the remains of one whom they had held in the highest esteem. Upon the shield of the coffin was the inscription, William Assheton Cross – born 19 May 1818 died 25 January 1883.

Red Scar and Horse Shoe Bend – 'Truly an Eden Spot'

In the southern corner of Brockholes, the wooded landscape rises precipitously from the river. Red Scar was so named after several landslides revealed the red scars of clay above the bend in the Ribble at the aptly named beauty spot of 'Horse Shoe Bend'. The quaint and beautiful Red Scar House stood proudly on a plateau surrounded by copper beech, giant oak and beech trees overlooking one of the most picturesque stretches of the Ribble Valley, and situated in a peaceful agricultural and woodland setting overlooking the meandering River Ribble. Fine oak furniture and portraits of the Cross family graced the oak-panelled dining room, music room, drawing room and library.

At the front of the building's prime location there were beautiful gardens, an orchard and two observatories, which were the private domain of Colonel William Assheton Cross. To the rear of the house, the servants' quarters overlooked a cobbled courtyard with an adjoining dairy, stable and byres, giving the whole a charming and aesthetically pleasing appearance. The renowned landscape artist Joseph Mallord William Turner (1775–1851) visited Red Scar in 1816 and completed a panoramic graphite drawing of Horse Shoe Bend on the River Ribble, looking north-east toward Pendle Hill. The manor house can be clearly seen in its woodland setting atop of the escarpment. Turner sketched the house in greater detail in the Yorkshire 2 sketchbook. The famous artist was based on the last leg of his northern England tour at Browsholme Hall near Clitheroe as the guest of his patron, Thomas Lister Parker.

Exactly the same view as Turner's was recorded by J. B. Pyne in a watercolour in 1828 and in an engraving for Hardwick's *History of the Borough of Preston*, published in 1857. Red Scar was recognised as a scene of unrivalled beauty by local historian Charles Hardwick, who published his *History of the Borough of Preston and its Environs* in 1857. It is not generally known that Hardwick was also a skilful amateur artist. Describing how the trees 'cling tenaciously to the crumbling earth', he adds that 'the subject is not quite wild and savage enough for the pencil of Salvator Rosa'. Such a comparison of Red Scar Wood with 'Savage' Rosa (a seventeenth-century Italian landscape painter known for his wild and rugged scenes) would have come more easily from an eighteenth-century tourist to the Lakes in search of the picturesque rather than a Victorian local historian!

Hardwick describes the scene standing upon the plateau overlooking Red Scar:

No single picture can do justice to this beautiful and unique scrap of English scenery. The whole is not presentable on canvas from any one point of view. It contains, rather within itself, a complete portfolio of sketches. It is a place to ramble about in, and not simply to stand staring at, truly an Eden spot, fashioned

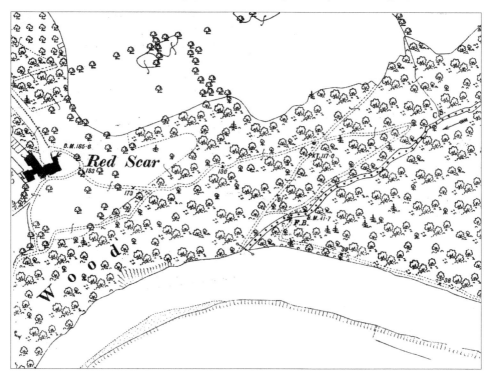

Red Scar Manor, indicated in black (left), nestled in woodlands above the Ribble escarpment to the north of Preston in 1893. To the right is the wooded valley of the Tun Brook. (Author's collection)

by bounteous nature, to dispel the fierce burning passion and choking heart-ache engendered by rude collision, with the outward world.

By Steam Train to the Manor Born

Red Scar was served by the 7-mile-long combined passenger-and-mineral Preston–Longridge branch line, which opened on 1 May 1840. All classes of society used the branch during the halcyon days of the mid-nineteenth century and, not surprisingly, there is abundant evidence that, long before the age of the motor car, several members of the Cross family and their staff put great reliance on this railway. The 1861 Census detailing the occupants of Red Scar includes William Assheton Cross and his wife, Katherine Matilda, and her eight children, described as 'scholars'. On the staff at Red Scar was a gentleman tutor, a dancing mistress, a housekeeper, a butler, a nurse, a lady's maid (Françoise Heiney, born in Switzerland), two housemaids, two nursery maids, one gardener and a groom and footman (John Hodgson from Millom, Cumberland).

In September 1864, Colonel Cross wrote a letter to his daughter, Katherine Ellen Cross, requiring the services of his groom and footman, Hodgson, to meet the local train: 'Everton, Thursday, My dear Kitty, I write a line to say that I come home tomorrow. Tell Hodgson to meet the 2.20 train, and as I have some luggage he had better bring the carriage.'

In consideration of the identity of the locomotive type waiting at the head of the 2.20 p.m. train in 1864, it is known that there were signs of improvement in 1856, with the acquisition of a new, pioneering steam locomotive. In 1856, Messrs Beyer Peacock of Manchester built a brand new 0-4-2 coke-burning saddle-tank locomotive, named *Gardner* and costing £1,600, to work with the original *Addison*. It is worth recalling that *Addison* first made its début in 1848, when it inaugurated steam, and was finally sold around 1856. On 24 December 1860, a second new engine was obtained from Sharp Stewart & Co. This locomotive, like its predecessor, exhibited the name *Addison* and was a coke-burning 0-4-2. Thus, the engine at the head of the 2.20 p.m. train in 1864 would have been either *Gardner* or *Addison*. The distinctive horse-drawn carriage was of a type that would have been used by the Cross family during the nineteenth century. The sound of 'clip-clop', moving along the rough road surface, no doubt harmonised with the vibrant whistles and steam emissions of the engine at the local station serving Red Scar, which would in 1864 have been either Gammer Lane, Ribbleton or Grimsargh, both equidistant from Red Scar.

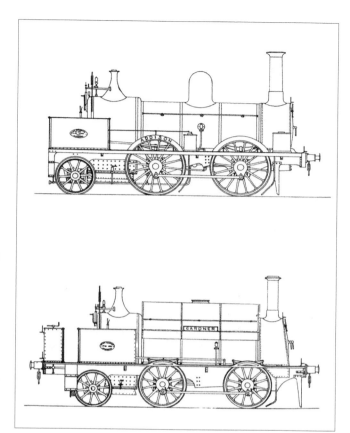

The locomotives *Addison* and *Gardner* would have hauled the trains hauled by the Cross family while residing at Red Scar. Grimsargh with Brockholes was their local railway station (below) throughout the Victorian era. The former LYR station is pictured in 1911. (Author's collection)

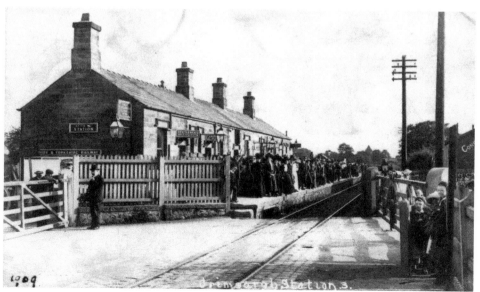

The Country Diary of a Victorian Lady

Katherine Ellen Cross was born in 1847 and was the eldest daughter of Colonel William Assheton Cross and his wife Katherine Matilda, residing at Red Scar, Grimsargh with Brockholes. It was Katherine Ellen (Kitty) who wrote a 'Family Manuscript' entirely by hand in a big, leatherbound ledger. From her came the most vivid memories of Red Scar as a delightful home, which she described as, 'the place on earth beloved over all'. To be sure, the evocative writing of Katherine Ellen Cross paints a moving and haunting picture of life at Red Scar and demonstrates how the Cross family were so closely associated with the history of Preston during the Victorian era.

Katherine Ellen Cross wrote, 'I must mention a little watercolour picture of myself at Red Scar, taken when I was three years old.'

Her grandmother, Ellen Cross, died when Katherine Ellen was only one year and eight months old. She wrote affectionately of her grandmother:

My grandmother died when I was only one year and six months old, the month before Hatty was born I always think. I remember her, but it can hardly be possible, and yet I feel I saw her in our 'day nursery' at 'Red Scar'. Our grandmother must have been a very loveable character. My father and uncles were all devoted to her and she was very clever and wise also. She brought up her six children carefully and well, a widow with six children, none of them nearly grown up. She must have had an anxious life but was greatly helped by her sisters, the Everton aunts. My grandmother and Aunts walked the mile and a half to Grimsargh Church every Sunday and remained there all day, taking their luncheon with them, so that they might teach at the Sunday school in the afternoon. Our father used to talk so much about her and in his last illness he said, 'I think I could eat one of my mother's puddings.'

It would seem that grandma Ellen Cross was more than capable of keeping an eye on her tenants on the estate:

She would say to a tenant, 'Well Martha, your house doesn't look at all nice, it's untidy and not as clean as it should be.' Then she would pull open the drawers and the cupboards and say, that they must be put tidy and kept so, and all in better order for the future. They seemed almost proud of being so carefully looked after and scolded. She must have had a pleasant way of doing it, as there is no doubt she was very much loved by all who recollected her there.

Katherine Ellen makes reference to her uncle Canon John Cross, who was a great benefactor for St Michael's church, Grimsargh. The church was rebuilt and enlarged by him in memory of his parents.

Uncle John or Uncle Johnny as we used to call him, was always a great favourite, having no children of his own, he gave us many a pleasure and treat, and a visit from him always meant a holiday and his favourite game of damming up 'Tunbrook', which he enjoyed fully as much as any of us. Then in the evenings he would sing to us in his beautiful tenor voice, 'Tom Bowling' and the 'Cork Leg' were our great favourites. He married in 1854, Elizabeth – daughter of Admiral Sir Phipps Horby GBE – the Aunt Pussy we all know so well, and well I remember the introduction to our new future aunt one day at St Michael's church. A new aunt was a very exciting and unusual guest, and made a great impression on us.

He was Vicar of Appleby, Lincolnshire and always said he would resign when he was seventy, but in fact, remained a little longer. He then bought a lovely place 'Halecote', Grange over Sands, from Lord Derby, but before he had had it many years, his illness began, and he took a house at Scarborough and died there.

Of Uncle Richard (Viscount Cross), she wrote,

> Uncle Dick – I need hardly say much about as his book tells he [sic] own tale well.
> He married Georgina in 1852 and I was one of the bridesmaids. Uncle Richard's
> own book tells of his gradually buying land, and building himself a house. It is
> wonderful how the trees have grown at 'Eccle Riggs' (Broughton-in-Furness). When
> I first stayed there, in I think 1871, the house stood bleak and bare, with small
> plantations of young trees in all directions. Now it is beautifully wooded.
>
> Uncle Richard turned out Sir Strickland (my mother's uncle) for Preston. I
> remember the excitement and Charlie, then a small boy, bursting into my mother's
> sitting room with the news.
>
> I remember Uncle Richard staying at Red Scar in very early days, probably
> before his marriage and hearing with a sort of awe that when we were all in bed –
> even papa and mama had gone to bed – that he was sitting in the library working
> and reading. He was always very fond of music and Aunt Gregory also, and like
> our father and Uncle John always liked to have some music in the evening.

Katherine Ellen proudly proclaimed the war record of her father, William Assheton
Cross, from his time serving in the Crimean War:

> I now come to our father who was only nine years old when his father died. He
> was educated at Rugby and afterwards went to Christchurch, Cambridge. He
> married Katherine Matilda Winn on 19 August 1846. During my grandmother's
> life she lived on at Red Scar, and my father and mother took a small house called
> Stodday Lodge near Lancaster and there in the following year (16 May 1847) I
> was born and christened at the Parish Church, Lancaster. In January 1849, my
> grandmother died and my father and mother moved to Red Scar.
>
> In 1850 my eldest brother William was born. Willie's birthday was always kept
> with great Éclat, we always had fireworks on the lawn, and several times a dance
> in the coach-house for the servants etc. In those days there were large oval flower
> beds on the lawn, in front of the drawing room windows. The fireworks were let
> off from these beds, which were also of use for the bonfire of all the Christmas
> Greens on Candlemas day. The gardens were quite in the old-fashioned style to
> suit the house. The present flower garden was the vegetable garden, with a few
> flower beds nearest the observatory. One was always filled with red carnations
> which my father liked for a button hall [sic]. Dinner in the early days was at 6
> o'clock, to give the servants more time to themselves. This early time enabled us
> to have strolls after dinner in summer, with our father and mother. I remember
> so well the Sunday evening walk – mamma in white muslin, my father in evening
> dress. We often went up the carriage road, and through 'Kitty's little stiles' into
> the fields beyond, my mother always arm in arm with my father. They always
> walked arm in arm like this and if she was not able to go I took her place. A funny
> little creature I must have looked stepping along – the pink of propriety, a little
> old woman in a black silk jacket, and a bouquet, at the age of say, ten!

In 1854 came the great event of our quiet lives. The 'Crimean War' had broken out, and my father's Militia, in which he was a Major, embodied and went to Portsmouth. We all went there too, and much enjoyed the change of air and scene after our quiet life at home. We used to walk on the ramparts and on the common. After three or four months the Regiment volunteered for foreign service and was sent to Corfu to relieve some regiments of the line sent to the front. My father came home on leave the following October, when Nellie was born [Ellen Priscilla, born in 1855]. One thing I have omitted to mention is that while we were at Portsmouth the whole Baltic Fleet came into the harbour under full sail. How well I remember my mother telling us 'to look at it well, for we would never see such a sight again'. My father came home when peace was signed, full of the beauties of the Ionian Islands, which of course then belonged to England.

My father's chief characteristics were his extreme modesty, and humble-mindedness. His life at Red Scar was very quiet. He walked nearly every day to one or other of the farms, seeing what was needed. On Saturday mornings he always went to Preston in the dog cart (driven by the old coachman Hodgson) while he smoked a cigar and attended meetings of various kinds. He and my mother were I think the most devoted couple I ever saw, and his whole life and character seemed changed after her illness and death. He was a most regular churchgoer, walking there twice every Sunday. He was very fond of astronomy and had two observatories, where he looked out many nights through his telescopes. His luncheon generally consisted of brown bread and butter, and beer, and a glass of sherry to end with, fish and eggs he liked and had a boiled egg for breakfast every day of his life, and only meat for dinner, and then very little. In the evening he read *The Times* diligently, having glanced at the news at breakfast time, and then some interesting book on astronomy, history or a biography. He was very clever and I think it never occurred to us that paps could not answer questions on any subject we liked to ask about. He taught himself to play the organ in a humble way, and almost built the beautiful organ we had in the dining room at Red Scar. The blowing done by water power was arranged by him. My sister Cecily, who inherited his musical tastes, used to play his organ beautifully to him every evening after dinner, greatly to his enjoyment.

Katherine had thoughts about grandfather Chaffers and Valentine's Day:

My grandfather William Cross was married in 1813 to Ellen, the daughter of Edward Chaffers. Our great-grandfather Edward Chaffers, though evidently very fond of his daughters, was a very strict father. My father used to often tell us how he would stop the postman on 14 February, in order that he might take out all the valentine cards and burn them before they reached his daughters' hands! We used to think this very cruel and rather had a dislike to his picture in consequence.

Katherine had warm feelings about days spent during Christmas at 'Red Scar':

Christmas Eve was a great day. The gardeners brought in ladders and evergreen wreaths which they had been busy making in the potting sheds for some days before and they were fastened up to the black oak beams in the dining room, with a big bush in the shape of a bell, and mistletoe hanging where the clapper of the bell should have been. The best pieces of holly with berries were put over each of the ancestors' pictures, and then we children 'did' the windows, sticking in choice little bits of green into the latticed panes. The church was decorated with green wreaths up all the arches, and in later years with texts of our paintings and later still came Altar vases and flowers.

At six o'clock on Christmas Eve we all assembled in the Servants' Hall, to give away beef to all the men, coachman, gardeners, bailiff, carter and labourers. They had a good piece of beef of 10 or 12 lbs each, with a piece of holly stuck in the middle. My father stood at the head of the table, all the men round it, while we all stood round the fire in the corner. A large silver tankard of hot spiced beer stood on the table in front of my father, in which he drank their healths. We followed in succession and then each man came up received half a crown and his beef and drank our healths; the man who had been with us the longest had two half crowns.

On Christmas morning, before our parents were up, we all assembled round their door and sang, 'God bless the Master of this House, and Mistress also, And all the little child-er-en, That round the table go, With a pantry full of good mince pies, And a cellar full of beer, We wish you a Merry Christmas, And a Happy New Year.' Then we often sang 'Once in Royal David's City', after which we heard 'Come in', and in we all trooped to get our kisses and thanks for the songs and our Christmas presents.

After Church and luncheon on Christmas Day my mother used to give presents to all the servants and we were the messengers to take these round – a print dress or a warm petticoat or something else useful and often a thick cardigan knitted waistcoat for Hodgson, our Coachman. Then came the Christmas Trees! First, Mama's tree, with presents to us all. Then our Tree, things we had made ourselves and that had kept us busy preparing for all the year nearly. Pincushions, needlebooks, and all sorts of things that Miss Turnbull, our Governess (generally known as Tubby) had helped us to make. The third tree was in the saddle room for the gardeners and the other men's children.

After dinner on Christmas Day, the singers, the church Choir, used to come into the dining room to sing Christmas hymns and carols and anthems and afterwards had supper. Another evening the servants sometimes had a dance in the kitchen, and we would to open the ball with a country dance, a 'Sir Roger de Coverly'. We always enjoyed the Christmas festivities, even after we were grown up. One good result of a very quiet life was the enjoyment we had in very small things – our lives were so very quiet that any little variety was welcomed.

Life at Red Scar was further described by Katherine Ellen:

> Visiting was very limited; a few days at St Michael's and Appleby Vicarage now and then was about all, except to Mr Staniforth's at Storrs, Windermere, generally for the yacht races on the lake, which my father enjoyed as much as we did, and could explain the whole mystery of it to us, and once he took Hatty and I up the Langdale Pikes, greatly to our pride and delight.
>
> I have said very little about our lives after we were grown up. I may now say without vanity that Hatty and I were considered very good looking, and certainly Hatty was a remarkably tall, handsome girl, while I was a shrimp by her. What I think we liked best of all was the 1st Royal Lancashire Militia Review and luncheon, and often dance in Lancaster. There were also some good private balls in those days, but our Mother was very particular about where we went, and who we talked with, and we were never allowed to go anywhere alone or unchaperoned.

The cotton famine crisis caused extreme social and economic repercussions for Preston, with many of the working class being reduced to pauperism. It is estimated that 49,000 people were receiving outside relief and that the number of people unemployed peaked at 14,500 during April 1863. Edwin Waugh comments on the level of poverty: 'I hear on all hands that there is hardly any town in Lancashire suffering so much as Preston … Destitution may be found almost anywhere there just now.'[44] The Cross family were great benefactors for Preston during the cotton famine and Katherine puts on record:

> The way our mother worked at the time of the great cotton famine of Lancashire. She collected several hundred pounds all among friends and relations, and with the money bought blankets, and warm things to distribute among the poor starving people. I have copied it [the accounts] to show what an immense amount of labour my mother gave herself and what a terrible time of distress it was.

Katherine wrote about her mother, Katherine Matilda Cross, that 'Mother always suffered from the most terrible headaches, and could not bear noise of any kind. This had a most profound effect on the lives of the children who always had to be very quiet. The only time that they were allowed to be noisy was at Christmas'. In the autumn of 1869, while mother and daughters were on a visit to Thurland Castle, Mrs Katherine Matilda Cross was taken ill. She asked Katherine to 'write and tell papa about it, but don't frighten him'. Their visit was curtailed and Mr Cross took his wife to see specialists in London. For a while she seemed much better but then, while on Preston station awaiting a train to take them on a visit to Smithhills, Bolton, she was again taken very ill. The family's omnibus was still outside the railway station and she underwent further medical attention. Her death, on 16 April 1871, was said to be caused by cerebral paralysis.

On 21 January 1875, Grimsargh church witnessed the fashionable wedding of her sister Harriet Esther (Hatty) to a military officer, Captain Pennethorne. The

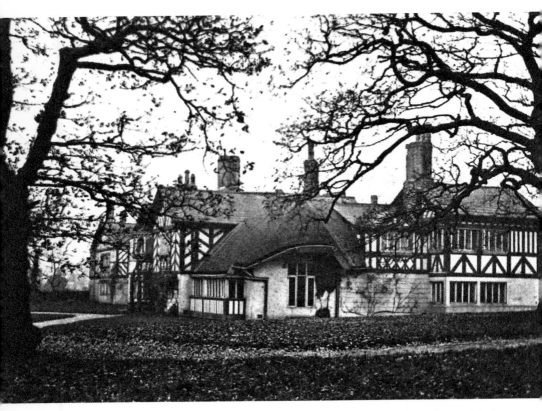

Above: A charming image of the manor of Red Scar at Grimsargh with Brockholes. (Courtesy of Preston Digital Archive)

officiating clergyman was her uncle, the Reverend John Edward Cross, Vicar of Appleby, Lincolnshire. The event was naturally documented in Katherine Ellen's diary: 'They were married at Grimsargh Church by Special Licence, as it was still a Chapel of Ease under Preston. Her bridesmaids were her four sisters and Mary Cross, Uncle Richard's daughters.' The local newspaper reported that 'the beautifully decorated church was crowded in every part and a covered way, laid with carpet, was formed from the churchyard gate to the porch'. After the wedding breakfast at Red Scar, the newly married couple left, amid a shower of old shoes and rice, for London, en route to the Isle of Wight where they spent their honeymoon.

Another four years were to pass before the wedding of her sister Margaret Lucy Cross to Mr W. W. B. Hulton JP.

In May 1879 came Maggie's marriage to W. W. B. Hulton. He often told the tale of how he brought his father on a drive one Sunday, just timed to catch us coming out of Church, that his father might have a look at her (this was before he had proposed to her) and his father's crushing remark, What! Do you think a girl like

that will look at you? Maggie was very good looking with auburn hair and a good figure, and he was a widower with four children. So there was perhaps some justice in his father's view.

People flocked to the wedding from all parts of the surrounding district, converging on 'the perennially isolated church of Grimsargh' by train. Maggie wore a white moire dress trimmed with orange blossom and white lilacs. She was led in by her father and attended by six bridesmaids dressed in white muslin trimmed with pearled Breton lace, each carrying a bouquet and wearing a gold locket set with pearls – gifts of the bridegroom. Again, the church was beautifully decorated, and among the invited guests was the Right Honourable Richard Assheton Cross, Home Secretary, 'Uncle Richard' to the bride. This time the bride's uncle, the Reverend John Cross, assisted the bishop in conducting the wedding ceremony, and as the couple left for Red Scar two of the children of the bridegroom's former marriage strewed flowers in their way. On the death of Mr Hulton's father they removed to Hulton Park, near Bolton. When in later years her husband was knighted, Maggie became Lady Hulton.

Her brother William (Willie) was next to be married, and Katherine Ellen reported hereon:

In that same month of May 1879, Willie was married to Marianne Adamson. Willie was a scientist like his father, and been apprenticed in 1872 to Sir William George Armstrong, the famous engineer, and became an inventor of some note. At the time of his death in 1916, he was engaged in important war work.

William Cross inherited Red Scar on the death of his father, William Assheton, in 1883. William spent most of his working life in Hexham and worked as a shipyard designer with Sir Charles Parsons to develop the first marine turbine boat, the *Turbinia*, around 1890. William Cross moved to south Devon and died on 30 August 1916.

Ellen Priscilla (Nellie) was to be the last daughter of William and Katherine Matilda to be married from Red Scar:

It was a quiet wedding which took place at the pretty old church of St Michael, Grimsargh, in September 1886. Miss Ellen Priscella Cross married Mr George Roupell, 15th Regiment and Deputy Assistant Adjutant General at Bombay. Her only bridesmaid was the young Miss Kitty Cross, daughter of William Cross and therefore the bride's niece. Even so, the event created the usual amount of local interest, and there was the same assemblage of distinguished guests as were seen at all the previous weddings of the Cross daughters.

Katherine devotedly wrote about the circumstances leading up to her father's death:

In the winter of 1882, our father got a bad chill and was most dangerously ill. I think if he had been to take more care and stay in bed he might have recovered, but he never did for more than a day or two at first ... Di had been playing the piano to him while he read and suddenly she heard a little gasp and found him lying back in his chair, looking very ill. She rang the bell, but when the butler came he was already dead – a most terrible shock to her. It was 20 January 1883. She telegraphed to us all, and to our Uncles John and Richard Cross. I cannot write more about that dreadful time.

In January 1883, Katherine Ellen witnessed the solemn funeral service of her father, Colonel William Assheton Cross, which took place at Grimsargh's St Michael's church:

The funeral service took place with marked simplicity, and an entire absence of ostentatious mourning, which accorded with the character of the deceased. No invitations were sent to the county gentry, and the attendants at the funeral beyond the relatives of the deceased comprised only those gentlemen who had been most intimately connected with Colonel Cross in his magisterial work and one or two friends.

The weather was beautifully fine and notwithstanding a sharp frost which prevailed, there was a large concourse of spectators, principally residents in the neighbourhood, who desired to evince by their presence their esteem for the memory of one who had been a good landlord and a kind friend. Leaving Red Scar shortly after 12 o'clock the cortege proceeded slowly through the grounds and up the Longridge Road in the direction of Grimsargh church. About twenty of the principal tenants of the estate walked in front of the hearse, then in the carriages which followed were Mr William Cross, the deceased's eldest son, the Reverend Canon Cross Vicar of Appleby, the Right Honorable Richard Assheton Cross M.P., his sons-in-law; Captain Pennethorne and Mr W.B. Hulton and his brothers-in-law Mr Rowland Winn M.P., and Mr Edmund Winn and many prominent people. At the conclusion of the service the coffin was carried to the family vault in the churchyard where other members of the Cross family had earlier been laid to rest.

The intriguing photograph opposite shows Cross family members and staff on the lawn outside Red Scar around 1884 and is by courtesy of Preston Digital Archive. William Assheton Cross died in 1883 and the house looks to be in good order on a hot summer's day; note the two upstairs windows open, garden furniture, and the curtains drawn in the sitting room to keep the sun out. The windows of the thatched portion are blacked out, suggesting that this part of the building is disused. Anthony Assheton Cross, residing in Devon, has examined the photograph, and I am grateful for his considerable analytical effort in attempting to identify his ancestors and staff.

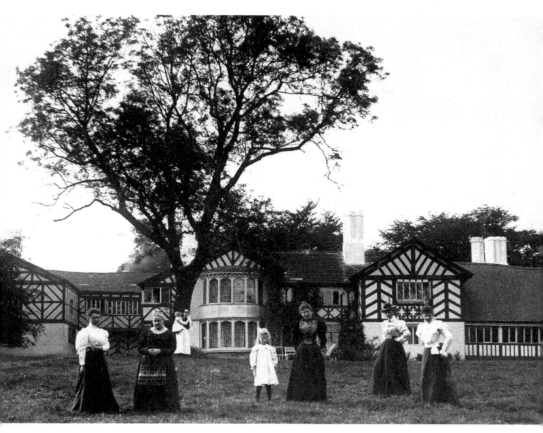

Although there is some conjecture, it is believed that the individuals depicted are, from left to right: either Cecily Sophia (b. 1857), unmarried, or Diana Beatrice (b. 1859), who married in 1884; second left, the housekeeper; third left, the babe in arms being held by the nanny is Dorothy (b. 1883), the younger sister of Katherine Mary Cross. The child in the centre is undoubtedly Katherine (Kitty) Mary Cross (b. 1880), daughter of William Cross of turbine engine fame and the godmother of Anthony Assheton Cross. Kitty was a redhead and would have been about four years old at the time of the photograph. Fifth left, standing next to Kitty wearing a hat, is Katherine Ellen Cross, the author of the 'family manuscript' and the eldest daughter of William Assheton Cross. Sixth left could be either Diana or Emily Cecily. Diana was living at Red Scar in 1884 following her father's death. Both the Victorian ladies to the right of the group appear to have paused for the photographer.

In February 1887, the two remaining unmarried sisters, Katherine Ellen, now aged forty and the writer of the journal, and Cecily Sophia, aged thirty, left Red Scar to make their home in London. In May 1889, Katherine's brother Charles Henry Cross married Edith Mackintosh at Plymouth. They went to Red Scar for part of their honeymoon. Katherine always regretted that the bride saw the house in a very dishevelled state and so different from the beautiful home of her childhood. The 1891 Census records that only two rooms at Red Scar were then occupied. The residents were a gamekeeper, his wife and two young children. How very different from the 1861 Census, when there were nine members of the family and fourteen servants resident at Red Scar. Admiral Charles Henry Cross died on 1 January 1915 and was buried with full naval honours at Plymouth. There is a memorial to him in Grimsargh church. The writer of the journal, Katherine Ellen Cross, spinster, died in hospital on the Isle of Wight on 16 March 1928. William Cross inherited Red Scar on the death of his father.

On 5 May 1887, a new era began at Red Scar when William Cross first advertised the manor and estate:

> Notice by William Cross of intention to lease Red Scar, together with Shooting and Sporting Rights. All that Messuage or Mansion House called, Red Scar with the gardens, grounds, stables, coach houses, Vinery, Greenhouses, buildings and other appurtenances thereto ... And also the Messuages or Cottages situate near the said Mansion House one of which has been used as a keeper's cottage. Also all that the exclusive right of hunting, coursing, shooting, and sporting in over or upon the lands belonging to me ... Also the right of fishing in or upon the streams and brooks on the said property and in the River Ribble – so far as I can grant such right and to the extent only of my right to fish in the said river.

Of those tenancies recorded in trade directories and existing documents, the first was that of Mr Walter M. Daniel from 1898 to 1901. This was followed by a lease to Mr Caleb Margerison of White Windsor Soap in 1904, who, when he left to live in the Isle of Man, was succeeded by his brother George. On 8 June 1925, the contract was renewed for the building and land to be rented to Mr Thomas Stanley Walker, who was already an established tenant. In 1927, Mr Joseph Hollas and Mrs Hollas moved in. Mr Hollas wanted so much to purchase Red Scar, but sadly witnessed its demise.

The elder daughter of William Cross was Katharine Mary Cross of London, who is mentioned as Lady of the Manor in *Kelly's Directory of Lancashire* in 1924. Katharine (Kitty) Mary Cross became the new owner following the death of her father, William Cross, in 1916. Miss Cross became the last member of the family to own Red Scar and secured its fate when she sold it to Messrs Courtaulds on 9 April 1934. In March 1936, Kitty Cross came to Preston and stayed at the Park Hotel. Mr and Mrs Hollas were in residence at Red Scar, which was by now the property of Courtaulds. Accompanied by her solicitor, she visited Red Scar and selected all the furniture and pictures she wanted for her 'Villa Bagatelle' in Bath. Later that

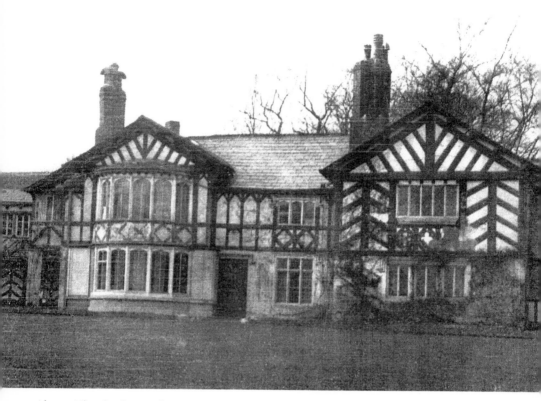

Above: The derelict Red Scar Manor awaits its ultimate fate around 1948. (Courtesy of Anthony Assheton Cross)

day she wrote, 'I feel like a murderess today as if I had torn the insides out of something living. I hope to goodness the poor furniture will like the Villa Bagatelle and settle down there.' Miss Cross died on 27 February 1959.

Red Scar was purchased by Courtaulds to enable that firm to build a new rayon factory for Preston. The remainder of the furniture and nearly all of the paintings from Red Scar were sent by road from Preston to Tavistock (Devon) for safe keeping and storage. Sadly, while the vehicle was parked overnight in Bath, an air raid took place and the vehicle, along with its contents, was hit and totally destroyed (letter to David Hindle from Anthony Assheton Cross, January, 2002).

Regrettably, the manor house was abandoned and left to decay until it finally vanished from the landscape around 1950. Meanwhile, nearby Preston Crematorium opened its doors nearby on 25 January 1962. There is no doubt that the Cross family were thoroughly honourable people. It seems a shame that all the descendants of the Cross family parted company with Lancashire and Red Scar in particular. A direct descendant is Mr Anthony Assheton Cross, who resides in Devon and still has treasured memories and souvenirs from Red Scar, including

a grandfather clock and another clock that was a wedding present to Colonel William Cross in 1846. Tony Cross tells me that no one regrets the loss of Red Scar more than himself and he has stimulated my interest further and kindly authorised this chapter, which has been partly fuelled by my own personal experiences and local knowledge of the site.

I am very grateful to Mr Tony Cross for the privilege of being able to quote extracts from the 'family manuscript' of Katherine Ellen Cross. I am also grateful to the late Mrs Marian Roberts, the author of *The Story of Winckley Square*, for help and information and to the late Miss Nellie Carbis. Miss Carbis once told me about the time she was a guest of the Hollas family at Red Scar in 1935. The keen gardener was naturally in her element in the gardens and there was even a hothouse with peaches, nectarines and grapes. In May 2001, I spoke to Miss Olive Simm, who recalled those early days at Red Scar. 'There was a large rose garden and dad provided white roses for Grimsargh church at Easter. I can remember that Colonel Cross's red-brick observatory was close to our house and was then being used as a cattle shed. Some of the fine beech trees are still here but the once abundant red squirrels are long gone.'

Appendix 1

Preston's established concert halls were annexed to public houses, where the venerable chairman introduced the genre of music hall acts.

Performance Styles in Victorian Music Hall

Venue and Date	Programme	Remarks
Wagon & Horses (*Preston Chronicle*), 26 October 1861	'With a talented company of male and female vocalists. The proprietor had newly decorated the hall and installed an organ for the playing of sacred music every Sunday evening.	Winter open Mon. Tues. & Sat only
Guild Concert Hall, Library St. Rear St John's church (*Preston Chronicle*), 6 October 1866	Week commencing Messrs Snape, Culliver and Robson, Negro Comedians, Will Vale – comique, Miss Julia Smythe, sentimental and serio-comic.	Serio-comics dominate
Theatre Royal Music Hall, Fishergate (*Preston Chronicle*), 16 March 1867	Monsieur Caselli, first appearance out of London of the wonder of the world. Performing and juggling on the invisible wire; Master Shapcott, vocalist, dancer and drummer.	Circus & music hall
The Sun, Main Sprit Weind (*The Era*), 11 September 1870	Madam Lorenzo (sentimental and operatic vocalist) a talented artist, Nelly Gilton (serio-comic – also very clever), Signor Saroni (piccolo player and baritone vocalist who is constantly demanded).	Evidence of refined culture.
King's Head (*The Era*), 28 January 1872	'Professor Capron – ventriloquist, F. Raymond – impersonator and clog dancer, The Brothers Panell – French clowns with performing dogs, Miss Amy Turner and Miss B. Anderson – serio-comic, Miss Jessie Danvers – vocalist and clog dancer, Tom Melbourne – star comic.	Clog dancers typical music hall genre in Preston.
George Concert Hall, Friargate (*The Era*), 21 July 1878	Tom and Rose Merry (duettists, vocalists and dancers), Marie Santley (serio-comic), Will Atkins (comic), Mr and Mrs Patrick Miles and Young Ireland (known as the solid man) and Tom Walker (described as topical)	Preston's first established pub concert hall of 1864

Appendix 2

Let us now ruminate over the revelations of what is believed to be the first historical account of a male striptease act to be staged in a Victorian Preston music hall during 1850! Interestingly, the following golden nugget provides plenty of evidence of the nature of the construction of the pub music hall. For example, the construction of the hall with two tiers and boxes, as well as gender, ratio and age of audiences, audience capacity, admission prices, alcohol provision and an account of the entertainment on offer, featuring singers and the sketch described as 'The Spare Bed'.

Having frequently heard of the demoralising scenes to be witnessed in the principal singing room in this town, and their effects on society, we were determined to visit it and judge for ourselves. Our visit was made on a Saturday evening. The advertisements announced that the 'Illustrious Stranger', would be performed; afterwards singing and dancing; to conclude with the 'Spare Bed'. On proceeding up the archway leading to the room, we passed several groups of very young boys; whose apparent poverty but not their will prevented their entrance. The price of admission is two pence or four pence. Desirous of seeing as much as we could, we paid four-pence. On receiving our tickets we went into the lower part of the room, and the sight which then presented itself baffles description. The performance had commenced and what with the 'mouthings' of the performers, the vociferous shouts, the maledictions, the want of sufficient light, and the smoke from about one hundred tobacco pipes, the effect was quite bewildering for a few minutes.

The room is oblong about 30 yards by ten and capable of holding with the galleries from 800 to 1,000 persons. One end is fitted up as a stage. The bar where the liquors are sold out is placed in the middle. The place between the bar and the stage is appropriated to juveniles or boys and girls from ten to fourteen years of age, of them there were not less than hundred, they were by far the noisiest portion of the audience, and many of the boys were drinking and smoking. The compartment behind the bar appears to have been fitted up for the 'respectables', the seats being more commodious. Leaving this lower part of the room we had to proceed up a dark staircase, (some parts being almost impassable owing to

the crowds of boys and girls) to the lower gallery, which extends around three parts of the room. This gallery was occupied by the young of both sexes, from 14 years and upwards. To reach the top gallery we had to mount some more crazy stairs. This gallery is composed of two short side sittings and four boxes in the front. The occupants of these boxes are totally secluded from the eyes of the rest of the audience. They were occupied by boys and girls. From this gallery we had a good view of all that was passing in the room. There could not be less than 700 individuals present, and about one seventh of them females.

The pieces performed encourage resistance to parental control, and were full of gross innuendoes, 'double entendres', heaving cursing, emphatic swearing and incitement to illicit passion. Three-fourths of the songs were wanton and immoral, and were accompanied by immodest gestures. The last piece performed was the 'Spare Bed', and we gathered from the conversation around, that this was looked for with eager expectation. We will not attempt to describe the whole of this abominable piece; suffice it to say that the part, which appeared most pleasing to the audience, was when one of the male performers prepared to go to bed. He took off his coat and waistcoat, unbuttoned his braces, and commenced unbuttoning the waistband of his trousers, casting mock-modest glances around him; finally he took his trousers off and got into bed. Tremendous applause followed this act. As the man lay in bed the clothes were pulled off; he was then rolled out of bed and across the stage, his shirt being up to the middle of his back. After this he walked up and down the stage, and now the applause reached its climax – loud laughter, shouting, clapping of hands, by both male and females, testified the delight they took in this odious exhibition. The piece terminated about 11 o'clock and many then went away. It is necessary to state that the man had on a flesh-coloured pair of drawers, but they were put on so that the audience might be deceived and some were deceived.

It needs little stretch of the imagination to form an opinion what the conduct of these young people would be on leaving this place-excited by the drink which they have imbibed, their witnessing this vile performance-their uncontrolled conversation. We have heard many persons express their sorrow at the apparent increase in the number of prostitutes in this town, some ascribing it to one thing and some to another. Visit this place and a very palpable cause is manifest. It is the manufactory and rendezvous of thieves and prostitutes. We saw several boys who had recently been discharged from prison. The audience was composed entirely of young persons. The average age of the whole assembly would not be above the age of 17 years. We did not see during the evening half a dozen respectable working men. The audience consisted of that portion of society that demands our most special care and attention – the rising generation. Many of them we could tell, by their conversation, were regular visitors. Some of the boys and girls were enabled to follow the singers in their songs; they could tell the names of the performers, their salaries, and converse on their relative merits. We did not see one female whose modesty seemed shocked or offended, by anything done or said on the stage.

We left the room about 11 o'clock, and there remained between 200 and 300 persons, one fourth of whom would be juveniles. As we have said, the room contained on one period 700 spectators; but the entire number which visited it, during the night, must have reached 1,000. We have visited many singing rooms, both metropolitan and provincial, but for gross and open immorality, for pandering to the depraved tastes of an audience, for exciting the passions of the young, for sensual exhibitions, this place surpasses all. We left it with a firm conviction that we may build Mechanics' Institutes, erect and endow churches, increase the number of gospel Ministers, and improve our Prison Disciple, but while we tolerate this nuisance we labour in vain.

Since the above account was drawn up, a boy has been committed to the prison, to take his trial on several charges of felony–whom we saw taking a prominent part among the loud applauders of the spare bed.

CHARLES CASTLES. AMOS WILSON.

Appendix 3

Here we map the evolution of entertainment styles in Preston between 1833 and 1900.

Theatre Royal, Fishergate

5 December 1840. Under the patronage of Sir Hesketh Fleetwood Bart MP, the theatre staged a dramatic production, *A Trip to Bath*.

14 September 1861. Tightrope walker 'Blondin' at Theatre Royal.

3 July 1872. 'Mr William Parkinson (manager) has much pleasure in announcing to the public of Preston that he has effected an engagement with the Rose Hersee Opera Company. Wednesday: *Bohemian Girl*, Thursday: *Norma*, Friday: *Faust*, Saturday: *Maritana*.

15 September 1878. 'Special representation of Mr Henry Irving to appear in his great representation of *Hamlet*. Imported by the Lyceum Company. Side boxes 8/-.' (Source *Preston Guardian*)

10 January 1880. 'Mr John Hudspeth's grand Christmas pantomime *Hop O' My Thumb* ... Morning matinees on Saturday, half price for children of schools connected with the workhouse.'

2 October 1880. Reopening of Theatre Royal with a dioramic season presented by H. Hamilton. Scenes from the Zulu and Afghan wars. Impressionist Miss Helen Heffer. The O.I.C.M. Minstrels Band. Private Box £1, 2s, 1s and 6d in the gallery. Family ticket to admit 6 to the 2s seats, 10s and 6 to the 1s seats, 5s.

11 September 1882. The Guild Merchant festivities. 'Management beg to announce that notwithstanding the enormous expense of the grand opera company there will be no change in the prices.' The 'Royal English Opera' presented six nights of different operas including *Faust* and *Trovatore*.

13 November 1882. (Victorian melodrama?) 'Miss E. Brunton's celebrated comedy drama company. *Won by Honours, Queen of Diamonds*. To conclude each evening with a laughable farce.'

14 January 1885. 'Morning performance of the grand pantomime *Robinson Crusoe*, next Saturday, 17 January. Children half price to circle, boxes and stalls.'

12 January 1889. *Dorothy* with the H. J. Lesley Opera Company.

17 May 1889. Gilbert and Sullivan's *Iolanthe*, given by Preston Amateur Operatic Society.

13 July 1889. *Catherine Howard* presented by Preston Amateur Dramatic Society.

1 January 1900. 'Pantomime *Babes in the Wood*.'

3 October 1900. Play, *Charley's Aunt*.

8 October 1900. Return visit of Mr C. W. Somerset and London Company in *The Sorrows of Satan*.

15 October 1900. 'Sam Hague's Minstrels' direct from St James's Hall, Liverpool.

29 October 1900. Dramatic production, *The Christian*.

5 November 1900. William Greet's No. 1 Company presents *The Sign of the Cross*.

26 November 1900. Mr Edward Terry's London Theatre Company presented five different plays.

10 December 1900. *Ben-my-Chree*, *The Sign of the Cross*. As played Princes Theatre, London.

1 January 1901. 'Pantomime, *Aladdin*. Acknowledged by press and public to be the prettiest, gorgeous and funniest panto ever seen in Preston.'

Gaiety Palace Theatre of Varieties, latterly known as Prince's Theatre, Tithebarn Street

13 November 1882. The Gaiety music hall bill boasted a reappearance of that great favourite *Yankee Henri Carney*, the three sisters Coulston, last six nights of Mr J. W. Mann, Parker and Temple, and Miss Amy McNally and Miss Minnie Ghent.

28 December 1889. *Professor Crocker's Educated Horses*. No theatre bar but interestingly the management were inviting patronage of the Waggon and Horses Hotel Harmonic Room, 'Mr Harry Yorke on the spot every evening, best in Preston, crowded nightly, free'. (This was adjacent but not adjoined.)

28 April 1900. Grand reopening of New Prince's Theatre following the fire in 1900. 'Mr Lingford Carson in play *The Heart of a Hero*.'

1 January 1901. New Prince's Theatre presented the pantomime *Cinderella*.

7 January 1901. Great drama, *The Grip of Iron*.

26 January 1901. London Company drama, *Gypsy Jack*.

Guild Hall (1), Located in Preston's Late Lamented Town Hall

The opening of the Town Hall, incorporating the Guild Hall, in 1867 provided audience capacity for 1,000 patrons, and was a venue for public meetings, balls, and concert recitals.

8 February 1868. '*New* Town Hall tonight. "Entertainment for the People", with Miles Myres, the Mayor, in the chair, Reverend T. W. Handford will read passages from Dickens. Robert Hilton will sing "Will O' the Wisp" and "Hearts of Oak", Heady Taylor will sing, "Come into the Garden Maude", Piano C. J. Yates, prices 6d and 1s.'

22 February 1868. 'Entertainment for the People at the Guild Hall, this Saturday, vocals by Miss Ellis, Mr Towers, Mr Bicker, solo clarinet J. Norwood, Piano Mr Richardson, Mr Edwin Waugh will also read, "the Barrel Organ" and other Lancashire poems, Edmund Birley in the chair.'

3 July 1872. 'Norwood Subscription Concerts, 1872 1873. J. Norwood begs to announce that he proposes giving during the evening of Autumn and Winter, four grand concerts. Arrangements have been made with Mr Charles Halle and his complete band for November 15.'

3 January 1880: 'At the Guild Hall, popular concert company of Liverpool. Monday, *The Sultan of Mocha*, patronised by the two Preston MPs and the Mayor, to raise funds for the Preston Industrial Orphan's Home.'

5 January 1880: 'Her Majestiy's [sic]Italian Opera Company.

Corn Exchange

Building work commenced on the Corn Exchange in Lune Street on 22 September 1822. The partially completed building then celebrated its first Guild, though it was not until June 1824 that the Corn Exchange was officially opened by the Mayor of Preston. The façade of the original Corn Exchange remains to this day as the entrance to a public house bearing the same name and incorporating the original iron gates that once opened onto the butter market. In the centre stood a large grain and vegetable market that was later transformed into the Public Hall auditorium, now sadly demolished.

25 February 1868. 'The Oddfellow's Tea Party and Ball in the Assembly Rooms of the Corn Exchange. "Mr Norwood's Quadrille Band". Tea at 7, dancing at 8 p.m., Ladies 1/3d and men 1/6d.'

12 January 1879. Corn Exchange: 'Sam Baylis's clever exhibition of marionettes, drawing as always, crowds of visitors' (*The Era*).

17 February 1880. 'Maudland Tea Party (25th Annual), Assembly Rooms of the Corn Exchange. Monday 2 February, eat at 7.30, dance at 8.30 to "Norwood's Quadrille Band".'

28 January 1880. 'The Yeomonary Band will play for dancing at the Yeomonary Ball.'

28 November 1880. 'Assembly Rooms for two nights; "Matthew's Minstrels" (established 1863), songs, dances, comic acts, void of vulgarity.'

1 January 1881. 'Sam Baylis's Marionettes' at the Corn Exchange.

Public Hall (1882)

During Guild Year 1882, the original Corn Exchange was extended and rebuilt as the Public Hall as a venue for public meetings, exhibitions and musical entertainment. With capacity for 3,500, it was one of the largest public halls in Lancashire.

20 October 1880. The *Preston Guardian* featured an article suggesting sites for a new Concert Hall. On the occasion of Preston Guild, September 1882, 'Mr W. Wyatt begs to announce the first popular concert in the new public hall – Monday next.'

13 December 1884: Lecture by Oscar Wilde at the New Public Hall.

5 January 1889. New Public Hall, 'The Carl Rosa Opera Company', prices 6*d* to 2*s* (*Preston Chronicle*).

12 January 1889. 'Norwoods popular concert' in the new Public Hall (2*s*, 1*s* and 6*d*). Mr M. Hillier in the chair.

19 January 1889. 'Sam Topping's Christy Minstrels' at the new Public Hall, 6*d* and 3*d*.

9 February 1889. 'Norwood's popular concert' in the new Public Hall, 'Gems from the Opera' (prices 6*d* and 3*d* – *Preston Chronicle*).

9 March 1889. 'Dioramas of Scotland' plus 'the Caledonian Minstrels'.

2 November 1889. Norwood's popular concert.

30 November 1889. Concert featuring a soprano, a bass singer with humour and whistling, and a charming ladies' orchestra called 'Les Militaires', prices 1*s*, 6*d* and 3*d*.

17 January 1905. The fourth annual 'Farmers' Ball' and concert.

18 January 1905. 'The Infirmary Ball'.

3 March 1910. Cinema presentation of *The Mad Woman of the Ruined Castle* (1*s*, 6*d* and 3*d*).

6 December 1911. *The Messiah*.

5 October 1922. Internationally famous pianist Pachman presented a Chopin recital.

Preston Guilds have long been associated with lavish productions. This is exemplified with a series of concerts featuring famous international performers launched at the Public Hall to celebrate Preston Guild in 1922:

'International Celebrity Subscription Concerts', Preston Guild, 1 September 1922. The Directors have the honour to announce their 1922–1923 record series:

Last appearance of Tetrazzini – world-famous Queen of song for a long period

Clara Butt and Kennerley Rumford – direct from the triumphs of their world tour

Kreisler – the world's master violinist, last appearance prior to world tour

Pachman – Whose art stands alone

Pouishnoff – the world famous Polish pianist

Stella Power – the little Melba
Aileen D'Orme – reappearance of this brilliant vocalist on the concert platform
Lamara – the celebrated Californian nightingale
Eric Marshall – the celebrated English baritone
Melsa – direct from a tour of three continents

During the twentieth century, many leading artists and politicians performed at the Public Hall and the hall hosted the historic 'Guild Court'. In 1962 an obscure pop group from Liverpool were paid £18 to appear at the Public Hall on the occasion of the annual Preston Grasshopper Rugby Club Dance. They even returned to the hall the following year for another gig, but this time to wide acclaim; they were called The Beatles, and the rest, as they say, is history!

Appendix 4

The 'Red Scar Memorial Walk'

The author planned and created the 'Red Scar Memorial Walk' as a short, circular walk during 2004 with the cooperation of Preston City Council and the Lancashire Wildlife Trust. It is primarily intended to offer some comfort to persons paying respect to their loved ones at Preston Crematorium during difficult times, and to stimulate interest in a historic site rich in wildlife. Red Scar parkland surrounds Preston Crematorium on all but the north side. Indeed, the former estate is a forgotten gem, enhanced by the Red Scar Woodlands Site of Special Scientific Interest and the elevated view overlooking the Ribble Valley. Preston Crematorium was built in the same woodland as the old Red Scar House that was the home to three generations of the Cross family of Preston throughout the Victorian era. The manor was demolished in the late 1940s, while the crematorium opened its doors on 25 January 1962.

Point One

Commence the walk from the crematorium car park by walking back along the drive to the interpretive board where two stone pillars indicate the entrance to the grounds of the mansion. Please examine the interpretive board that indicates the points of natural and historic interest as well as the course of the walk. Turn left along the old coach road, which is also indicated by an avenue of lime trees. Song thrush, blackbird, Dunnock, chaffinch, greenfinch, goldfinch, nuthatch, great spotted woodpecker and an assortment of titmice are regular in the crematorium wood.

Point Two

There are still faint traces of a junction here. The left fork originally led to the front main entrance of Red Scar while the right fork was to the rear of the mansion,

where the stables, servants' quarters and gardeners' cottage were situated. The beautiful gardens at the front and a cobbled courtyard at the rear enhanced the overall appearance of the house. Today, bluebells carpets the woodlands hereabouts during April and May, thriving in old woodlands such as this, and great spotted woodpeckers excavate their nest holes in trees. The holes are usually 5–6 centimetres in diameter and may be used for several years.

Point Three

The bench marks the site of the mansion, though the foundations are barely discernible. Time to sit for a while in tranquil surroundings in moments of quiet contemplation. The mansion's sylvan setting consisted of ancient evergreen yew, ash, oak, striking copper and impressive green beech trees and long-abandoned formal gardens in a park-like setting. Fortunately, most of the original trees coexist here as a legacy to William Cross, while a row of holly trees provides evidence of the location of the gardens. A fragment of pie-crust pottery dating back to the seventeenth century was found here in 2007 and is now on display in the Harris Museum.

Point Four

A huge, upright piece of concrete that once formed Colonel Cross's observatory may be seen from the Ribble Way footpath next to the ghostly yet serene woodland site. Those who value the aesthetic appreciation of our local countryside and wildlife may now seek woodland paths originally enjoyed for genteel walks by the Cross family. Look out for roe deer throughout the memorial walk, for they have expanded their range in Britain are now widespread throughout the Ribble Valley woodlands.

Point Five

The Ribble Way footpath provides good viewing of Horse Shoe Bend and the wooded valley of Tun Brook before the walker is taken back across a field and past the pond within the crematorium grounds to complete the circular walk. During the summer months the woodlands are a haven for numerous breeding species, including chiffchaff, willow warbler, blackcap, garden warbler, whitethroat, lesser whitethroat, kestrel, sparrowhawk, tawny owl, little owl, tree creeper, nuthatch and, if you are very lucky, all three species of woodpecker. The woodlands along the River Ribble have been growing here for thousands of years and are designated as ancient woodlands. The steep, inaccessible slopes have protected it from the pressures of agriculture and industries. Historical references to the flora of Brockholes in 1883 are contained in Dobson's *Rambles by the Ribble*.

Notes

1. Hewitson, A., *History of Preston* (Preston, 1883), p. 174.
2. Morgan, N., *Deadly Dwellings* (Mullion Books, 1993), p. 59.
3. Hewitson A., *History of Preston* (Preston, 1883), pp. 203–4.
4. Hewitson, A., *History of Preston* (Preston, 1883), pp. 195–209.
5. Elsewhere a fair at Hull had cinematograph tents from 1897. Reid, D., 'Playing and Praying' in Daunton, M. (ed.), *Cambridge Urban History* (Cambridge Univ. Press, 2000), p. 760. Also Toulmin, V., 'We take them and make them' in *Lost World of Mitchell and Kenyon* (British Film Institute, 2004), p. 59.
6. Hindle, D., *'Twice Nightly'* (Carnegie Publishing, 1999), p. 70.
7. *Lancashire Daily Post*, 5 September 1913.
8. *Burnley Express*, 23 February 1990.
9. *Burnley Express*, 14 March 1997.
10. *Burnley Express*, 23 February 1990.
11. *Burnley Express*, 27 February 1992.
12. *Burnley Express*, 4 June 1974.
13. *Burnley Express*, 31 January 1992.
14. *Burnley Express*, 4 June 1974.
15. *Preston Chronicle*, 17 March 1866.
16. Reid, D., 'Popular Theatre in Victorian Birmingham' in Bradby, D. (ed.), *Performance and Politics in Popular Drama* (Cambridge Univ. Press, 1980), pp. 65–85.
17. Pye, H., *The Story of Christ Church* (Preston, 1945).
18. *Era Almanac*, 9 June 1872.
19. Newsome first opened permanent circus buildings in Northern towns during the mid-nineteenth century.
20. *The Era*, 7 November 1880 and 8 January 1881.
21. Poole, R., *Popular Leisure in Bolton* (Lancaster University, 1982), p. 48.
22. *Preston Chronicle*, September 1882.
23. *Preston Guardian*, 12 March 1884.
24. *Preston Chronicle*, 1 December 1889.
25. Pye, H., *The History of Christ Church and Parish* (Preston, 1945), p. 154.

26. Russell, D., *Popular Music in England* (Manchester Univ. Press, 1987), pp. 72–80.
27. *Memorial Primitive Methodist School, Preston, 1852* (L.R.O. M.S.S. DPR 138/62).
28. Bailey, P., *Music Hall* (Open Univ. Press, 1986).
29. *Preston Chronicle/Guardian*, 1841–1882; *The Era Almanac and Annual*, 1868–1919.
30. *Preston Chronicle*, 22 August 1868; *Temperance Petitions* (L.R.O. DDPR 138/62).
31. *Preston Chronicle*, 10 December 1864.
32. Honri, P., *Working the Halls* (Saxon House, 1973), p. 28.
33. *Lancashire Daily Post*, 17 January 1905.
34. *Ibid.*
35. Russell, D., 'Edwardian Music Hall' in Booth & Kaplan, *The Edwardian Theatre* (Cambridge Univ. Press, 1996), p. 81.
36. Documentation provided by Major A. Burt-Briggs, April 1999.
37. *Lancashire Evening Post*, 13 January 1930.
38. Oral testament *of* Major A. Burt-Briggs, August 1998.
39. Russell, D., *Popular Music* (Manchester Univ. Press, 1987), pp. 79–82.
40. Russell, D., 'Edwardian Music Hall' in Booth & Kaplan, *The Edwardian Theatre* (Cambridge Univ. Press, 1996), p. 65. Also Russell, D., *Popular Music* (Manchester Univ. Press, 1987), p. 81.
41. Rutherford/Bratton, *Music Hall Performance and Style* (Open University Press, 1986), p. 132.
42. *Preston Guardian*, 22 March 1924.
43. *Preston Guardian*, 23 August 1924.
44. Waugh, E., *Home Life of the Lancashire Factory Folk* (1867), pp. 24–25.

Bibliography

Anderson, M., *Family Structure in Nineteenth Century Lancashire* (Cambridge, 1971)

Anglesey, N., *The People's Theatre* (Manchester, 1981)

Bailey, P., *Music Hall: The Business of Pleasure* (Milton Keynes, 1986)

Bratton, J., *Music Hall Performance and Style* (Milton Keynes, 1986)

Clemesha, H., *History of Preston in Amounderness* (Preston, 1912)

Cotterall, J., *Preston's Palaces of Pleasure* (Radcliffe, 1988)

Cunningham, H., *Leisure in the Industrial Revolution* (London, 1980)

Hardwick, C., *History of the Borough of Preston* (Preston, 1857)

Harrison, B., *Drink and the Victorians* (Keele, 1994)

Henderson, W., *The Lancashire Cotton Famine* (Manchester, 1969)

Hewitson, A., *History of Preston* (Preston, 1883)

Hindle D. J., *Around Preston,* (Carnegie, 2012)

Hindle D. J., *Grimsargh: The Story of a Lancashire Village* (Carnegie, 2002)

Hindle D. J., *Victorian Preston & Whittingham Hospital Railway* (Amberley, 2012)

Hindle D. J., *All Stations to Longridge* (Amberley Publishing, 2010)

Hindle D. J., *From a Gin Palace to a King's Palace* (History Press, 2010)

Hindle, D. J., *Twice Nightly* (Preston, 1999)

Hunt, D., *History of Preston* (Preston, 1992)

Joyce, P., *Visions of the People* (Cambridge, 1991)

Kift, D., *The Victorian Music Hall* (Cambridge, 1996)

Morgan, N., *Vanished Dwellings* (Preston, 1990)

Pye, H., *The History of Christ Church and Parish* (Preston, 1945)

Reid, D., 'Popular Theatre in Victorian Birmingham' in Bradby, D., James, L. and Sharratt, B. (eds), *Performance and Politics in Popular Drama* (Cambridge, 1980)

Russell, D., *Popular Music in England 1840–1914* (Manchester, 1987)

Scott, H., *The Early Doors* (London, 1946)

Thompson, F., *The Rise of Respectable Society* (London, 1988)

Vicinus, M., *The Industrial Muse* (London, 1974)

Walmsley, T., *Reminiscences of the Preston Cockpit* (Preston, 1892)
Walton, J., *Lancashire: A Social History, 1558–1939* (Manchester, 1987)
Whittle, P., *History of Preston* (Preston, 1837)
Wilkinson, J., *Preston's Royal Infirmary* (Carnegie, 1987)

Acknowledgements

Research has encompassed a wide range of primary sources. I acknowledge the help of staff at the National Archive, Kew, London; Harris Reference Library, Preston; and the Lancashire Record Office; and to the following photographers: Linda Barton, Peter Fitton, Stan Withers, Noel Machell, Martin Willacy, John Barnett and David Eaves. I further acknowledge the unstinting support provided by Stephen Sartin, Paul Swarbrick, Graham Wilkinson and Anthony Assheton Cross. I am especially grateful to Barney Smith for being afforded the privilege of selecting photos from the splendid portfolio of photographs of old Preston provided by the Preston Digital Archive. I thank all contributors, while pointing out that I have made every effort to trace copyright owners of material and apologise for possible omissions.